Moving Images

THE ASIAN AMERICAN EXPERIENCE

Series Editor
Roger Daniels

A list of books in the series
appears at the end of this book.

Moving Images

Photography and the
Japanese American Incarceration

JASMINE ALINDER

UNIVERSITY OF ILLINOIS PRESS
Urbana and Chicago

© 2009 by the Board of Trustees
of the University of Illinois
Manufactured in the United States of America
C 5 4 3 2 1
∞ This book is printed on acid-free paper.

Library of Congress Cataloging-in-Publication Data
Alinder, Jasmine
Moving images : photography and the Japanese American
incarceration / Jasmine Alinder.
p. cm. — (The Asian American experience)
ISBN 978-0-252-03398-8 (cloth : alk. paper)
1. Japanese Americans—Evacuation and relocation, 1942–1945.
2. World War, 1939–1945—Photography.
I. Title.
D769.8.A6A64 2009
940.53'1773—dc22 2008027212

For Scott and Mickey Street,
Jim and Mary Alinder,
and Aims, Alice, and Eliza McGuinness.
And dedicated to the memory of Masumi Hayashi.

Contents

Illustrations

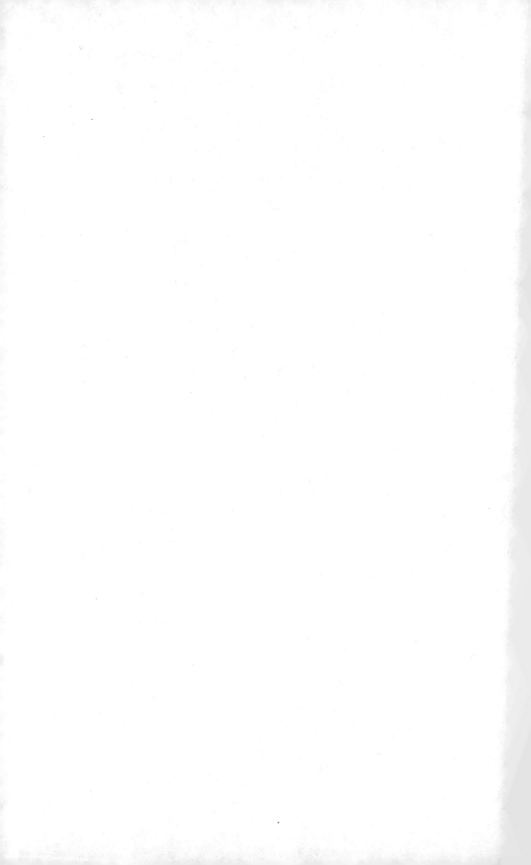

Foreword

ROGER DANIELS

Since Matthew Brady recorded images of the Civil War, photographers and their pictures have been important in recording important events in American history and communicating impressions of those events to the public. But in terms of historical photography, the Confucian adage about a picture being worth a thousand words needs to be modified: understanding such photographs takes thousands of words.

Jasmine Alinder's *Moving Images: Photography and the Japanese American Incarceration* is a stunning reexamination of the ways in which a variety of photographers recorded images of the process of rounding up Japanese Americans in 1942 and of their lives in the concentration camps in which they were held, the ways in which two great museums exhibited some of those images, and images of the concentration camps made by two Japanese American photographers in recent decades. Her analysis of a variety of these images, both iconic and mundane, is penetrating, but what really sets this book apart as the best single work on photography and the camps is Alinder's understanding of the processes by which both American citizens and resident Japanese nationals were deprived of their liberty, and, as she puts it, "the importance of photography in the struggles over the meaning of incarceration in the present as well as the past."

To do this she first examines the ways in which the government's War Relocation Authority used pictures as well as words to obscure the plain meaning of the camps, and then devotes a chapter each to the work of three skilled wartime photographers—Dorothea Lange, Ansel Adams, and Toyo Miyatake—intended to counter those images. A separate chapter dissects

the ways in which New York's Museum of Modern Art and Washington's National Museum of American History used photographs to construct different interpretations of the incarceration during the war and in the 1980s respectively. A final chapter interprets the work of two Sansei photographers, Patrick Nagatani and Masumi Hayashi, and their visions of camp ruins as sites of memory.

As the foregoing suggests, my enthusiasm for Jasmine's book is all but unlimited. My first comment to my colleagues at the University of Illinois on reading the original manuscript from which this book evolved was "This blows me away!" Several years of research and honing have made it even better.

Acknowledgments

I am grateful to Roger Daniels, the editor of this series, who has been my ideal mentor. His intellectual support and encouragement were crucial, and without him the publication of this book would not have been possible. I would like to thank Laurie Matheson, Breanne Ertmer, Cope Cumpston, Tad Ringo, and the rest of the staff at the University of Illinois Press. I would also like to thank my colleagues in the History Department at the University of Wisconsin–Milwaukee, particularly Margo Anderson, Rachel Buff, Michael Gordon, and Dan Sherman for their guidance. At the University of Michigan, I owe debts of gratitude to Diane Kirkpatrick as well as Matt Biro, Howard Lay, and Jennifer Robertson. My sincere thanks to Steve Sumida at the University of Washington. Comments from colleagues at other institutions including Martin Berger, Jacqueline Francis, and Tony Lee have been tremendously helpful.

During various stages of research, I was supported by a number of grants. I offer my thanks to the UW System Institute on Race and Ethnicity, the UWM Center for 21st Century Studies, the Woodrow Wilson Foundation, the American Council of Learned Societies, the University of Michigan's Institute for the Humanities, the University of Michigan's Center for the Education of Women, and the American Association of University Women.

I would also like to thank Lara Blanchard, Erica Bornstein, Jennifer Cash, Susan Edwards, Paul Eiss, Nicole Hood, Joe Grigley, Will Jones, Erica Lehrer, Daryl Maeda, Melanie Mariño, Jon McKenzie, Natsu Oyobe, Patrice Petro, David Rosenfeld, Trevor Schoonmaker, Sandra Seekins, Maureen Shanahan, Leela Wood, and Valerie Yoshimura for their input and assistance during various stages of this project.

The personal rewards I have received while working on this project are many and derive primarily from relationships I have developed with those I have met through research as well as those closer to home. I would like to thank Patrick Nagatani for sharing his photographs, ideas, sense of humor, and poker strategy, and his parents, John and Diane Nagatani, for discussing their wartime experiences with me. Masumi Hayashi was very generous with her photographs and remembrances and also introduced me to Fumiko Hayashida, who graciously allowed me to interview her. Hayashi's son Deen Keesey has been very helpful, as have been the members of the Masumi Hayashi Legacy Project. I owe a large debt of gratitude to Archie Miyatake, who invited me into his home and allowed me to look at more than one thousand photographs made by his father. Since then he has continued to share his vast knowledge and personal experiences with me. I would also like to thank his son Alan. To Ruth and Mitch Shapiro, who offered me a place in their home on numerous research trips, I offer my sincere appreciation. I also would like to acknowledge the assistance of the staff at the Special Collections Department of the UCLA Research Library, Joe at Photo Response, and the staffs at the Center for Creative Photography, the Bancroft Library, the Oakland Museum of California, the U.S. National Archives, the Japanese American National Museum, the Manzanar Interpretive Center, the National Museum of American History, and the Museum of Modern Art.

On the homefront, I am grateful for the friendships of Lisa Bessette, Jane Dini, Nicole Hood, Chris Nardone, the Basting/Lichtenstein family, the Hansen/Bradleys, the Bornstein/Aneesh clan, and the Kim-Paiks. I owe an inexpressible amount of gratitude to Aims McGuinness and our daughters Alice and Eliza. My parents, Jim and Mary Alinder, have provided tremendous emotional and intellectual support throughout, as have Susie and Aims McGuinness. I would also like to thank my grandparents, Scott and Mickey Street. They are my models of citizenship.

Introduction

I spied [my] mother with tears burning pictures
of her relatives back in Japan, looking at them
one by one for the last time and burning them.

—Incarcerated college sophomore, 1942

After March 31, 1942, no person of Japanese ancestry
shall have in his possession or use or operate at any time
or place within any of the Military Areas 1 to 6 inclusive, as
established and defined in Public Proclamations Nos. 1 and 2,
above mentioned any of the following items a. firearms
b. weapons c. ammunition d. bombs e. explosives f. short
wave radio g. radio transmitting sets h. signal devices
i. codes or ciphers j. cameras.

—Bulletin 126, Japanese American Citizens League,
24 March 1942

A little more than two months after the bombing of Pearl Harbor, the United States government ordered the imprisonment of Japanese American citizens and noncitizens living on the West Coast. Nearly 120,000 Japanese Americans, known euphemistically as "internees," spent the war years in concentration camps located in remote and often desolate areas of the western and southern United States. During the incarceration, photography became a representational battleground.

The struggle over photography figured in nearly every aspect of the incarceration. The military criminalized Japanese Americans through identity photographs and prohibited cameras in the concentration camps. After the attack on Pearl Harbor, the FBI began conducting raids of Japanese American homes, and many Japanese Americans destroyed artifacts, including family photographs, that might have been construed as evidence of a link to Japan. The government hired photographers to make an extensive record of the

forced removal and incarceration, and forbade Japanese Americans from documenting photographically the conditions of the camps or any aspect of their lives. Despite the strict regulations, some Japanese Americans managed to find ways to make snapshots and even home movies of their lives behind barbed wire.[1] Eventually, outside visitors were permitted to bring cameras into the camps, including Japanese American soldiers on furlough.[2] Some of the camps also established photography studios under administrative oversight to make portraits and document important events.

That the U.S. military and government used photography in an attempt to legitimize the imprisonment of Japanese Americans is in some ways a familiar story. Such scholars as John Tagg, Allan Sekula, Martha Rosler, Anne Maxwell, and Martin Berger have written extensively about the repressive uses of the camera.[3] From the composite image of deviant types to the photographic construction of the colonial subject, photographs have long been deployed to establish categories and hierarchies that justify structures of power. Such scholarship has provided a much fuller understanding of the exploitive function of photography, exposing how it has been used to construct differences in terms of race, class, sex, gender, criminality, and sanity.[4]

Yet the photographic archive of Japanese American incarceration also contains two surprising twists. First, these images reveal the existence of photographic narratives that were sometimes at odds with and even defied official governmental directives. Second, after a civilian agency—the War Relocation Authority (WRA)—took over the administration of the camps, the majority of state-sponsored images do not represent Japanese Americans as criminals. Although repressive images made of the imprisoned often portray their subjects as inferior, even subhuman, the majority of incarceration photographs produced for U.S. officials depicted Japanese Americans in ways that celebrated their putative virtues rather than their purported flaws. The images depict smiling faces more often than guilty stares.

After the bombing of Pearl Harbor, the camera was initially used to designate Japanese Americans as incarcerable and unworthy of the rights of citizenship. By 1943, however, the government changed course and instead cultivated an image of Japanese Americans as releasable and as deserving of the same rights as other Americans. Yet the image of Japanese Americans as fit for participation in American civic life outside of the concentration camps hinged implicitly on its opposite pole: the purportedly dangerous, disloyal Japanese American.

The two categories of loyal and disloyal became a tragic binary trap that

was used to overturn the principle that people are innocent until proven guilty. U.S. officials incarcerated people en masse without regard to their constitutional rights. Japanese ancestry, inscribed in one's features, determined one's guilt. As one Japanese American wrote in frustration as his loyalty was being questioned, "'I'm an American, but I've got a Japanese face—what am I going to do?' . . . I think something is amiss . . . that the Army decrees that unless you look and act like a Rover boy fresh from a picnic you are a 32 JU, a damned Japanese bastard. . . ."[5] Throughout the incarceration, the camera created and reinforced the stark terms that divided Japanese Americans into two categories: the loyal or clean-cut "Rover Boy" and the disloyal or enemy "Japanese bastard."

In this context of incarceration, the camera served as a kind of visual gatekeeper that determined who was fit to be a part of the body politic and who should be cast out. As Erika Lee has written, the ideology of "gatekeeping" dominated U.S. immigration policy beginning in the late nineteenth century. The Chinese Exclusion Act in 1882 placed limits in terms of race and class on those who could come to the United States. The government consciously crafted an immigration policy that defined Americanness as being anti-Chinese, and by extension anti-Asian. According to Lee, "Chinese exclusion also introduced a 'gatekeeping' ideology, politics, law, and culture that transformed the ways in which Americans viewed and thought about race, immigration, and the United States' identity as a nation of immigration. It legalized and reinforced the need to restrict, exclude, and deport 'undesirable' and excludable immigrants."[6] Through the guise of providing protection, the exclusion movement sought to contain the racialized danger that the immigrant was presumed to present. The impact of gatekeeping ideology on subsequent immigration policy was enormous. Lee argues, "Americans learned to define American-ness, by excluding, controlling and containing foreign-ness."[7]

To maintain the ideology of gatekeeping, the government erected a complex bureaucratic apparatus. As Anna Pegler-Gordon has argued, photography became a key piece of that machinery. Similar to the function of immigration law, photographs could be used to articulate the boundaries of who was fit for entry. Although U.S. officials did not require all immigrants to supply photographs with their visas until 1924, they compelled everyone of Chinese ancestry in the United States, regardless of citizenship status, to obtain photographic documentation.[8] This requirement reinforced the idea that the Chinese signified ultimate foreignness, and were impossible to distinguish from one another without the aid of the camera's "objective" lens.[9]

With the incarceration of Japanese Americans sixty years after Congress passed the Chinese Exclusion Act (and one year before the exclusion laws expired), the government projected the ideology of gatekeeping into the citizenry itself. The practice of segregating citizens according to the classification of race was not new, as both the government's policy toward Native Americans and the Jim Crow South attest. During World War II, the gates stood not only at the nation's borders but also in the center of the country, at the entrances of the concentration camps where Japanese Americans were imprisoned without regard to their citizenship status.

Through a comparative analysis, the chapters in this book examine documentary photographs of the evacuation and incarceration made by Dorothea Lange, Ansel Adams, and Toyo Miyatake, as well as more contemporary images of the deserted incarceration sites made by Patrick Nagatani and Masumi Hayashi. Calibrated readings of Japanese American incarceration photographs that consider artistic intention, critical interpretation, institutional deployment, and popular reception reveal the complex issues embodied in this historical moment and its recollection; this includes the relationship of "official" history to personal memory and the construction of race, citizenship, and patriotism.

Incarceration in Context

As wartime hostilities began, false rumors of illegal activity by Japanese in the United States became widespread. General John DeWitt, head of the Western Defense Command (WDC), incorrectly reported that Japanese Americans were communicating with the Japanese Navy.[10] The sight of a camera in the hands of a Japanese American became fodder for accusations of spying. Even before the bombing of Pearl Harbor, in March of 1941, DeWitt complained that Japanese American draftees or, as he said, "a couple of Japs," were "going around and taking pictures."[11] In a different incident, a young Japanese American recalled to an interviewer, "One day we went to Long Beach on business and somebody phoned the FBI saying that we had been taking pictures of the Vultee Aircraft Factory. The road we took was two miles from the factory. . . . It made me feel that if the public were that gullible, our goose was cooked."[12]

Military officials' course of action before the signing of Executive Order 9066 was convoluted, controversial, and based on racism, outright lies, a disregard for the constitutional rights guaranteed to U.S. citizens, and an assertion that Japanese Americans were unworthy of those rights. DeWitt

viewed the Japanese as an incorrigible enemy who required annihilation for the Allies to obtain victory. As he put it, "the Japs we will be worried [about] . . . until they are wiped off the face of the map."[13] Whether a Japanese person was a U.S. citizen or not was irrelevant to DeWitt, who viewed the purported racial characteristics of the Japanese as overriding all other affiliations. DeWitt's position was neatly summed up by this infamous syllogism, which he uttered as a justification for the incarceration: "A Jap's a Jap." Despite his racist views, however, DeWitt wavered in his opinion about whether Japanese Americans should be incarcerated en masse. Influenced by Major Karl Bendetsen, who in turn was operating under the Provost Marshal General Allen Gullion, DeWitt began to support the incarceration by January of 1942.[14]

The press, including respected journalists such as Edward R. Murrow, abetted the military's architects of incarceration by spreading rumors of collusion between Japanese Americans and the Japanese Army. Murrow announced, "[I]f Seattle ever does get bombed, you will be able to look up and see some University of Washington sweaters on the boys doing the bombing!"[15] California newspapers continually confused the Japanese enemy with Japanese Americans in headlines such as "Jap Boat Flashes Message Ashore" and "Caps on Japanese Tomato Plants Point to Air Base."[16] To convince the United States Congress of the necessity of incarceration, Earl Warren, then attorney general of California, argued that the absence of sabotage on the West Coast was only an attempt to lull the United States into complacency, a notion earlier advanced by DeWitt.[17] Japanese Americans were trapped by circular logic. Unfortunately, the argument convinced many other Americans.

President Franklin Roosevelt signed Executive Order 9066, which legislated the vague terms of the mass incarceration, on February 19, 1942. The brief document, subtitled "Executive Order Authorizing the Secretary of War to Prescribe Military Areas," did not mention people of Japanese descent specifically. Instead, the order ceded control to U.S. military commanders, through the power of exclusion, of "any or all persons" considered threatening to the United States. In practice, however, government and military officials applied the order only to Japanese Americans.

On March 2, 1942, DeWitt created two military areas in Washington, Oregon, California, and Arizona. Military Area 1 ran from the southern half of Arizona through coastal California, Oregon, and Washington. Non-coastal California was designated as Military Area 2. Three weeks later, DeWitt issued a strict curfew for the two military areas that applied to enemy aliens and "persons of Japanese ancestry."[18] During the next few months, the military posted exclusion orders on telephone poles and in shop windows in Japanese

JAPANESE-AMERICAN CONCENTRATION CAMPS

called "Relocation Centers" by the government

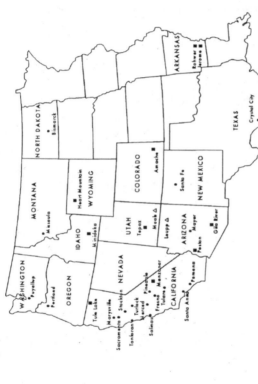

ASSEMBLY CENTERS
Puyallup, WA
Portland, OR
Marysville, CA
Sacramento, CA
Tanforan, CA
Stockton, CA
Turlock, CA
Merced, CA
Pinedale, CA
Salinas, CA
Fresno, CA
Tulare, CA
Santa Anita, CA
Pomona, CA
Mayer, AZ

RELOCATION CENTERS
Amache, CO
Gila River, AZ (2 camps)
Heart Mountain, WY
Jerome, AR
Manzanar, CA
Minidoka, ID
Poston, AZ (3 camps)
Rohwer, AR
Topaz, UT
Tule Lake, CA

JUSTICE DEPT. INTERNMENT CAMPS
Santa Fe, NM
Bismarck, ND
Crystal City, TX
Missoula, MT

CITIZEN ISOLATION CAMPS
Moab, UT
Leupp, AZ

ASSEMBLY CENTERS - Temporary detention camps in operation from late March, 1942, to about the middle of October, 1942 where internee families were kept until relocated to more permanent detention camps called "Relocation Centers."

JUSTICE DEPARTMENT INTERNMENT CAMPS - For non-citizens which included Kibei (born in Japan), Buddhist ministers, newspaper people and other community leaders.

CITIZEN ISOLATION CAMPS - War Relocation Authority Penal Colonies for United States citizens.

Figure 1. Map showing the locations of the Japanese American concentration camps. Courtesy of Patrick Nagatani.

American neighborhoods on the West Coast. In June, DeWitt reported that one hundred thousand Issei and Nisei, or first and second generation Japanese Americans, had been moved out of Military Area 1. By August 7, five months after "evacuation" had begun, both military areas had been purged of their populations of Japanese descent.[19]

While the main concentration camps were under construction, "evacuees" were first taken to "assembly centers" or intermediary incarceration camps, including state fairgrounds and race tracks where some were compelled to live in horse stalls. After a few months in these make-shift prisons, the military moved Japanese Americans to more permanent concentration camps. The ten main Japanese American concentration camps were located in Tule Lake, California; Manzanar, California; Gila River, Arizona; Poston, Arizona; Amache, Colorado; Rohwer, Arkansas; Jerome, Arkansas; Topaz, Utah; Minidoka, Idaho; and Heart Mountain, Wyoming (see figure 1). In addition to these ten central camps, there were other, higher security, Justice Department incarceration camps for those deemed enemy aliens, as well as two isolation centers for those accused of being especially dangerous.

Works on Japanese American incarceration by scholars including Roger Daniels, Michi Weglyn, and Harry H. L. Kitano have examined the historical origins, depth, and degree of anti-Asian racism in the United States.[20] These historians have shown that, instead of being an aberration or an unfortunate exception, the imprisonment of Japanese Americans was the culmination of long-standing racist practice. According to Daniels, "The wartime abuse of Japanese Americans . . . was merely a link in a chain of racism that stretched back to the earliest contacts between Asians and whites on American soil."[21]

The first group of Japanese immigrants arrived in California in 1868. Between 1900 and 1910, the population of Japanese in the United States increased from just under twenty-five thousand to over seventy thousand.[22] As the immigrant population continued to rise, legislation to contain the growth of Japanese economic power also increased. In 1907–1908, the Gentlemen's Agreement between the United States and Japan limited the migration of male Japanese laborers to the United States. The 1913 California Alien Land Act forbade ownership of land by aliens and joined other laws that prohibited certain immigrant groups from becoming naturalized U.S. citizens, including immigrants from Japan, Korea, and China. The only people of Japanese descent that could be U.S. citizens were those who were born in the United States. The effect of this national and state-level legislation in California was that foreign-born people of Japanese descent were prevented from gaining

title to the land on which they worked. Instead, immigrants were forced either to lease land or register the title of their property in the names of their U.S.-born children. The 1922 Supreme Court decision in *Takao Ozawa v. United States* reaffirmed the exclusion of Japanese from the ranks of immigrants who could apply for U.S. citizenship.[23]

Wartime hysteria and military necessity have been coupled as reasons to excuse or explain away civilian support for the incarceration and to defend military and government indifference to Japanese American civil rights. Historians including Weglyn and Daniels have sought to debunk wartime hysteria as a justification for the incarceration by pointing to deeply ingrained anti-Japanese attitudes, the long history of anti-Japanese policies stretching back to the 1860s, and increasing economic competition in California agriculture. The notion that incarceration was required for national defense, meanwhile, is now generally acknowledged to be illusory, as the U.S. government itself affirmed in its 1982 study *Personal Justice Denied: Report of the Commission on the Wartime Relocation and Internment of Civilians,* which concluded that "no military necessity supported the exclusion."[24]

As scholarship on Japanese American incarceration continues to grow, historians, activists, and others have become more critical of the language used to characterize incarceration. The question of how to refer to the camps has been contested since they opened in 1942. U.S. government officials, including the president, originally referred to the prisons as "concentration camps." After learning of Hitler's death camps, however, U.S. officials avoided the term "concentration camp" and called the American camps "relocation centers" or "internment camps."[25] Referring to the sites of imprisonment as "internment camps" and their prisoners as "internees" has become common practice in historical scholarship. The usage is so prevalent that the entire process is often referred to simply as "internment." But as Roger Daniels argues, the word "internment" as defined in U.S. law is a legal process that pertains only to foreign nationals, not to U.S. citizens: ". . . 'internment' was an ordinary aspect of declared wars and referred to a legal process, described in United States statutes, to be applied to nationals of a country with which the United States was at war . . ."[26]

The majority of incarcerated Japanese Americans were U.S. citizens, who by definition could not be legally "interned." Euphemisms such as "relocation center" or "internment camp" fail to reflect the fact that Japanese Americans were stripped of their citizenship rights and incarcerated en masse.[27] The word "internment" obscures the government's culpability as it suggests a wartime convention governed by law. As Raymond K. Okamura explains,

the official terminology used to describe the incarceration "sidetracked legal and constitutional challenges, helped the government to maintain a decent public image, helped lead the victims into willing cooperation, permitted the White civilian employees to work without self-reproach and kept the historical record in the government's favor."[28]

Currently, four adjectives are commonly used to describe the camps: "relocation," "internment," "incarceration," and "concentration." Many among the Sansei, or third generation Japanese Americans, refer to the sites by the more politically charged "concentration camp." Some who object to any comparison between the incarceration of Japanese Americans and the Holocaust have criticized this usage. But the term "concentration camp" applies more accurately to the U.S. camps. In the context of the Holocaust, the term "concentration camp" is itself a euphemism that obscures the murderous designs of death camps such as Auschwitz or Buchenwald. The crucial similarity, however, lies not in the ultimate fate of the prisoners, which was starkly different, but in the construction of the camps as places where people were deprived of rights and segregated on the basis of purported difference.[29]

Nisei often refer to the sites by the names commonly used while they lived in them: "relocation center" or "internment camp." Frank and Joanne Iritani, for example, subtitled the indispensable account of their journey to each of the central sites as "Accounts of Visits to all the Japanese American Relocation Centers."[30] The more euphemistic terms may at times be preferable to those who lived in the camps as they lessen the implication of criminalization. In general conversation, Nisei sometimes go so far as to drop the adjective "internment" and the individual sites of incarceration are referred to simply as "camp." Some Sansei have complained that when their parents spoke of "camp," they could not discern the severity of the event or the experience, and often thought that their parents were discussing a summer-type camp. "Camp" became a code word or short hand for Nisei to exchange stories or remembrances to one another without revealing the specifics of their wartime incarceration to their children.[31]

The ten principal sites of Japanese American incarceration are all located in desolate environments, distant from major towns and cities. The government went out of its way to use land in particularly remote areas of the country. The sites of the concentration camps were chosen precisely because they had little strategic importance.[32] With the exception of Manzanar, most of the incarceration sites are hard to locate and are not well marked. Even the Iritanis warn that "most camp sites may be difficult to find even with directions. So, a road map should be used with the sketch map and instructions in

this booklet."[33] The Iritanis had a particularly difficult time locating the site in Gila River, Arizona: "On our first visit in October, 1989, we experienced much difficulty in locating the camp site. Only a graffiti covered semi-circular skeleton of a monument and water tank foundation were seen on the Butte knoll."[34] The farm roads at Gila River seem to stretch out endlessly, bordering on field after arid field. The incarceration grounds are privately owned by the Gila River Indian Community (Pima and Maricopa) and are closed to visitors. In order to see the site, one has to apply to the tribal council, pay a fee, and wait while a committee processes the application.

The lack of public access to the Gila River monument makes one aware that these environments have been largely forgotten. Perhaps the most disturbing site to visit today is Topaz, Utah—another very difficult site to find and one of the most unsettling. The reward for finding it includes fallen-down barbed wire fences, shards of pottery resting on a similarly cracked earth, and a monument accompanied by a set of commemorative plaques that have been used for target practice and bear dime-sized welts where they have been struck by bullets.

The site of the former camp in Rohwer, Arkansas, provides a poignant reminder of both how far from public view these camps were and how they continue to be marked by their wartime function.[35] The remains in Rohwer do not reveal evidence of failed sabotage plans, but rather of Japanese American patriotism to the United States. Several small tombstones and a few large monuments commemorate the concentration camp and Japanese American soldiers who fought bravely in the war while their families remained imprisoned at home. One monument of stacked concrete blocks is inscribed with the word "Courage" and topped with an eagle. Another takes the shape of a tank that flies a painted American flag and is emblazoned with the numbers "100 442" in reference to the 100th Infantry Battalion and the 442nd Regimental Combat Team, the highly decorated all–Japanese American units of the U.S. Army. These markers sit quietly in a grove of trees off a minor road in a tiny Arkansas town in a county whose current population barely tops fourteen thousand. The populations of the camps, which varied from a few thousand to more than eighteen thousand, often outnumbered those of the small towns in their vicinity.[36]

Like the camp sites themselves, the wartime experiences of Japanese Americans remained largely hidden from view during the first three decades after the war's end. Japanese Americans had to struggle with the fact that what in many ways was the most significant event in their collective history was one that remained largely unacknowledged by the rest of the country. Per-

haps that is one reason why memorials to Japanese American soldiers are so prominent in the Rohwer cemetery. In the environment that once served as their jail, former prisoners from Rohwer marked the land with an aspect of public history about which they and every other American could be unequivocally proud.

After World War II, many Japanese Americans wanted to forget about the experience and move on with their lives.[37] Those from the West Coast who relocated to cities in the Midwest often did so with the hope that they could make a fresh start among people who were less hostile to their presence.

Most Sansei came of age in the 1960s, when the struggle for civil rights and the expression of ethnic identity consumed much of the country's cultural and political consciousness. As Sansei sought to understand their history as Japanese Americans, many found it impossible to do so without coming to terms with their parents' and grandparents' experiences in the concentration camps. At the urging of their children and by their own volition, more Nisei began to tell their stories. The move toward recognizing and articulating the experiences of Japanese Americans became more politically charged in the late 1960s as some Japanese Americans organized to repeal Title II of the 1950 Internal Security Act, which permitted the government to conduct mass incarcerations of civilians suspected of sabotage.[38]

In the 1970s, increasing numbers of Japanese Americans demanded that the federal government make amends for the wartime incarceration. The struggle for redress began in 1970 with a resolution passed by different chapters of the Japanese American Citizens League. In 1980, the U.S. government formed the Commission on the Wartime Relocation and Internment of Civilians, which held public hearings throughout the country and gathered testimony from over 750 witnesses during an eighteen-month period. Congress passed the Civil Liberties Act of 1988, which authorized monetary compensation for former prisoners, and in 1990 the first redress payments were issued with the following presidential apology:[39]

> A monetary sum and words alone cannot restore lost years or erase painful memories; neither can they fully convey our Nation's resolve to rectify injustice and to uphold the rights of individuals. We can never fully right the wrongs of the past. But we can take a clear stand for justice and recognize that serious injustices were done to Japanese Americans during World War II.
>
> In enacting a law calling for restitution and offering a sincere apology, your fellow Americans have, in a very real sense, renewed their traditional commitment to the ideals of freedom, equality, and justice. You and your family have our best wishes for the future.[40]

The letter acts as a curious apology. The government remains unwilling to assume responsibility by using a passive voice instead of an active one. The second paragraph implies a continuing separation between the status of Japanese Americans and all other Americans that echoes the divisive rhetoric of race and citizenship that made incarceration possible in the first place. The credit given to "your fellow Americans" for renewing their "traditional commitment to the ideals of freedom, equality, and justice" ignores the efforts of Japanese Americans to bring the issue of redress to Congress. Nor is there mention of the fact that President Reagan, who signed the bill into law, had opposed it until the 1988 election.

Concentrated Smiles

In the thousands of photographs made of the incarceration process by government photographers, independent documentarians, and prisoners themselves, it is much more difficult to find photographs that portray suffering than it is to find images of smiling faces. A few photographs in the Japanese American National Museum's core exhibition, Common Ground, reveal an overt level of violence that largely escaped the camera's lens. The caption for one of these photographs, a slightly blurred, black-and-white image depicting a prisoner under direct physical custody, explains that it is of the "Segregation Concentration Camp at Tule Lake, CA c. 1945" and was "Smuggled by Wayne Collins"—a lawyer for the ACLU (see figure 2). This smuggled image depicts a brutality rarely captured in the photographic record of Japanese American incarceration. The violence depicted in this photograph validates a major reason for writing this history: to acknowledge the suffering of Japanese Americans and condemn the crimes committed against them. They were stripped of their citizenship rights, forced to abandon their houses and possessions (resulting in failed businesses), and families were separated.

A very different photograph, made on April 1, 1942, by Clem Albers, a photographer for the War Relocation Authority, depicts three well-dressed young women who have just boarded a train in Los Angeles that will take them to a so-called assembly center (see figure 3).[41] The women smile and extend their arms out of a raised train window to wave goodbye, as if they are embarking on a vacation or some other pleasant excursion. Although the exuberance seems forced, the Albers photograph is much more typical of the photographic record of the incarceration than is the Collins photograph.

Not surprisingly, these photographs of smiling Japanese Americans are troubling for many scholars, curators, and activists who have worked to ex-

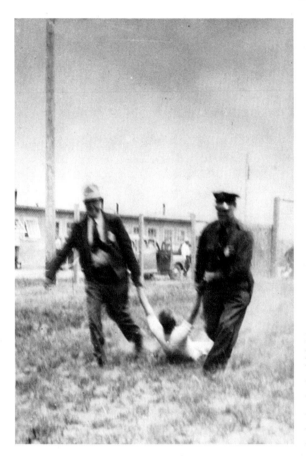

Figure 2. Wayne Collins photograph, "Segregation Concentration Camp at Tule Lake, Calif. c. 1945." Gift of Michi Weglyn. Japanese American National Museum (96.33.3).

pose the injustices of the wartime imprisonment. To contemporary viewers, the images may present an iconologic challenge because they fail to render incarceration in the visual terms that have become associated with imagery of traumatic events in the wake of World War II. Contemporary notions of the representation of traumatic events are most directly influenced and informed by photographs of the Holocaust. Current familiarity with Holocaust photographs affects viewers' perceptions of Japanese American incarceration images. As Karen Ishizuka, former senior curator at the Japanese American National Museum acknowledged, "People have a preconceived notion of what suffering or injustice should look like. . . . The comparison with Nazi death camps further complicates the issue."[42]

As photographs of war and atrocity, Holocaust images represent a water-

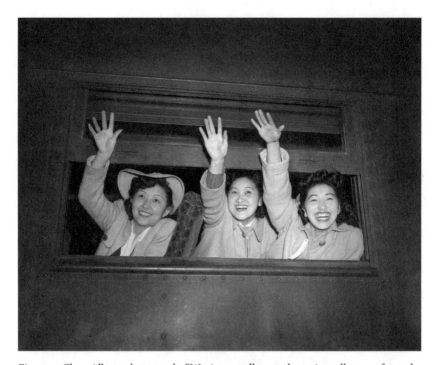

Figure 3. Clem Albers photograph, "Waving goodbye as the train pulls away from the station. These girls are on their way to an assembly center with others from this area of Japanese ancestry. They will later be transferred to War Relocation Authority Centers to spend the duration." April 1, 1942, Los Angeles, Calif. Photo #210-G-B18 (ARC #536767), United States National Archives, College Park, Md.

shed. The release of photographs of the victims of the Nazi death camps in 1945 collectively exposed the public to unprecedented horrors. Although photography had been used to portray traumatic events since the U.S. Civil War, the publication of Holocaust photographs set a new paradigm for the photographic depiction of suffering with shocking images of "piles of human ashes, mounds of corpses, crematoria . . . , dazed looks of barely alive skeletons, gaping pits of bodies."[43] By comparison, photographs of Japanese American incarceration may appear mundane.

Without the iconography of torture and abuse, for example, one could think of the incarceration photographs as the flipside of the atrocity photograph, which could lead to a kind of nostalgia for the time when the United States was capable of humanely imprisoning those who were thought to be disloyal or enemies.

Whereas Holocaust photographs stress the extraordinary nature of the extermination camp, Japanese American incarceration photographs seem to portray the concentration camps as somehow normal. The imprisonment of Japanese Americans during World War II was not genocide, nor a single violent act of terrorism, nor prolonged physical torture. Nonetheless, it is dangerous to think of atrocity photographs as exceptional or as unrelated to incarceration images, even those depicting smiling faces, because it eclipses the fact that such suspensions of morality and human rights occur on the same continuum. This disposal of morality and humanity, expressed through Giorgio Agamben's claim that the camp is the "fundamental biopolitical paradigm of the West," ties such photographs together.[44] If photographs of the Holocaust and more recently of prisoners at Abu Ghraib provide stark evidence that these camps may be the rule and not the exception, it is photographs of Japanese American incarceration that naturalize the state of exception with the false assurance of the smile.

Not surprisingly, the photograph by Albers and others like it have been left out of prominent retellings of incarceration history, particularly in museum exhibitions. As Ishizuka writes, "When reflected in photographs, positive images of camp are found disturbing by outsiders. The camps look too nice; the inmates look too happy."[45] The Albers photograph certainly would send an inappropriate message if it were included within the narrative of the Common Ground exhibition. The smiles that the women offer to the camera are charged for several reasons: they appear to belie the injustice of incarceration and the suffering it caused; they are reminiscent of the ugly stereotype of the grinning "Oriental"; and they suggest that those portrayed were entirely compliant with the government's racist agenda.

But suppressing this kind of photograph from public representations of incarceration does not erase its existence within the archive. How does one read these photographs and reconcile smiling faces with imprisonment? Unfortunately, the absence of overt violence in photographs like the Albers image has actually convinced some scholars that this is evidence of the benign character of the wartime camps. Sylvia Danovitch, for example, pushes this reading to what in her mind is the logical conclusion: "We can look with relief to these pictures, cognizant that, like other nations, we imprisoned people who we believed might be dangerous in wartime, but, unlike other nations, we did not mistreat, dehumanize, or starve them. Reporters freely entered the camps and internees were often allowed out. We committed a grave error, but we were civilized. The photographs are our witness."[46] Danovitch, content to read the photographs transparently, finds very little evidence of

suffering in the images and regards that apparent lack as proof of the relative absence of mistreatment and dehumanization.

Other scholars have characterized the photographs as unrepresentative of the incarceration experience. Kristine Kuramitsu, for example, treats the photographs as deceptions crafted to disguise or obscure the injustice and harshness of incarceration. She writes, "This documentation, produced by government employees and freelance artists such as Dorothea Lange and Ansel Adams, created the definitive record of the internment experience presented to the U.S. public. These images reinforced the perception that internment camps were like summer camps, as they focused only on the visually benign, pleasant, or 'poetic' aspects of the experience."[47] These conclusions drawn by Danovitch and Kuramitsu make it clear that what determines one's interpretation of these photographs has less to do with the actual images than it does with the expectations brought to them and the viewer's stake in a particular version of history. Danovitch's commitment to the idea that incarceration was civilized requires her to insist on the truthfulness of the photographs, while Kuramitsu's project of condemning incarceration leads her to dismiss the same images as deceitful.

In this book, my primary interest lies not in evaluating the status of the photographs as truthful or false, but rather in examining the ways in which photography was used to construct and project representations of Japanese Americans during the war. Photographs function neither to reveal history transparently nor to obscure it. Photographs make history. As such, images were integral to the incarceration process from its beginning and shaped the historical events that they purported to disclose. In order to explore how photographs produce history, it is necessary to pose a set of questions that does not focus on whether or not they provide an accurate view of the experiences of the incarcerated, but rather on how they construct those experiences for particular audiences.

Photographic meaning is far from fixed and fluctuates greatly depending on how the photograph is deployed and who is viewing it. As Roland Barthes has written, "The number of readings of the same lexical unit or lexia (of the same image) varies according to individuals The variation in readings . . . depends on the different kinds of knowledge—practical, national, cultural, aesthetic-invested in the image . . ."[48] The presence or absence of a smile, for example, is neither a reliable indicator of the constructedness nor candidness of an image. Smiles themselves could be deployed by subjects and read by viewers in a wide range of ways, from servile obedience to an assertion of humanity that flew in the face of dehumanizing war propaganda.[49]

In her reading of incarceration photographs, Wendy Kozol also emphasizes how meaning fluctuates: "Yet just as the notion of a totalizing governmental gaze is highly problematic so too is any presumption that the pictures show the 'real' experiences of the Japanese Americans. Pictures that show proud, strong people refusing to be depicted as victims, I argue, reveal something of Japanese Americans' attitudes, even their agency."[50] In a situation of power relations as lopsided as the incarceration, when the U.S. government seemingly had all the power in its hands, competing photographic agendas were at work. In addition to officially sponsored photographs made for the military and the War Relocation Authority, independent documentarians and prisoners themselves also created images.

More than merely recording the movements and attitudes of Japanese Americans, the constant presence of the camera itself influenced both the images produced and the process of incarceration. Photographers, their cameras, and their equipment were not flies on the wall during the incarceration process. On the contrary, they must have been all too conspicuous to the Japanese Americans whose imprisonment they were there to document. Occasionally, photographs made by WRA photographers give a sense of the degree to which the camera was integral to an event. Two photographs made by Francis Stewart, for example, show professionals aiming their cameras at incarcerated subjects in Tule Lake.[51] A Dorothea Lange image of the forced removal of Japanese Americans from San Francisco (see figure 4) depicts one such family walking down the sidewalk between two long lines of luggage as two press photographers lean against store windows and prop their feet on crates. The caption for the image reads, "Many news photographers were present for the first contingent of evacuees of Japanese ancestry boarding buses for Assembly Centers."[52] A camera captured Lange herself as she perched above a crowd of Japanese Americans undergoing the evacuation process, her own camera resting on her knee.[53] In a hand-written note explaining why the use of her personal car was necessary for the WRA assignment, Lange stated that she required extensive photographic equipment including three cameras, artificial lighting equipment, tripod, and ladder.[54]

The proliferation of government and press photographers and their cameras may have played a large part in encouraging the smiles, the orderliness, and the patience. Intensely aware that the dominant media and the government were portraying them as criminals, many Japanese Americans apparently went out of their way to counter such images and salvage whatever shred of dignity they could by dressing in their finest clothes and putting "the best face" on a situation that was fundamentally humiliating and degrading. The

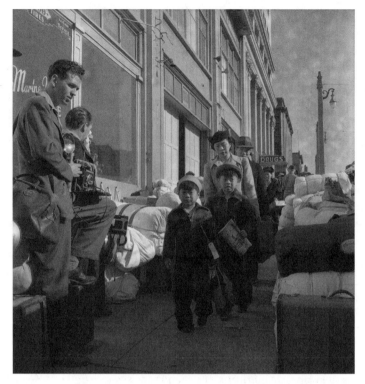

Figure 4. Dorothea Lange photograph, "Many news photographers were present for the first contingent of evacuees of Japanese ancestry boarding the buses for Assembly Centers. The family coming down the aisle between piled baggage, have been checked and are on their way to board a bus. This baggage, belonging to the evacuees, will be taken to the Assembly Center by large moving vans." April 4, 1942, San Francisco, Calif. Photo #210-G-C438 (ARC #537758), United States National Archives, College Park, Md.

Japanese American Citizens League (JACL) was a small but vocal group of Nisei who favored assimilation, and so they also exerted pressure on Japanese Americans to comply fully with the government's policy.[55]

In her poem "Evacuation," Mitsuye Yamada expressed the photographic predicament faced by Japanese Americans: "As we boarded the bus / bags on both sides / . . . / the Seattle Times / photographer said / Smile! / so obediently I smiled / and the caption the next day / read: / Note smiling faces / a lesson to Tokyo."[56] The photographer's injunction to "Smile!" for the camera was a phrase that had proliferated throughout U.S. culture by the early 1940s, an

artifact of the popularization of the camera in everyday life over the first half of the twentieth century. Smiling for the camera had become for many an automatic response, as instinctive as halting for a stop sign. But as Yamada's poem indicates, smiling for the camera became charged with new meanings once the people bearing those smiles were forced from their homes and U.S. officials or press photographers in the employ of fervently anti-Japanese newspapers wielded the cameras. Smiling for the camera, nearly a reflexive response, could now be read as obedience to U.S. government policy, or alternately as "a lesson to Tokyo," as the newspaper headline proclaimed. Some Japanese Americans, under pressure from the JACL and armed soldiers to appear loyal and compliant to the executive order, may have consciously offered up smiles for the cameras to demonstrate their acquiescence to the government's orders.[57]

This book examines why photographs of the incarceration were made, how they were meant to function, and how they have been reproduced subsequently by the popular press and museums to construct versions of public history. Uncovering how photographs were created and how contemporaries read them can help us to understand photography not simply as a tool of the powerful, but perhaps more productively as a medium in which different representational strategies vied to define the experience of the incarceration. It also suggests ways in which photographs might be used more productively in public history projects, including exhibitions and documentary films. Rather than portals to the past, photographs are artifacts in their own right that can be mined to enrich historical understanding. In the telling of these histories, photographs have been deployed in many ways: as windows onto the event that reveal real subjects and truthful occurrences, as opaque surfaces that project hegemonic interests and tell false stories, and as mirrors that reflect the photographers' intentions more than the subjects themselves.

Chapter Overview

The range of photographic practices engaged in depicting the incarceration brings together three of the central veins of the history of photography: the image as social document, the image as artistic expression, and the image as repressive instrument. Incarceration photographs represent a convergence of these three categories and reveal how these distinct currents of photographic practice came together in new ways during the incarceration.

Scholars such as Maren Stange and Martha Rosler have questioned the power relations involved in documentary photography and critiqued the

motives behind the charitable claims of photographers and their sponsors.[58] Incarceration photographs provide a fruitful area in which to examine those claims because official photographers hired by the War Relocation Authority made images that were sometimes at odds with their employer's goals. Using documents from the National Archives and the Bancroft Library, chapter 1 analyzes photographs made by staff of the War Relocation Authority, focusing on the work of Dorothea Lange. This government agency, similar to its better-known predecessor, the Farm Security Administration, was much like a New Deal agency that used photography to place its actions in a positive light. Lange, however, sought to create a representational practice with an embedded critique of the incarceration. In its efforts to control the meaning of the photographic record, the WRA used caption writing as a key method of manipulation.

Chapter 2 examines the 1944 publication of *Born Free and Equal: The Story of Loyal Japanese Americans,* with photographs and text by Ansel Adams. Adams intended his positive representations of Japanese Americans to counter dehumanizing images then current in the U.S. popular media and war propaganda. The cool reception of Adams's book and subsequent exhibition at the Museum of Modern Art in New York suggests the limits of such a counternarrative in the midst of a national mobilization against the Axis powers. Adams's tendency to portray Japanese Americans as servile and industrious, and his own subscription to the underlying rationale of the incarceration—the fiction that incarceration was based on legitimate questions of loyalty as opposed to race—also indicate the limits of his own photographic politics.

The potential of photography to challenge the official narrative of incarceration was most fully realized by Toyo Miyatake, a lesser-known professional photographer who owned a studio in Los Angeles before he was incarcerated in Manzanar. Chapter 3 considers artful images such as "Boys Behind Barbed Wire," more conventional images of daily life, and Miyatake's yearbook photographs that openly critiqued incarceration. The photographs of life in the camp that he made for Japanese Americans themselves rendered questions of their humanity and loyalty moot.

The work of Miyatake, Lange, and other World War II–era photographers has been used to powerful effect in museum exhibitions. Drawing on exhibition records and interviews with curators, chapter 4 looks at how two important museums have deployed photographs of Japanese American incarceration to construct national art and historical narratives of this event. The Museum of Modern Art exhibited photographs of Manzanar by Ansel Adams

in 1944. Despite this early claim to incarceration history, a 1997 exhibition that included a photograph of the incarceration by Dorothea Lange failed to acknowledge the circumstances of its making. The chapter concludes with an analysis of the central role photographs played in the National Museum of American History's exhibition, A More Perfect Union: Japanese Americans and the United States Constitution. Relying on more than five hundred photographs, the exhibition used them innovatively, but also at the expense of acknowledging the photographers who made them.

Chapter 5 considers the contemporary significance of the sites of the concentration camps as active places of pilgrimage. This chapter provides close readings of photographs by Sansei artists Patrick Nagatani and Masumi Hayashi, who journeyed to the camp sites at mid-career and created portfolios of photographs that bridge the intergenerational divide between their Nisei parents, themselves, and their Yonsei children.

1

When the Innocents Suffer

Dorothea Lange and the War Relocation Authority

At this hour of evacuation when the innocents
suffer with the bad, we bid you, dear friends of ours,
with the words of beloved Shakespeare,
'PARTING IS SUCH SWEET SORROW.'
Till We Meet again,

—T. Z. Shiota, 1942

The words above appeared on a small sign placed in a store window by T. Z. Shiota, an importer of Asian art in San Francisco. Dorothea Lange photographed this sign during the spring of 1942 as she traveled throughout northern California documenting the forced evacuation of its Japanese American residents. Shiota's invocation of Shakespeare claims a cultural kinship with other Americans—an assertion of a shared literary heritage that looks to the Occident, despite the "oriental" focus of the shop's contents and the branding of its Japanese American owner by the government as potentially disloyal.

Photographers working under the auspices of the War Relocation Authority (WRA), including Lange, made thousands of photographs of the forced evacuation and incarceration of Japanese Americans from 1942 to 1945.[1] The photograph of Shiota's store and other images by Lange exhibit a tension between her obligation to fulfill War Relocation Authority expectations and her own desire to depict what she perceived as the pathos and injustice of incarceration. Although the WRA did not want to perpetuate confusing Japanese Americans with the enemy Japanese, neither did they favor photographs that critiqued the government's policy of incarceration. This left the WRA with an almost impossible representational task—portraying Japanese Americans as loyal citizens while at the same time condoning their imprisonment. In an

attempt to smooth over this contradiction, the WRA tried to control photographic meaning through caption writing. The conflicts in this assignment were readily apparent to Lange, who also sought to establish the meaning of her photographs through captions and content. In the end, however, she voiced frustration with the limits of her own resistance within the WRA.

The WDC, the WCCA, and the WRA

In the weeks following the attack on Pearl Harbor, the United States military and the Justice Department began to intervene in the lives of West Coast Japanese Americans in a variety of ways. Bank accounts of Issei were frozen, and curfews for all Nikkei (people of Japanese descent) were imposed. The military office of Provost Marshal General Allen Gullion requested that the FBI be allowed to conduct raids of Japanese American homes without obtaining warrants and that the Justice Department transfer control of civilian enemy alien populations to the military.[2] Both of these tactics of coercion exploited photography as a target and tool of repression.

Efforts by the Western Defense Command (WDC) to monitor and control the activities of those labeled "enemy aliens" included making and confiscating photographs. Major Karl Bendetsen, Gullion's emissary, submitted a plan for enemy alien control that called for the registration of all West Coast enemy aliens through techniques usually used for criminals, including making mug shots for identification. During the raids, the FBI also seized family photo albums. A document titled "The Great January Panic" describes the fear that caused many Japanese Americans to destroy objects, including family photographs, which might connect them to Japan: "One night he took everything that had anything to do with Japan out to the incinerator and burned them. Among which were this valuable set of books, the etchings, and all the picture snapshots he had of his relatives in Japan. Some of these snapshots cannot be replaced, as the subjects are dead. When I asked this boy why he had done it, he said, 'It's bad enough to have a Japanese face, but if they find out I had all that stuff in the house, I don't know what might have happened. . . I thought it safest to get rid of it and think of the consequences later.'"[3]

The WDC treated Japanese Americans as the enemy and used the camera to help codify this practice. However, the military eventually relinquished control over the operation of the camps and, with that transfer of power, government officials with very different ideas about how such camps should be run and how Japanese Americans should be treated took over.[4]

The WDC created the Wartime Civil Control Administration (WCCA) on March 11, 1942, to oversee the forced removal of Japanese Americans from the West Coast. The head of the WCCA was none other than Karl Bendetsen, who had been promoted to Colonel and who had fought extremely hard to orchestrate the incarceration. Despite the fact that Bendetsen's military agency was in charge of getting Japanese Americans into camps, and that Bendetsen and Gullion imagined that the camps would be run by the military, Secretary of War Henry Stimson and Attorney General Francis Biddle decided that the burden on military personnel would have been too great.[5] In mid-March, Executive Order 9102 established a civilian agency, the War Relocation Authority, to manage the concentration camps. Initially under the jurisdiction of the Office for Emergency Management, the WRA was transferred to the Department of the Interior in February 1944.[6]

Once the military shifted control of the Japanese American population, the civilian agency of the WRA put photography to other uses. Instead of small portraits of enemy aliens used to record and keep track of suspicious persons, the WRA used photography primarily to publicize and record the work of the government agency and the conformity of those incarcerated to the government's orders. The task of the camera in this new context was to portray the incarceration process as efficient and humane, and "internees" themselves as orderly.[7]

Although the shift may seem surprising given the WRA's function as jailers, this strategy was fully in accord with the agency's mission. According to a 1942 WRA publication, the agency's goals were "[to] reestablish the evacuated people as a productive segment of the American population; to provide, as nearly as wartime exigencies permit, an equitable substitute for the lives and homes given up; and to facilitate the reassimilation of the evacuees into the normal currents of American life."[8] As this statement exemplifies, the WRA characterized Japanese Americans in a much different light than had the WDC. Instead of identifying Japanese Americans as suspect, the WRA portrayed them as a potentially "productive segment of the American population." As part of the mission to "facilitate . . . reassimilation," WRA officials sought to counteract the conflation of Japanese Americans with the enemy Japanese. In this context, the WRA sought to reverse the damage done by previous representations by depicting Japanese Americans not only as deserving of rights, but as suitable to be rewoven back into the larger fabric of American citizenry.

WRA officials presented themselves as paternalistic caretakers who would shelter the incarcerated population and then guide their integration into normal American life. The first director of the WRA, Milton Eisenhower, did not

initially envision placing Japanese Americans behind barbed wire. Instead, he envisioned placing them in transitional areas that would serve to relocate Japanese Americans from their homes inside the WDC to new homes in states outside of military control. When politicians who governed those states vehemently opposed such plans on the racist grounds that Japanese Americans were dangerous, Eisenhower backed off. According to Roger Daniels, Eisenhower's ability to rationalize his New Deal liberalism with the policies of incarceration was typical of many New Deal bureaucrats who worked for the WRA.[9] Although their politics were far different from those who strongly advocated the incarceration, the WRA officials in charge of the camps nonetheless carried out the corrupt policies enabled by Executive Order 9066. Eisenhower himself, however, lasted only three months in the position.

The FSA and the WRA

A decade earlier, during the 1930s, the Farm Security Administration (FSA) created the standard for photographic documentation of government social programs.[10] Although the aims of the WRA were different from the FSA's goal to advertise government social programs to help displaced migrants, the WRA did adopt some of the rhetorical strategies of the FSA. WRA photographs pictured Japanese Americans in ways that resembled earlier photographs of Dust Bowl migrants, only in this case the displacement was created by purported military necessity instead of drought. Employing the mantle of the government agency, as did the FSA, was one way for the WRA to couch the terms of the incarceration in a manner that connoted benevolent, social welfare instead of racist, unconstitutional policy.

There were also several bureaucratic connections between New Deal agencies and the WRA. Before he became the head of the WRA, Eisenhower had been in the Department of Agriculture, the government body that had overseen the FSA.[11] Another example, as Jason Scott Smith has pointed out, is that the Works Progress Administration played a significant role in the bureaucratic supervision of the assembly centers and concentration camps.[12] Among other continuities between agencies was the presence of photographer Dorothea Lange.

Lange began her work as a documentary photographer for the federal government of the United States in 1935. For the first two years of her government employment, she worked as a salaried "photographer-investigator" for Roy Stryker, the chief of the photography department of the Resettlement Administration (RA). After a ten-month hiatus from government work, Lange was rehired by the RA from October 1938 until January 1941, which

by then had been renamed the Farm Security Administration.[13] During her government tenure she produced some of the best known documentary photographs ever made. The most famous of these, "Migrant Mother," an image of a young mother with three children, has been reproduced with incomparable frequency in a wide variety of contexts from postage stamps to book covers (see figure 5). It is by far the most familiar image of the Depression and was, in Roy Stryker's view, the quintessential photograph of the period.

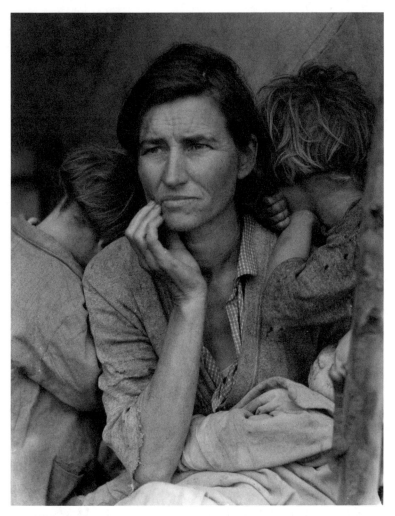

Figure 5. Dorothea Lange photograph, "Destitute peapickers in California: a 32-year-old mother of seven children, February 1936," a.k.a. "Migrant Mother." Library of Congress, Prints and Photographs Division, FSA/OWI Collection, LC-USF34-9058-C.

In her incarceration work, Lange relied on representational strategies developed during her FSA work photographing rural poverty. Lange frequently distracted and directed her FSA subjects in order to get the image that communicated their poverty most forcefully. In "Migrant Mother," Lange constructed pathos by appearing to capture the central figure gazing off soulfully into the distance, as if the subject were unaware of the photographer's presence. However, this photograph is highly posed and is one of several Lange took of this subject. Lange's FSA colleagues used similar strategies. Arthur Rothstein lamented that when people became aware of his camera, "forlorn attitudes gave way to . . . Sunday-snapshot smiles."[14] In a culture where smiling for the camera was a generalized practice, creating a seemingly candid photograph required careful planning and either explicit instructions to the subject not to smile or surreptitious releasing of the camera's shutter. In other words, the relative lack of smiles in Lange's images should not convince us that her photographs of incarceration are any less constructed than are other photographs that depict smiling faces.

The documentary photographs of the FSA entered the American consciousness in the 1930s through the efforts of Stryker, who disseminated them by way of museum exhibitions, the popular press, and picture magazines. In addition to facilitating the images' proliferation, Stryker directed his photographers' subject matter through photo scripts and selected the images that were distributed for publication. Stryker hired photographers who considered themselves artists, including not only Lange but also Walker Evans and Ben Shahn. The selection of photographers with artistic aspirations resulted in powerful images, but also produced tensions between Stryker and the photographers. Stryker avoided using the word "art" and was uncomfortable with the display of FSA photographs as such.[15] As Maren Stange argues, Stryker's deployment of photographs to construct a particular vision of the agency was more akin to modes of corporate public relations emerging in United States business enterprises than it was to museum display of the same period.[16]

A key difference between the two agencies was the apparent absence of an analogue to Stryker's FSA position within the War Relocation Authority. The photographic section of the WRA was based out of the Midland Savings Bank Building in Denver, Colorado—a location noted on the verso of every WRA photograph. Within that section, which formed part of the information division, the responsibilities that were solely Stryker's in the FSA fell to a number of WRA employees.[17]

Within the WRA, the Information Division was responsible for the entire public relations program in all media.[18] The goals of the agency included both

the positive portrayal of WRA programs and activities, and the depiction of Japanese Americans as loyal citizens. The Information Division was charged with presenting ". . . national and international aspects of the agency's program, with the object of avoiding unfair association of Japanese Americans with the Japanese."[19] The division launched a multimedia campaign—including radio, newsprint, magazines, photography, and film—charged with the task of untangling the conflation of race and nationality. This extended to the production of popular Hollywood movies, as an "information specialist" was explicitly directed to cultivate relationships with movie directors and encourage the fair representation of Japanese Americans in their films.[20]

In addition to the emphasis on shaping public perception of Japanese Americans during the war, the Information Division created photographic documentation that would provide a historical record of the entire project. Under the principal information specialist, who maintained a centralized photographic service, the information specialist dealt with the daily operations of the photography section, including advising a staff of photographers, maintaining a record of the entire project, and distributing images to newspapers and services. According to the position description, the information specialist also was to assign subjects to photographers if there was an aspect of the project "on which there is a paucity of photographic evidence."[21]

In the Information Division, senior photographers and assistant photographers carried out the actual taking and printing of photographs.[22] Senior photographers supervised darkrooms and reviewed all negatives submitted by project photographers. It was then up to the senior photographer to separate the negatives into "those most desirable for the historical record and those which are most desirable for current use as informational material."[23] The job description for photographer, the position held by Dorothea Lange, makes it clear that although general assignments were given, a great deal of the responsibility for choosing subject matter fell to the individual photographers; there were no Stryker-like scripts to follow.

Photographers were to document the process of incarceration and the living conditions of the prisoners, and also present Japanese Americans in such a manner as to encourage their employment after their release. Despite the large bureaucratic network surrounding photographic production, photographers were "responsible for carrying out rather independently very difficult field assignments involving photographic interpretation."[24] The job description also gave parameters for appropriate subject matter, including general information images directed to incarceration camp staff and "internees," the promotion of the understanding of incarceration by the general public,

"overcoming of public prejudice and the stimulation of potential employers" of Japanese Americans, and the historical documentation of the program.[25] The three audiences to whom these photographs were to be addressed were "Japanese residents of the projects . . . White communities bordering the projects, and the public at large."[26] These directions explain in part the dearth of photographs that portray incarceration negatively and precluded the portrayal of Japanese Americans as victims.

Lange and the WRA

Soon after its formation, the WRA hired Lange to photograph the forced removal of Japanese Americans from northern California, but how Lange came to work for the new agency remains unclear.[27] In an interview conducted thirty years after Lange's involvement with the WRA, her husband, the economist Paul Taylor, recalled the circumstances of her employment as follows: "I had done work for the Social Security Board. We knew the regional director very well. He had on his staff an information man, who shifted over and became the information man for the War Relocation. So when they wanted a photographer, he knew Dorothea and me, knew her work and got her onto his staff."[28] In the same interview, when asked why the WRA wanted to record the process of the evacuation and relocation, Taylor responded: "I suppose the reasons were not perfectly clearly worked out. But to have a photographer in a government agency was becoming a little more acceptable than it had been only a few years earlier. Probably there were some who said, 'We want to show that we are handling these people all right.' There were possibly some others who saw it another way; but anyway, WRA started to document it, and Dorothea went right to work."[29] In contrast to her earlier work for a government social program to aid the poor, Lange now found herself photographing the execution of a government order to incarcerate American citizens based on their ancestry.

Lange traveled to family farms in small California towns, including Centerville and Lodi, where she made images of families grouped in such a way as to resemble a formal portrait with patriarch, matriarch, and children in front of the family house.[30] In addition to more formally posed portraits, Lange photographed Japanese American families at work tending their fields.[31] These photographs pictured values that were in accord with the WRA's agenda to portray Japanese Americans as normal and industrious, but the family farm images also spoke to two tense issues surrounding the incarceration: the financial accomplishments of Japanese American farmers and the rac-

ist rhetoric that charged Japanese American farmers of complicity with the Japanese enemy.

Despite the barriers to Issei economic success, many Japanese immigrants managed to develop a relatively strong foothold in California agricultural production. As Michi Weglyn writes, "Although the Japanese minority comprised only a miniscule 1 percent of the state's population, they were a group well on their way to controlling one-half of the commercial truck crops in California by the onset of World War II." Weglyn continues: "Centuries-old agricultural skills, which the Japanese brought over with them, enabled Issei farmers not only to turn out an improved quality of farm produce but also to bring down prices. The retail distribution of fruits and vegetables in the heavily populated Southern California area was already a firmly entrenched monopoly of Japanese Americans."[32]

Whites who claimed that Issei had driven them out of California agriculture resented Issei agricultural success.[33] Three weeks after the bombing of Pearl Harbor, the Agricultural Committee of the Los Angeles Chamber of Commerce recommended that all Japanese aliens be placed under the control of the federal government.[34] Earl Warren falsely asserted that Issei farmers had "infiltrated themselves into every strategic spot in our coastal and valley counties."[35] These purportedly strategic spots included land near airports, tractor companies, railroads, and power lines—tracts that were difficult to cultivate and undesirable as farmland for most California farmers. These areas were among the only pieces of land available to Issei farmers, who lacked the capital and legal means to cultivate more desirable properties. Through hard work, Issei turned these leftover scraps into high-yield farms. Ironically, the very undesirability of their land—its proximity to industrial areas—was read as evidence of Issei subversion.

The alleged subversiveness of Issei was the straw man used to incite prejudice against all Japanese Americans. Even before the bombing of Pearl Harbor, President Roosevelt had ordered that the loyalty of West Coast Japanese Americans be ascertained through secret intelligence channels. A businessman named Curtis Munson collected information in the fall of 1941, and in his classified report concluded that both Issei and Nisei were loyal to the United States. As he asserted, "There is no Japanese 'problem on the coast.' There will be no armed uprising of Japanese."[36] Munson's positive description of people of Japanese ancestry living in the United States was virtually ignored by the political and military decision-makers, however, who characterized Japanese Americans in exactly the terms that Munson had carefully rebutted. Lange's photographs of families farming the land can be read as

pictorial refutations of these claims because they depict hardworking children and parents who are busy cultivating their fields, not sending messages to Japanese bombers.

Once Japanese Americans were removed from their homes, farms, and businesses, Lange focused on the accoutrements of the forced removal itself, including piles of luggage on curbsides, lines of Japanese Americans with tags dangling from their coats, and busses readied for boarding. In these photographs, Lange continued to use strategies of representation she developed with her FSA photography, including the creation and appropriation of signs that commented both on the process of the incarceration and the conditions that made it possible.[37] Lange frequently photographed posted texts: evacuation orders, billboards, and newspaper headlines. In urban settings, she photographed store windows that advertised clearance sales and displayed farewell letters. Figure 6, a photograph Lange made in Oakland in April 1942,

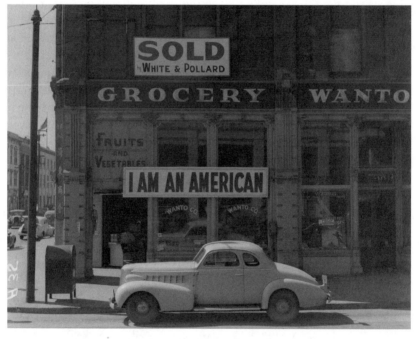

Figure 6. Dorothea Lange photograph, "Following evacuation orders, this store, at 13th and Franklin Streets, was closed. The owner, a University of California graduate of Japanese descent, placed the 'I AM AN AMERICAN' sign on the storefront on December 8, the day after Pearl Harbor. Evacuees of Japanese ancestry will be housed in War Relocation Authority centers for the duration." March 13, 1942, Oakland, Calif. Photo #210-G-A35, United States National Archives, College Park, Md.

was captioned, "Following evacuation order, this store, at 13th and Franklin Streets, was closed. The owner, a University of California graduate of Japanese descent, placed the 'I AM AN AMERICAN' sign on the store on December 8, the day after Pearl Harbor." The sign displayed by the owner coexists with other signs on the storefront: the store's name, "Grocery Wanto," which is also reiterated in the windows; its offerings of "Fruits and Vegetables;" and above them all a very large realty sign that reads "SOLD." The signs express a distressing trajectory from business owner to suspect to deportee. The sold sign trumps those below it and transforms the plea "I am an American" into a poignant artifact of a failed attempt to preserve the business, for no expression of loyalty was sufficient to avoid a process of incarceration based on race rather than an individual's actual politics.

In addition to these central elements, other more subtle displays of signs add layers of meaning. The building's surface also reveals a torn poster, an advertisement for Phillip Morris, a row of Japanese characters that read "East Bay Merchant Company," and a poster of a person by the store's entrance.[38] In front of the store sits a large car (dating the photograph to the 1940s), a mailbox, and an electricity pole. To the left of the building, the viewer is led around the corner to other buildings with other cars parked out front. Sandwiched between the pole and the row of Japanese characters along the left side of the grocery is an American flag, which flies atop a four-story building. In the flattened space of the photograph, the flag flies next to the row of Japanese characters, thus linking the iconic symbols of America and Japan (the flag and the characters) to their indexical expression in the lettered signs on the front of the building ("I am an American" and "Grocery Wanto"). This remarkable feat of juxtaposition points to the juncture of the Japanese and the American, while the sold sign seems to question whether that nexus of identity can be sustained.

Lange also photographed signs of overt American aggression toward the Japanese. Figure 7 depicts a Southern Pacific billboard in Richmond, California, with the slogan "It takes 8 tons of freight to k.o. 1 Jap."[39] The immediate foreground of the billboard photograph is occupied by a wild growth of weeds, and the left side of the image, which recedes to reveal abandoned cars and a row of small houses, implies a residential neighborhood behind the sign. Lange positioned her camera at a slight angle so that the top line of the billboard is not parallel with the picture's frame and contrasts with other edges and lines included in the image. Power wires run from the top of the frame and disappear behind the billboard. A "For Sale" sign is propped up against the bottom of the billboard. Whether it refers to the surrounding property or the billboard itself is unclear.

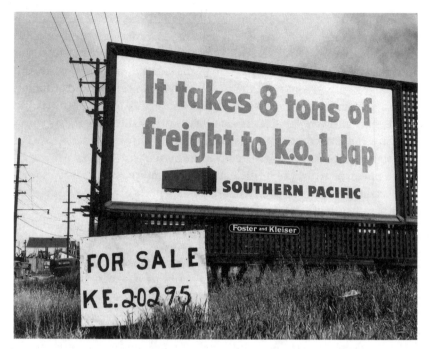

Figure 7. Dorothea Lange photograph, "Signs, Metropolitan Oakland Wartime—Do You Remember, 1945" (It takes 8 tons to k.o. 1 Jap, Richmond, Calif.). Copyright the Dorothea Lange Collection, the Oakland Museum of California, City of Oakland. Gift of Paul S. Taylor.

Despite these details that compete for visual attention around the image's periphery, the billboard's message dominates. It is a slogan that publicly and positively equates industrial productivity with the taking of human life. As Bill Hosokawa has argued in his analysis of a similar anti-Japanese billboard, which read "Buy Stamps, Buy Bonds, Bye Bye Japs!," the "link between purchasing war bonds and evacuating Japanese is hard to see, but was typical of the feeling of the time."[40]

The slightly oblique position occupied by the photographer and the instability implied by the "For Sale" sign suggest a critique by Lange of the billboard, although the absence of a more overt demurral to the billboard's message leaves the meaning of the photograph ambiguous. In her 1966 one-person exhibition at the Museum of Modern Art in New York, the image was included in both the installation and the catalog. In both instances the photograph was placed next to another image made in the same year of a class

of schoolgirls pledging allegiance (see figure 8). The Japanese American girls in the center of the image glance up at what one assumes to be an American flag, right hands held up to their hearts. Lange positioned the camera lower than the girls, resulting in an image that gives their gesture a heroic stature. The photograph is captioned, "One Nation Indivisible, San Francisco. 1942 (WRA)." In the back of the catalog, additional captioning material is provided from Lange's unpublished notes: "Rafael Weill Elementary School, San Francisco, 1942. Two days before the Army evacuated all persons of Japanese ancestry from the Pacific Coast."[41] These notes add a foreboding element to what appears otherwise to be a celebration of unity.

In a more recent book, the billboard photograph was again placed next to the photograph of the pledging schoolgirls. Both retain the same brief titles from the Museum of Modern Art exhibition, but a quotation by Dorothea Lange was included under the billboard image: "In 1942, I worked for the War Relocation Authority. I photographed the billboards that were up at

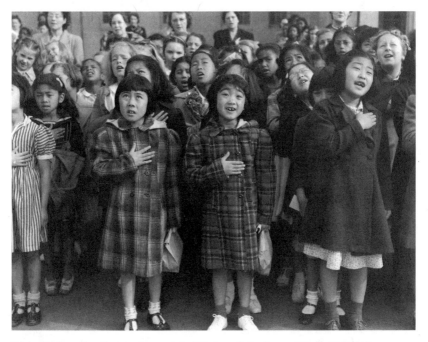

Figure 8. Dorothea Lange photograph, "Pledge of allegiance at Rafael Weill Elementary School, a few weeks prior to evacuation." April 20, 1942, San Francisco, Calif. Photo #210-G-A76, United States National Archives, College Park, Md.

the time. Savage, savage billboards. I photographed the evacuation of the Japanese, the Japanese Americans from the Bay Area. I photographed their arrival in the assembly centers. And then they were moved again, into the interior."[42] With the addition of this text, the photograph of the billboard emerges more clearly as a criticism of anti-Japanese propaganda. Although the inclusion of signs within Lange's photographs may have been a way to critique the implementation of Executive Order 9066, caption writers for the WRA generally avoided calling attention to any detail in the image that might place the government in a negative light. Funneling all WRA photographs into the same central processing location in Denver allowed for strict control of captioning and distribution. The script, in a sense, was written after the photographs had already been made.

CAPTIONS

Each image produced by WRA photographers was carefully captioned with the date and place of its making, the name of the photographer, and a short description of its content under the entry "data." The detailed information sent with each image was the WRA's attempt to control the presentation of the photographs made within the agency. Captioning fell to WRA clerk-stenographers within the photography section. They were responsible for composing about 300 captions a month "from data furnished by Photographer . . . which will conform to the journalistic standards of brevity, narrative value and attractiveness."[43] These employees were also in charge of filling requests for photographs from publications by selecting "appropriate photographs for specified purposes."[44] Supplementing the work of the photographers in the information division, reports officers were also required to obtain "illustrative material for reporting social, cultural, political . . . life of evacuees." Instructions for these officers included the following: "Determines what scenes should be photographed. Takes or directs taking of pictures and prepares accompanying verbal material."[45]

Although the description of the photographer's duties did extend a certain degree of autonomy, photographs that did not conform to the WRA's specifications were impounded and not published during the war. A Clem Albers photograph dated March 30, 1942, for example, depicts a long line of men walking either from or into a fenced area supervised by soldiers (see figure 9).[46] The caption that accompanies the figure states: "Aliens at Sharp Camp following the evacuation order for persons of Japanese ancestry. This camp was set up as a detention station where suspects were held before given hearings." This photograph, which stands in sharp contrast to the Albers

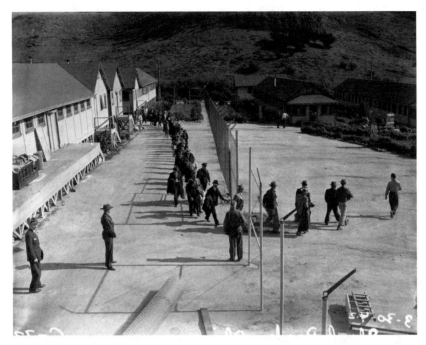

Figure 9. Clem Albers photograph, "Aliens at Sharp Camp following the evacuation order for persons of Japanese ancestry. This camp was set up as a detention station where suspects were held before given hearings. They remained here only a short while, being sent to an internment camp or a relocation center following the hearings." March 30, 1942, Sharp Park, Calif. Photo #210-G-C73, United States National Archives, College Park, Md.

photograph of the smiling women on the train, was censored probably because it criminalized the line of "aliens" and portrayed the WRA as jailers. Because Lange studiously avoided depicting smiling faces and often called attention to the injustice of the incarceration, the WRA impounded most of her photographs. As Linda Gordon notes, although Lange's FSA images were well known, the WRA kept the vast majority of Lange's incarceration photographs far from public view.[47] Previously, Stryker had deemed the serious expressions of the subjects in Lange's FSA work to be visually appropriate. In contrast, it would appear that the WRA censors favored smiles over pensive looks of the kind expressed by the subject of "Migrant Mother."[48]

In many of Lange's photographs, text present within the image vies for attention with the caption written by the WRA. Figure 10 is a particularly striking photograph taken inside the Wartime Civil Control Administration station in downtown San Francisco. It pictures a small boy who stares at the

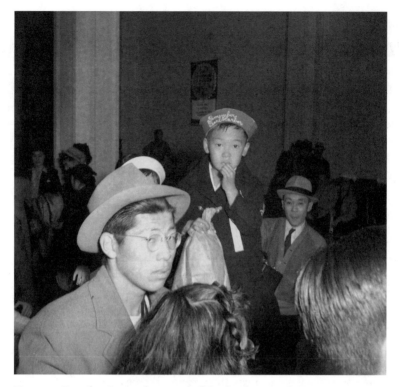

Figure 10. Dorothea Lange photograph, "The family unit is kept intact in various phases of evacuation of persons of Japanese ancestry. Above is a view at Wartime Civil Control Administration station, 2020 Van Ness Ave on April 6, 1942 when first group of 664 was evacuated from San Francisco. The family unit is likewise preserved at War Relocation Authority centers where evacuees will spend the duration." April 6, 1942, San Francisco, Calif. Photo #210-G-A96 (ARC #536069), United States National Archives, College Park, Md. Note the text "Remember Pearl Harbor" embroidered on the boy's cap.

camera and holds one hand to his mouth while his other hand clutches a large paper bag. Like all other Japanese Americans in the photograph, a tag bearing his family number hangs from his coat. But more than the tag, the sailor's cap he wears demands attention. On it are embroidered the words "Remember Pearl Harbor." Certainly on the day of "evacuation" it would have been difficult for anyone of Japanese descent to forget Pearl Harbor—the event used by United States officials to justify incarceration. The Japanese American boy wears the hat as any other young American boy might have at the time. It is a badge that marks him as American despite the tag that labels him as

potentially disloyal. Given Lange's sensitivity to paradox, it seems unlikely that she was unaware of the irony in an image of a boy whose cap proclaims his patriotism even as his tag disregards that proclamation.[49] Yet the WRA employee who wrote the caption for the picture ignored this apparent irony and instead employed the image as evidence of the government's understanding of the importance of maintaining the nuclear family. The caption reads: "The family unit is kept intact in various phases of evacuation of persons of Japanese ancestry. Above is a view . . . when the first group of 664 was evacuated from San Francisco. The family unit likewise is preserved at War Relocation Authority centers where evacuees will spend the duration."[50]

As this caption exemplifies, the WRA frequently emphasized the maintenance of the family. If one looks carefully at the photograph of the boy with the cap, however, it is difficult to locate a nuclear family unit. Two men on either side of the boy look at the camera, but it is unclear whether either is the boy's father. The image offers no candidate for his mother, with the possible exception of the back of a female head in the extreme foreground. The content of the image seems almost incidental to the WRA's effort to portray evacuation positively. In fact, the emphasis on the maintenance of the family stressed in many WRA captions obscured policies that very consciously served to erode intergenerational unity. They also contributed greatly to the disruption of power relations within the Japanese American family, including the widening of the social and political gap between Issei and their Nisei children.[51] Stripped of their independence, Issei often found their authority as parents under siege.

Even when Lange wrote extensive captions explaining the content of her photographs, those descriptions were often modified or simply overridden by the WRA. For instance, the original caption that Lange gave to figure 11, a photograph taken on April 6, 1942, reads, "Labeled, checked against the master list, this evacuee is ready to leave the assembly point for Santa Anita Assembly Center." The image of an older Asian man dressed nicely in a suit and wearing a felt hat depicts the humiliating process of the loss of freedom.[52] Behind him, a large group of Asian Americans look about in different directions. Two hands emerge from the edges of the image and inspect the man. One pair of hands holds a form and presses onto the man's lapel. The other holds up a tag dangling from the man's coat for examination. This photograph is a representation of the moment when the government attempted to strip Japanese Americans of their identities as individuals, reducing them to a racial identity and then sanitizing that identity with the substitution of a number for a name. The WRA abridged Lange's caption, however, and

Figure 11. Dorothea Lange photograph, "Just about to step into the bus for the Assembly Center." April 6, 1942, San Francisco, Calif. Photo #210-G-A95 (ARC #536068), United States National Archives, College Park, Md.

under the "data" entry wrote, "Just about to step into the bus for the Assembly Center." The official caption failed to mention the label and excised the portion of the Lange caption that implied the exertion of power over the man pictured. The caption was the WRA's effort to neutralize the content of Lange's photograph.

The WRA certainly was not the only entity that sought to manipulate the meaning of photographs through captions. Newspapers and popular publications also crafted prose that was meant to override photographic content. Photographs that did not necessarily have anything to do with war could be manipulated into jingoist icons with the right caption. The 1944 *U.S. Camera* annual, for example, included a photograph of an unidentified Asian man dressed in a suit with a camera, presumably in the act of taking a picture.

Labeled "Very Honorable Tourist," the photograph was accompanied by the following caption:

> Nothing could be more symbolic of our sneak thief friend than this picture taken some time before Pearl Harbor. He was actually photographing and tak-ing notes on a small government power project when Peter Sekaer, at that time a Rural Electrification Administration photographer, snapped him. A camera in his hands became deadly, as deadly as the bite of a rattlesnake; we were soon to learn. Scattered through our homes, our restaurants, our universities, these condescending little gremlins found our every weakness; attempted to analyze and duplicate our every strength. Our stupidity aided their cupidity, aided it to the very brink of disaster. On December 7th, 1941, they struck with an ef-fect so shattering we were not to know its full meaning until all the pictures of our helpless sunken fleet were shown—just one year later.[53]

The caption equates the photographer and, in fact, every Japanese person with reptiles and "gremlins." Like insects, Japanese are said to be "scattered through our homes, our restaurants, our universities." No one of Japanese ancestry is beyond reproach, all are "condescending little gremlins." Furthermore, the author of this caption, through his use of the first person plural, makes clear that the image and text are for the consumption of a public in which Japanese Americans are absent or from which they have been removed. The presence of the "deadly" camera in the hands of the man renders his own presence all the more dangerous. The content of the photograph itself, of the well-dressed man holding up a large and conspicuous camera to his face, appears to be completely innocuous. His subject is outside of the image's frame. Although the caption presumes to reveal the sinister nature of the subject's snapshot, the photograph itself confirms no such crime. Using similar tactics, the WRA also married captions to images that seem to be far from compatible. Yet, this very insidious propaganda, which does nothing to distinguish between the enemy Japanese and the Japanese American, was precisely the kind of image that WRA photographers and caption writers sought to counter.

Despite the ultimate instability of photographic meaning, establishing a practice of documentary photography gave the WRA an appearance of transparency. That appearance was enhanced by eschewing the strict shoot-ing scripts mandated by Stryker in the FSA. The WRA instead used caption-ing in an attempt to control the way a photograph would be read, assuming the preeminence of the caption over the visual content of the image. Maren Stange identifies four elements that contribute to meaning in documentary photographs: realist photograph, caption, written and graphic texts, and

authoritative presenting agency.[54] The officials in the information division made use of both the WRA's institutional power and the seemingly straightforward testimonial authority of black-and-white documentary photographs to create their own, official vision of incarceration.

Despite the fact that Lange tried to assert autonomy through her own practice of captioning, her terms were incorporated into and overshadowed by the larger institutional practice that sought to redefine the images' meaning for its own purposes. However, if caption writers were unable to transcend the photograph's content, the WRA could exert the ultimate power and have the image disappear from public view.[55] In that sense, the social-reform, government-agency photography that Lange helped to shape in the 1930s became an even more powerful tool in the 1940s, one that could easily transcend the politics of the documentary photographer herself.

"I ACCOMPLISHED NOTHING"

In 1940, two years before the signing of Executive Order 9066, Ansel Adams asked his colleague Dorothea Lange to contribute text and images to a catalog of photographs for an exhibition titled A Pageant of Photography. She submitted a brief essay to him on "Documentary Photography" that summarized her definition of the photographic document:

> Documentary Photography records the social scene of our time. It mirrors the present and documents for the future. Its focus is man in his relation to mankind. It records his customs at work, at war, at play, or his round of activities through 24 hours of the day, the cycle of the seasons or the span of a life. It portrays his institutions—family, church, government, political organizations, social clubs, labor unions. It shows not merely their facades, but seeks to reveal the manner in which they function, absorb the life, hold the loyalty and influence the behavior of human beings. . . . Documentary photography stands on its own merits and has validity by itself. A single photographic print may be "news," a "portrait," "art," or "documentary"—any of these, all of them or none.[56]

Lange's categories for the photographic print assert the autonomy of the photographic image, but the history of Lange's involvement with the WRA complicates this assertion. Despite Lange's attempt to portray the harshness of the evacuation, without control of the caption and image placement, the meaning of her photographs proved to be all too malleable.

In letters written after she concluded her work for the WRA, Lange acknowledged her disappointment that, despite her intentions, her WRA pho-

tographs did nothing significant in her view to help Japanese Americans.[57] She channeled this distress into encouragement of her friend Ansel Adams and his independent project to photograph Manzanar. On November 12, 1943, Lange wrote to Adams: "I fear the intolerance and prejudice is constantly growing. We have a disease. It's Jap-baiting and hatred. You have a job on your hands to do to make a dent in it—but I don't know a more challenging nor more important one. I went through an experience I'll never forget when I was working on it and learned a lot, even if I accomplished nothing."[58] Adams, however, began his project at a much later moment in the history of incarceration and he had different goals in mind. Although Lange continued to offer her support while Adams worked on his project, later in life she voiced her dissatisfaction with his photographs of incarceration, finding his images complicitous with the government's point of view.[59] The next chapter addresses Adams's Manzanar photographs in the context of his own political agenda as well as the specific history of Manzanar.

2

The Landscape of Loyalty
Ansel Adams's Born Free and Equal

> We must be certain that, as the rights of the individual
> are the most sacred elements of our society, we will not
> allow passion, vengeance, hatred, and racial antagonism to
> cloud the principles of universal justice and mercy.
> —Ansel Adams, *Born Free and Equal,* 1944

In 1943 Ansel Adams took up Dorothea Lange's challenge to advocate for Japanese Americans through a documentary project that has been largely overlooked by art critics and aficionados of his work. The year 2002 marked two seemingly unrelated anniversaries: the one hundredth birthday of the famed photographer and sixty years since the implementation of Executive Order 9066. Adams is best known for his heroic landscapes, which have been the focal point of public celebrations of Adams's birth, including the exhibition curated by John Szarkowski, Ansel Adams at 100, and the documentary film biography by Ric Burns. Adams's photographic work at Manzanar was notably absent from these public remembrances.

Even as Adams's photographs have been marketed in the form of calendars, posters, and, most infamously, as an advertisement for Rockwell International, his work has received markedly little attention from art historians who have tended to see his images as naïve, if skillful, celebrations of nature, devoid of ideological content. Both the hyper-commodification and the apparent academic disdain of Adams's work share a misapprehension of his visual politics, particularly his belief in the power of nature to work positive social change. Since he received his first camera as a boy and began making exposures in Yosemite Valley during family vacations, Adams closely associated picture making with his love for the natural world. Adams believed that places such as Yosemite were sources of spiritual renewal and healing.

Representing such sites through photographs codified his belief in the transformative power of both art and nature.[1] Nowhere are the possibilities and limits of Adams's vision more apparent than in his work on Manzanar titled *Born Free and Equal: The Story of Loyal Japanese-Americans*.[2] Banished from Adams's oeuvre by his publishing machine and largely ignored by critics, *Born Free and Equal* reveals an important moment both in the history of Adams's visual politics and in the role of the camera in defining the boundaries of loyalty and citizenship in the twentieth century.

In his work at Manzanar, Adams challenged the derogatory portrayal of people of Japanese descent in U.S. war propaganda by insisting on the loyalty and "Americanness" of the incarcerated. Respectful portraits and sympathetic scenes of everyday life in the camp, interspersed with stunning images of natural beauty, represented Japanese Americans as dignified and respectable—a relatively radical move at a time when U.S. war propaganda and the popular media questioned the very humanity of people of Japanese descent. But *Born Free and Equal* also uncritically reproduced other aspects of dominant stereotypes of Japanese Americans, including the perception that they were passive and thus ideally suited for domestic labor and other forms of servile work. Finally, although Adams questioned aspects of official incarceration policy, his defense of Japanese Americans at Manzanar left largely unscathed the primary justification for that policy: the fiction that they were imprisoned on the basis of their supposed allegiances rather than their ancestry.

Adams and Social Documentary

After the bombing of Pearl Harbor, Ansel Adams, like many other Americans, desperately wanted to become involved in the U.S. war effort. Approaching the age of 40, with six family members dependent on his income, Adams was ineligible for the draft. Unable to enter the front lines, his work during World War II initiated with minor civilian assignments, beginning in Yosemite where he served as a guide/photographer for troops on leave. Later he worked for the civil defense program in Los Angeles.[3] As friends of his departed for boot camp, Adams became increasingly convinced that his own civil assignments lacked sufficient gravity. Beaumont Newhall, curator of the Museum of Modern Art's photography department, was among these friends.[4] Frustrated in his efforts to make a more substantial contribution, Adams left Los Angeles for his home in Yosemite in March 1943. Appropriately

for Adams, his return to the national park led to his most meaningful wartime assignment—photographing Japanese Americans at nearby Manzanar.

In the fall of 1943, Adams received a visit in Yosemite from Ralph Palmer Merritt, a friend of his from the Sierra Club who was also director of the camp at Manzanar.[5] During this visit, Merritt suggested a documentary project on Manzanar to Adams, who had voiced disappointment over his lack of direct involvement in the war.[6] Adams took to the project immediately. Located in the Owens Valley and marked by the majestic stretch of Sierra Nevada to the west and the imposing reach of Death Valley to the east, this part of California was familiar photographic territory for him. Lying just off of U.S. Highway 395, not far from Death Valley and Kings Canyon National Parks, Manzanar was sited in the midst of some of Adams's favorite natural subjects.[7]

Born Free and Equal represented for Adams an opportunity to integrate his long-standing commitment to the landscape with social documentary at a time when documentarians such as Dorothea Lange were favored over landscape photographers by art critics and curators. Impressed by the popularity and critical adulation of photographers who had worked with the Farm Security Administration, Adams's letters indicate that he began to consider taking up documentary work in the late 1930s.[8]

This openness to documentary photography represented a shift for Adams, who in 1934 had defined himself against social documentarians and identified himself as an aesthetician in a letter to Edward Weston. In their correspondence, Adams and Weston shared their frustration over the characterization of their photography as socially insignificant. In a letter written to Weston in November of 1934, Adams dismissed the charge of "inhumanity" that had been leveled at his work and stated his belief in a human need for the purely aesthetic.[9] In December of 1934, Weston commiserated with Adams, asserting that there was social significance in a rock as well as a line of unemployed people.[10] This form of criticism continued through the onset of the war when Tom Maloney, the head of U.S. Camera (which ultimately published *Born Free and Equal*), found fault with Adams for portraying landscapes at a time of crisis.[11]

Adams's skepticism regarding documentary photography may have been altered in 1936 when he assisted Lange by making prints of her Farm Security Administration images. The experience of printing such iconic photographs of the Depression as "Migrant Mother" apparently instilled in him an abiding respect for Lange's work and also familiarized him thoroughly with the documentary genre. In a letter written in 1938 to his friend and benefactor David

McAlpin, Adams paid homage to Lange while maintaining his characteristic faith in the redemptive power of nature: "Let us show everything that is false and inhuman, sordid and without hope, without alleviation of the larger fact and our infection can only widen and deepen and eventually consume us. But, as Dorothea has done with her Farm Security photographs—showing a magnificent moment in the plowing of the land in one picture, and in the next showing a pitiful shack of a migrant family—we can show the good along with the evil—making the good more desirable and the evil more detestable."[12] Foreshadowing his work at Manzanar by five years, Adams envisioned how he might combine his interest in landscape with a more explicit social agenda: "If I feel I have any niche at all in the photographic presentation of America, I think it would be chiefly to show the land and the sky as the settings for human activity. And it would be showing also how men could be related to this magnificent setting, and how foolish it is that we have the disorganization and misery that we have."[13] Clearly, for Adams, even a social documentary project would not ignore the land. Adams's sense of urgency regarding the integration of landscape and documentary photography increased with the onset of World War II. Adams would eventually find his response to questions of his own work's relevance in his documentary project of Manzanar.

The Question of Loyalty

Located two hundred and fifty miles northeast of Los Angeles, Manzanar was one of two concentration camps that lay within the West Coast Military Zone, which was declared off limits to anyone of Japanese descent.[14] Because of its location, the concentration camp was more militarized than the camps sited outside of California, such as Rohwer in Arkansas or Amache in Colorado. Armed sentries surveyed the camp from atop gun towers, and the 550–acre site, including the living quarters, was surrounded by barbed wire fences.[15] Most of Manzanar's residents, whose population peaked at more than ten thousand, came from Los Angeles. Manzanar operated as a fortified encampment within a corridor of small towns such as Lone Pine and Independence whose inhabitants were often openly hostile to the nearby concentrated presence of Japanese Americans.[16]

Ralph Merritt became the project director of Manzanar in late November of 1942. Tragedy marked the early weeks of his tenure. On December 5, 1942, a group of Japanese Americans accosted a suspected government collaborator, Fred Tayama, who was also a member of the Japanese American Citizens League. Merritt's administration arrested those thought to be responsible for

the beating. Harry Ueno, a Kibei and the president of the Kitchen Worker's Union, was imprisoned in the Inyo County jail in the town of Independence.[17] A group of approximately two thousand Japanese Americans led by five negotiators demanded that Ueno be released and returned to Manzanar, as they feared for his safety in Independence, which was rife with anti-Japanese racism. Merritt finally agreed to hold Ueno in the camp jail on the condition that mass meetings ended and those responsible for the beating were apprehended.[18]

On December 6, 1942, a few thousand unarmed Japanese Americans gathered to protest the presence of informants and Ueno's jailing.[19] Part of the group went to the jail and another faction gathered at the hospital where Tayama was recovering. The jail was barricaded from the crowd as negotiations between the administration and prisoners continued. Armed with machine guns and tear gas, military guards fired tear gas after some of the protestors threw stones and bottles. Soon thereafter the guards fired on the crowd, causing the deaths of two Japanese Americans and wounding at least ten others.

The riot constituted a problem for Merritt not only in terms of the internal administration of the camp, but also the appearance of the incarceration process itself to the outside public. War Relocation Authority administrators were very invested in maintaining the public perception that Manzanar was a model American community. As Arthur Hansen and David Hacker have noted, Merritt and the other administrators underplayed the significance of the events of December 6th so as not to suggest any flaw in WRA policies.[20] In a memo to Lt. Col. Kenneth Craycroft, Merritt tried to counteract press accounts of the riot.[21] He described the protestors as being neither pro-Japanese nor Japanese nationals and revealed that the leader, Joe Kurihara, was a U.S. citizen and a veteran of World War I who was protesting the detention of other Japanese Americans.[22]

Merritt's invitation to Adams to document camp life arose out of a similar impulse to portray incarceration and "internees" themselves in a way that stressed their loyalty to the U.S. government. From the instructions Merritt gave Adams, it is clear that he did not want Adams's photographic project to reveal the violent side of incarceration but instead a more benign picture of "internees" at work. For example, Merritt forbade Adams from including barbed wire or guard towers in any of his photographs. Nor did Adams explicitly discuss in *Born Free and Equal* the riot of December 1942, although as an avid newspaper-reader and a friend of the camp director, it is hard to believe that he was unaware of the event. To have mentioned the riot in

the book, however, would have been counter to both Adams's and Merritt's objectives—to establish and confirm that the "American factions" of Japanese were trustworthy and that Manzanar was a well-run, peaceful "relocation center."[23]

Adams stressed Nisei loyalty at every turn. He asserted that "the loyal American citizens of Japanese ancestry were retained in relocation centers from which they are moving to their rightful place in the stream of American life. These people are normal and intelligent citizens of our country. Their loyalty has been proved."[24] In a letter Adams wrote to Dillon Myer, however, it appears that he initially had been uncertain of Nisei loyalty: "My doubts and fears were resolved by direct experience with the loyal Niseis. The rumors were terrific! Practically every houseboy and gardener were 'enemy agents'!"[25] After his visits to Manzanar, Adams dismissed the rumors of disloyalty. Even before his letter to Myer, Adams sent a telegram to Nancy Newhall, acting head of the Museum of Modern Art's Department of Photography, describing his project: "Subject very hot out here. Must stress people are loyal American citizens of Japanese descent. It is a question of fair dealings with racial problems. No truck with Axis sympathizers"[26] The telegram that Adams sent to Newhall indicated his firm belief that his photographs depicted loyal citizens.

The question of loyalty was of particular concern not only to Adams; it was also a strongly debated issue in the camp, particularly in early 1943 with the implementation of a questionnaire that many Japanese Americans regarded as outrageously unfair and prejudicial. The WRA used the questionnaire, which was distributed two months after the riot to all prisoners over the age of 17, to try to segregate the disloyal from the loyal within the imprisoned population. Euphemistically called the "leave clearance questionnaire," the document posed two questions in particular that struck many as an insulting form of entrapment. Question 27 asked if one would be willing to serve on combat duty in the armed forces of the United States military if ordered. Question 28 asked whether one would renounce all loyalty to the Japanese Emperor and swear allegiance to the U.S.

At the time of the distribution of the questionnaire, many were struck by what they perceived as the impudence of question 27, which asked if they would be willing to risk their lives for a country that disregarded their citizenship rights and placed them in concentration camps. Question 28 was also deeply offensive to many Nisei. Through the executive order, the government had already denied these American citizens their right to due process, as formal charges were never leveled against them. Question 28 now implied

that Nisei held prior allegiances to the Japanese Emperor, even though they were U.S. citizens. The imputation of disloyalty inherent in the question was all too obvious to Japanese Americans, who complained bitterly of what they perceived as a trap: to answer yes to question 28 admitted a prior loyalty to Japan, while answering no denied loyalty to the United States. The military had placed Nisei men in the category of 4–C, or enemy alien, simply on the basis of ancestry, making them ineligible for combat.

Question 28 also placed Issei in an excruciating situation. In contrast to European immigrants, including Italians and Germans, Issei were barred legally from becoming citizens. With the onset of World War II, the discriminatory naturalization policy put Issei in a special bind. Proponents of incarceration used the alien status of Japanese immigrants to question the loyalty of all people of Japanese descent and to stigmatize Issei in particular as potential anti-American subversives.[27] Thus, for Issei to renounce Japanese citizenship would have effectively left them stateless.[28] This issue did not go unnoticed by camp officials in Manzanar. They blamed the Army officers responsible for writing questions that assumed everyone answering enjoyed dual citizenship, and reported that the results of the questionnaire were "disastrous." Manzanar officials set up a committee that included two Issei and two Nisei to try to rewrite the question so that Issei would not have to renounce their citizenship. The next day Dillon Myer sent a telegram from WRA headquarters in Washington with a substitute question, but it was not used in Manzanar because officials feared it would only add to the confusion and anxiety already surrounding the questionnaire.[29]

One frustrated Nisei prisoner wrote to Merritt in an attempt to get himself removed from the Western Defense Command segregation list after he had answered the two key questions in the negative. He explained his No-No status with these potent words: "It wasn't a 'No-no' to loyalty—there was too much wrapped up in that No-no to mean disloyalty. The evacuation, the strain of living in Manzanar during those tight, hard days of the riot, the helpless and futile feeling. . . . Mr. Merritt, if I wanted to be a damned Japanese I'd be sitting in Tule Lake with my head shaved."[30] The image he evokes is powerful. Although Merritt and other administrators could not stop the segregation, they did communicate to Army officers that the questionnaire did not effectively determine loyalty. In a memo to Lt. Col. Kenneth Craycroft, Merritt explained that answering no did not prove disloyalty but rather more likely described "a protest against conditions" in camp, an "attempt to preserve family unity, or the result of threats and pressure from the pro-Japanese element subsequently removed (February, 1944) to Tule Lake."[31]

The number who responded no to questions 27 and 28 at Manzanar was 2,165—20 percent of the peak population.[32] The effect of the questionnaire was divisive and tore at the fabric of already disrupted lives. Those who answered no to the crucial questions were branded as disloyal by the government, segregated from other Japanese Americans—including in many cases their own families—and sent to Tule Lake, a higher security concentration camp in northern California. Thus the title of the leave clearance questionnaire became painfully ironic, as those who answered no to the two crucial questions were forced to leave their family and friends.[33] Far from a proper and legal form of due process, the leave clearance questionnaire reinforced the artificial categories of loyal and disloyal that could then be used both to justify the suspension of rights for the supposed disloyals and to support a return to American life for the loyals.

Adams was well aware of the loyalty questionnaire and wrote of it in *Born Free and Equal*. The way that he addressed the problem in the text is a good example of his approach to the general issue of incarceration. He emphasized the loyalty of Japanese Americans but did not openly criticize the government policies that denied or ignored that loyalty. He did not critique the two questions but neither did he condemn those who answered no. Adams provided the context for readers to comprehend how a person might have answered no to both questions. As he wrote, answering yes "would place them [non-U.S. citizens] literally as a people without a country. . . . There were some whose records revealed Japanese allegiances, and some who answered an outright 'no' to the loyalty question because they felt it best to make a clean breast of it and clarify their status from the first. They are detained at Tule Lake Center."[34] Adams realized that neither answering no to those questions, nor a lack of citizenship, should necessarily be equated with disloyalty.[35] But after this analysis, Adams deferred to government justification of segregation and simply concluded, "now the WRA can relocate those who are loyal."[36]

Although the questionnaire had already been distributed and answered by the time that Adams arrived in Manzanar, not all of those who were to be moved to Tule Lake had yet made the journey. Correspondence between Adams and authorities at Manzanar reveals that each and every photograph that Adams made was scrupulously checked for the presence of segregees or "no-no's." On the backs of proof prints Adams sent to Manzanar, an employee of the Office of Reports identified each person in the photograph by name and noted their loyalty status.[37]

It is unclear who suggested that Adams go to such lengths to denote the loyalty status of his subjects. It is possible that the WRA authorities insisted

upon checking each photograph.[38] However, given the choice of images included in *Born Free and Equal,* it appears that Adams himself was very much concerned with the loyalty status of the people he portrayed in the book.[39] This is also the implication of a letter written by Robert L. Brown, acting project director of Manzanar, to Adams in March of 1944: "As you are aware, many of the subjects in the photographs are segregees. We recall your saying that you are interested only, or primarily, in loyal Niseis."[40]

Only two photographs in *Born Free and Equal* contain segregees and in neither case is the subject an adult. One image is of two boys singing in the high school choir (on the back of the proof one boy is cleared as loyal and the other is not). The other photograph is of nurse Aiko in the Manzanar hospital nursery presenting a baby to a woman. On the back of this contact print, Adams guessed at the title "Nurse Aiko Hamaguchi, baby and Mother." The hand from the Office of Reports crossed out the word "Mother" and corrected, "not mother: all cleared? OK: except baby Fukumoto."[41] Labeling the baby as disloyal is a blatant example of the absurdity of the questionnaire process, and indicates that children under 17 probably were given the loyalty status of their parents. Indeed, as was noted in Manzanar's final report, "almost two-thirds of the people sent to Tule Lake were persons electing to accompany segregants and immediate family members, [which] in a measure defeated the purpose of dividing loyal from disloyal persons."[42] In addition to the removal of segregees to a higher security camp, those who took issue with the leave clearance questionnaire and their families were also erased from representation within the pages of *Born Free and Equal.*

Instead of eschewing the terms of the loyalty debate, Adams tried to counteract the military, government, and press claims that Japanese were inassimilable. Adams's aim was to change anti-Japanese sentiment in order to aid in the transition of Nisei from the camps into their post-incarceration lives. The subtext of *Born Free and Equal* included a critique of the executive order and an overview of the lives of the prisoners at Manzanar, but the book's primary objective was to celebrate Nisei Americanness defined by loyalty, energy, ingenuity, and pride.

Portraying Nisei as Human Beings

For Adams the most pressing issue was the plight of Japanese Americans who were beginning to relocate from the confines of Manzanar to communities in the Midwest and the East Coast. In a letter to Dillon Myer, Adams wrote, "I am pointing my ideas towards the future, rather than rest on a descrip-

tion of the present condition of the evacuees."[43] Although it may appear surprising in retrospect that Adams's effort to portray evacuees in a positive light would have garnered support from government officials such as Myer and Harold Ickes (then secretary of the interior), by 1943 Adams's agenda was fully in accord with the WRA's policy of relocating Japanese Americans deemed loyal out of the camps and into American communities away from California and the Pacific Northwest. As Adams explained in a draft of *Born Free and Equal*, "In the Fall of 1943 Mr. Ralph Merritt . . . asked me to bring my cameras to Manzanar and make some photographs of the loyal Nisei for the express purpose of illustrating and clarifying the highly controversial problems which the process of relocation has created."[44] Adams hoped that his publication would play an important role in the quelling of anti-Japanese sentiment as Japanese Americans slowly reentered the America on the other side of the barbed wire fences.

Depictions of the Japanese enemy in the press fueled anti-Japanese sentiment and white fears of the disloyalty of Japanese Americans. John W. Dower has analyzed the impact that negative images of people of Japanese descent produced in the United States. Using a wide range of documents, including films, soldiers' diaries, and war posters, he argues that ruthless caricatures in U.S. propaganda facilitated the killing of the enemy as soldiers were fed an image of the Japanese as "nonhuman or subhuman . . . as animals, reptiles, or insects (monkeys, baboons, gorillas, dogs, mice and rats, vipers, rattlesnakes, cockroaches, vermin)." The effect of such imagery (including figure 12) was to cast people of Japanese descent out of the human race in visual terms. Although U.S. propaganda also portrayed Germans and Italians in a negative light, Dower points out that images of people of Japanese descent were considerably more extreme.[45]

Magazines such as *Life* frequently used both negative symbolism and racist captions in their representations of Japanese. For example, an issue of *Life* published five weeks after the bombing of Pearl Harbor reproduced two photographs of Tokyo showgirls wearing swastika hats and Nazi Bund Mädchen uniforms. Another photograph in the same issue depicted a group of men standing outside with the caption, "Down with Britain banner is carried in a Tokyo mass meeting. All Japanese slogans are parroted in set forms, as few Japanese do any thinking for themselves."[46] Japanese Americans were equated with the Japanese enemy, and the slur "Jap" was used to refer to both groups. This tendency was exemplified by a *Los Angeles Times* article that stated "A viper is nonetheless a viper wherever the egg is hatched—so a Japanese American born of Japanese parents, grows up to be Japanese not an American."[47]

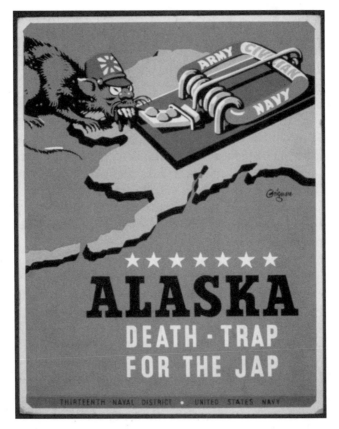

Figure 12. "Alaska—death-trap for the Jap." Poster for the 13th Naval District, United States Navy, 1941–1943, by Edward T. Grigware. Library of Congress, Prints and Photographs Division, WPA Poster Collection, LC-USZC2-985 DLC.

Similarly, one of the chief military proponents of incarceration argued that Japanese operated as a "national group almost wholly unassimilated and which has preserved in large measure to itself its customs and traditions."[48] Symptomatic of this widespread suspicion of Japanese Americans was congressional candidate Al Dingeman's belief that Japanese Americans "have proved to be a treacherous and untrustworthy race" and a *Christian Science Monitor* reporter's assertions that Japanese Americans are "member(s) of a race whose loyalties to the US have not been fully established."[49] Adams acknowledged the impact of the press in a draft of the introduction to *Born Free and Equal*: "For months past the storms of public prejudice have beaten

on these citizens, fanned by almost every newspaper on the Pacific Coast, by meetings and by strong organizations acting in the name of America."[50]

Adams was deeply disturbed by the viciousness of anti-Japanese propaganda and feared its effects both on Japanese Americans and U.S. society more generally. In the text of a section of his book subtitled "The Problem," Adams refers several times to the damage leveled by the representational machine of the popular press. He wrote: "Opinion should be free, of course, but anti-racial propaganda is as dangerous to our spiritual and social existence as bad foods and drugs are to our bodies. This insidious propaganda should be neutralized by education and a liberal application of the constitutional guarantees."[51] The central images and text in *Born Free and Equal* were meant to serve as an antidote to such dehumanized representations. In a letter from Harold Ickes (secretary of the interior) to Adams dated May 30, 1944, Ickes wrote, "I am glad to know that you have turned your photographic talents to the interpretation of the Issei and the Nisei as *human beings*" [emphasis added].[52] As Ickes's letter suggests, the representation of Nisei as "human beings" was not something that could be taken for granted at that time.

"COME WITH ME"

Adams introduced his readers to the camp by simulating a visit by an outsider to Manzanar. He concluded a draft of the book's introduction with the invitation, "Come with me and let us pass through the soldier-guarded gates of Manzanar . . ."[53] Once inside the gates, Adams focused on short biographies and portraits of several individual Japanese Americans and a few families. The image used for the title page (see figure 13) brings together Adams's two main representational strategies employed throughout the book: the portrait of the individual and the landscape. In the photograph a man is shown in profile as he stares intently into the distant foothills. His gaze also directs the viewer to the text box on the right side, which contains the book's title and author. This combination of genres, portrait and landscape, was Adams's solution to combining social documentary with his predilection for picturing the land.

While the explicit representational strategy of *Born Free and Equal* is the power of the individual in the grand western landscape, the implicit rhetorical strategy is irony, questioning the negative portrayals of Japanese Americans by mixing conventional visual codes.[54] According to Linda Hutcheon, irony "is the intentional transmission of both information and evaluative attitude other than what is explicitly presented."[55] Adams's use of irony was most overt in his juxtaposition of icons of Americanism with images of people of

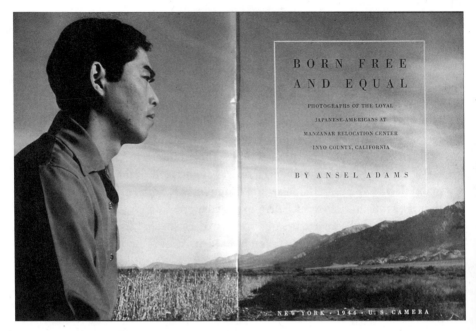

Figure 13. Title page of *Born Free and Equal: The Story of Loyal Japanese-Americans*, by Ansel Adams.

Japanese descent, who at the time were portrayed in the popular media as the embodiment of the foreign enemy and the antithesis of the home front. For example, following the fourteenth amendment to the U.S. Constitution and a quotation from Abraham Lincoln on the hypocrisy of prejudice, Adams positioned a full-page portrait of a young Japanese American with the caption "An American School Girl" (see figure 14).[56] The caption describes her without referring to her race. Through its very banality, the text asserts the girl's citizenship over her origins—a relatively radical move at a time when popular rhetoric defined Japanese Americans exclusively by their ancestry, and Japanese origins were portrayed as irreconcilable with assimilation, even for those people of Japanese descent who were born in America.

As many Japanese Americans complained, their identification with the enemy resided in their physical features. Their potential guilt was evidenced by the face itself. Instead of de-emphasizing the face, however, Adams riveted his lens directly on it. *Born Free and Equal* includes dozens of tightly cropped portraits of Japanese Americans that focus insistently on eyes, nose, and mouth. In "An American School Girl," the distance between lens and

Figure 14. Ansel Adams photograph, "An American School Girl," in *Born Free and Equal,* p. 6. Library of Congress, Prints and Photographs Division, LOT 10479-8, no. 21, LC-DIG-ppprs-00443 DLC.

subject is so negligible that the viewer experiences the subject from neither the comfortable distance of a studio portrait nor the standardized remoteness of an identity photograph. That degree of proximity is generally reserved for close family members. By placing the viewer so close to the subject, Adams demands that the face be reckoned with and acknowledged on familial terms.

In a section titled "The People," Adams focused on a more controversial group—male, adult Nisei in their late teens to early thirties. In *Born Free and Equal* there are twelve portraits of youthful, male Nisei—more than of any other age group and far more than the number of portraits devoted to women.[57] All of the photographs have captions that indicate their professions instead of their names. Emphasizing a lost work force desperately needed during wartime, the captions include the following: "Here is an accountant and a business man. . . . An electrician and a student of journalism . . . a garment designer . . . a tractor farmer . . . a tractor and diesel expert . . . and a student of diplomacy." The images, including figure 15, are earnest, flattering portraits in which each face fills the photograph's frame. The camera is positioned head-on, slightly lower than the subject, lending the faces a monumental quality. Some smile, others adopt a more serious expression.

They all address the camera directly, looking straight into the lens. The style of the images, both in terms of lighting and position of the head, purposefully avoids the connotations of official identity photographs such as mug shots and racial classification images, and again collapses distance between the viewer and subject.

Other groupings of images and text reinforce the iconic notion of Americanism. Over the caption "Americanism is a matter of the mind and heart," figure 16 depicts a three-quarter-view portrait of a young girl. Her smile is broad and her hair is curled and set in a popular 1940s style. The photograph does not give us access to her mind and heart as the caption suggests, but only to her outward appearance. Internal Americanism, it seems, is evidenced by one's dress and hairstyle. The caption comes from a speech by President Roosevelt and would have been recognizable to most readers of the book. Again, Adams is creating dissonance between the text and the image, putting

Figure 15. Ansel Adams photograph, "A tractor and diesel expert. . . ." in *Born Free and Equal,* p. 78. Library of Congress, Prints and Photographs Division, LOT 10479-1, no. 3, LC-DIG-ppprs-00256 DLC.
Figure 16. Ansel Adams photograph, "Americanism is a matter of the mind and heart," in *Born Free and Equal,* p. 59. Library of Congress, Prints and Photographs Division, LOT 10479-8, no. 22 LC-DIG-ppprs-00434 DLC.

the very words of the president who signed Executive Order 9066 to the test by placing them under the picture of the "enemy."

Figure 17 portrays a double-trucked image of a baseball game with the caption, "All like baseball and other sports" that appears toward the end of the book.[58] That this statement has to be asserted implicitly acknowledges that the Americanness of those pictured cannot be taken for granted. With rows of barracks in the middle ground and mountains behind, people line up along the first and third base lines watching the game. The game serves as a litmus test—the caption backed up by the number of observers provides evidence that Japanese Americans are like all other Americans. By representing people of Japanese descent engaged in the archetypal American activity, this image serves as a counter-argument to the claims that Japanese are inassimilable. Adams also was careful not to trivialize incarceration in his depiction of recreation. Not only are the barracks plainly visible, calling attention to the

Figure 17. Ansel Adams photograph, "All like baseball and other sports," in *Born Free and Equal*, pp. 90–91. Library of Congress, Prints and Photographs Division, LOT 10479-4, no. 22, LC-DIG-ppprs-00369 DLC.

meager living quarters, but he positioned his camera so that the immediate foreground is dominated by three rows of spectators who line up against a tall fence. The posts and wire allude to the sturdier fences that enclose the camp, which Adams was forbidden to picture overtly.

At the very center of the book is a photograph that borrows from the tradition of still life in its depiction of the contents of a tabletop (see figure 18). The caption focuses on one element within the image: the framed photograph of a young man in uniform. It reads, "One son of the Yonemitsu family is in the U.S. Army. . . ." The photograph is propped up against an image of Jesus. Next to them, two letters rest against a potted plant, which sits on a crocheted doily. Under the images is a flat piece of paper with Japanese characters, the date 28 June 1943, and the names of four members of the Yonemitsu family.[59] The objects on the table serve as irreplaceable markers of family identity. At the center of the image is the formal portrait of the Yonemitsu son in his uniform as a U.S. solider—a son sent out to risk his life for his country. The photo is positioned next to the other important picture in the household, that of the son of God—the model of sacrifice—which also signals to the viewer that

Figure 18. Ansel Adams photograph, "One son of the Yonemitsu family is in the U.S. Army. . . ." in *Born Free and Equal,* pp. 64–65. Library of Congress, Prints and Photographs Division, LOT 10479-2, no. 16, LC-DIG-ppprs-00278 DLC.

this family is Christian. In addition to his photograph, the image of young Bob Yonemitsu is reinforced by the two letters. The letters are the correspondence between Bob and his sister Lucy. They claim their rightful place on this family "altar" as would any memento from a distant loved one.

The juxtaposition of these letters with the photograph of their author sets up the point of disjuncture in this image. The letters are clearly addressed to Miss Lucy Yonemitsu, whose name appears over her block number and the place name Manzanar, California. The return address indicates that her brother wrote to her from a hospital in Springfield, Missouri. The irony is clear: Bob Yonemitsu fought to protect the rights, security, and freedoms of all Americans at the same time that his own family was incarcerated in Manzanar.[60] Mrs. Yaeko Nakamura, whose picture also appears in *Born Free and Equal*, is quoted as saying, "They [Japanese American soldiers] are proving their loyalty to the country which gave them home and citizenship."[61]

Lucy Yonemitsu also appears in the work of WRA photographer Francis Stewart, which raises the possibility that she may have been selected as a particularly apt exemplar of the themes that photographers sought to develop.[62] Japanese American subjects could be both photographic models, acting out "normal" activities for the camera to "document" such as reading in one's barrack or farming, and "model internees" carefully selected by the photographers to exemplify Americanness.

In one of the Stewart photographs, Yonemitsu sits in a comfortable chair in her barrack and smiles. The caption given to the image reads, "Lucy Yonemitshu [*sic*] former student from Los Angeles, California, enjoys a few free moments from her household duties and listens to swing music from her familiar and favorite Los Angeles radio station." Both the caption and the smile serve to communicate comfort and deflect further inquiry into the circumstances of her incarceration. At the moment of its production, Yonemitsu's smile functioned to create a positive impression of the incarceration process and of Japanese Americans themselves, who eventually would have to leave their prisons, for the general American public.

Adams juxtaposed two photographs to indicate how the executive order had been deployed with absurd indiscrimination against all people of Japanese descent, regardless of loyalty. Figure 19 depicts four children in generic cribs with one attendant, captioned, "Evacuation struck the very young. . . ." The pendant image (see figure 20) is a portrait under which the previous caption continues "And the very old. Nobutero Harry Sumida, Spanish-American War Veteran." One photograph depicts vulnerable innocence, while the other is of an aged veteran who under any other circumstances would have been

Figure 19. Ansel Adams photograph, "Evacuation struck the very young...." in *Born Free and Equal*, p. 56. Library of Congress, Prints and Photographs Division, LOT 10479-5, no. 25, LC-DIG-ppprs-00355 DLC.

the object of veneration. The following page further contextualizes these two images. Adams relates that an orphanage in Manzanar called "Children's Village" housed all orphaned children of Japanese descent from "Alaska to San Diego" who were incarcerated.[63] Shortly after, an entire page is devoted to recount the life story of the veteran Sumida, who was born in New York in 1872 and enlisted in the U.S. Navy during the Spanish-American war. After receiving disabling wounds, he was honorably discharged. An invalid since that time, Sumida had been living out his years in a sanitarium in Los Angeles when he was incarcerated. Adams's portrait of Sumida conveys dignity and integrity, with the camera positioned just below the level of the sitter's head. To any reader it would have been difficult to reconcile an executive order based on military necessity with the incarceration of orphaned children and a disabled veteran. Adams relied on the photographs and his informational text to question the legitimacy of the executive order. Adams's frequent reference to official sources (the information about Sumida, for example, was cited from the Manzanar Office of Reports) enables him to appear as an objective observer who simply lets facts speak for themselves.

Figure 20. Ansel Adams photograph, "And the very old. Nobutero Harry Sumida, Spanish-American War Veteran," in *Born Free and Equal*, p. 57.

The central position that the images and the text of *Born Free and Equal* advocate is that the Japanese Americans at Manzanar were loyal citizens. Although Adams refers to their hardships in the text, Adams makes his argument not by depicting victims but by showing strong, capable individuals—people who do things that Americans like to do, who embrace American styles of dress and ethics of professionalism.[64] Whereas Dorothea Lange's

photographs critiqued the incarceration process, critique in Adams's work is subordinated to his desire to make the case for the reinclusion of Japanese Americans into the body politic.

THE NEW PIONEERS

In addition to making the case to outsiders that certain Japanese Americans should be allowed to leave the concentration camps, camp administrators also promoted relocation to the prisoners themselves. Although relocation meant freedom and a return to life outside of the barbed wire fences, Japanese Americans could not yet return to their West Coast homes. In order to leave the concentration camps, Japanese Americans had to locate a job or a school outside of the Western Defense Command and then move to an unfamiliar city. For Nisei, this meant leaving their Issei parents behind. Alice Imamoto, who left the concentration camp in Jerome, Arkansas, to attend college at Oberlin, recalled, "Oh, I had mixed emotions. I was happy about leaving camp, but I wasn't happy about leaving mother and father. This was the unknown. So I was scared. Really scared."[65]

In Manzanar, the rhetoric surrounding relocation emphasized Japanese American claims to citizenship through the metaphor of the trailblazing pioneer. The Japanese American pioneer would not be blazing a trail west, however, but east, heading to sections of the country where few Americans of Japanese descent lived before the war. The new terms of the pioneer borrowed the powerful imagery of bravery and fortitude, and couched in a language of heroism the government's efforts to keep Japanese Americans from resettling together in large numbers. In speeches and editorials, Ralph Merritt encouraged those who were about to leave camp to head east and expressly discouraged them from returning to their homes in California. In his 1943 commencement speech delivered to students at Manzanar High School, Merritt stated, "Your world does not lie in the old home in California—your world does not lie in this temporary home between the Inyos and the Sierra, . . . your home lies in the great country to the east. . . . You are the new pioneers."[66]

Two years later, commencement speaker Edwin E. Lee, dean of the School of Education at the University of California, Los Angeles, delivered a speech aptly titled "The New Pioneers." He said that ". . . all Californians, all Westerners, have a matchless heritage which comes from the fact that this great State was born of pioneers—brave, stalwart, fearless men and women. . . . this heritage is yours, too, and . . . it cannot be taken from you. . . . it is an attribute of the spirit. . . . your fathers and mothers and grandfathers and grandmothers,

were pioneers, too . . . you have a second heritage of the pioneer spirit."[67] The native Californian Nisei he addressed thus acquired a double dose of "pioneer spirit," first through their status as westerners and second through the more literal pioneership of their immigrant parents. As immigrants who were forbidden from becoming naturalized citizens, however, the Issei—whose numbers were severely curtailed after the 1907 Gentlemen's Agreement, and whose citizen-born children had been stripped of their constitutional rights after the attack on Pearl Harbor—had not only been excluded from the standard narrative of western pioneer settlement, they had been portrayed as the very antithesis of the bold American citizenry that the pioneers represented. Rewriting history so that the experience of Asian immigrants could appear to be identical to that of their European American counterparts was not enough, however, to keep Japanese Americans from trying to pick up their lives in the California homes they had been forced to leave. While thousands did take up the invitation to pioneer east, the majority returned to the West Coast after the war.

In this updated version of the pioneer myth, the threat posed by unfriendly Indians became the racism practiced by whites who were unwilling to accept Japanese Americans as fellow citizens. Yet the WRA vigorously encouraged resettlement in the East as part of a strategy to integrate the Japanese minority. Approximately three months before Manzanar closed, Merritt drafted an editorial for the *Manzanar Free Press* that expressed his aggravation toward those Japanese Americans who did not take up the pioneering banner. In a rare loss of temper, Merritt blamed his charges for their imprisonment: "My friends, don't you realize that if people of Japanese ancestry had not been so crowded into the seven southern counties of California there would not have been any evacuation? Now, when Los Angeles has its greatest housing shortage, many of you want to crowd back under conditions that are worse than those you left three years ago. Don't create another Japanese problem by such selfish demands—remember, many others have also suffered in this war."[68] Japanese Americans did not create a "Japanese problem." Merritt's criticism of Japanese Americans for creating insulated communities conveniently neglected the role of white discrimination in restricting Japanese Americans to certain urban neighborhoods. Japanese Americans were hardly the first immigrant group in the Untied States to find themselves concentrated in racially defined quarters.[69]

Nonetheless, some Japanese Americans followed Merritt's advice to leave California in their efforts to reestablish their lives. In a far different graduation speech, one student also invoked the symbol of the pioneer, but cast

the relocation outside of the state as a mission of social justice. According to Teruko Hayashi, "The members of this class, who will soon be scattered among communities throughout the United States, will find themselves pioneering in this great cause.... Let us with the other forward-looking citizens of the multi-colored world, hasten to build a united people."[70] Expressed this way, Japanese Americans who braved the uncharted territories of the East in an effort to assimilate did so with a higher moral charge.[71]

There was certainly no artist in a better position to confer visually the status of the pioneer evoked through the western landscape than Ansel Adams. The last section of *Born Free and Equal,* titled "The Problem," argues for the reintegration of Japanese Americans back into the rest of society. Adams again utilized the strategy adopted from the book's outset, the juxtaposition of the individual and the landscape, when framing the section with two images. The first image (see figure 21) shows a woman in uniform standing in a doorway; the caption reads, "A United States Cadet Nurse." This smiling, professional woman served as an example of the loyal, highly skilled, and employable Japanese American for whom Adams sought to pave the road of relocation. Her polished appearance, including crisp white gloves held confidently in her hand, is nevertheless incongruous with the shabby condition of the wall next to her. The flimsy coating of tar paper peeling around the vertical line of nails makes her neat row of polished buttons closing her wrinkle-free uniform seem all the more remarkable and out of place. The vertical edge of the doorway could have been easily cropped out of the image. Adams used the contrast between the jagged, irregular edge of tarpaper and the straight edge of her jacket to highlight the incongruity. Rather than eliminate the evidence of unbecoming surroundings, he accentuated it by placing her at an angle in the doorway, providing a hard shadow to fall to the right of the buttons.

The photograph directly following this section of text is the well-known landscape photograph, "Winter Sunrise, the Sierra Nevada from Lone Pine," with the caption "In the presence of the ancient mountains the people of Manzanar await their destiny."[72] Adams uses "Winter Sunrise" along with his text to position Japanese Americans in the iconic landscape of the American West. The image's formal beauty heightens the power of the argument that Japanese Americans were born free and equal, and suggests that they are integral to the American landscape and the core values, including the pioneer spirit, that the American West connoted.

THE LIMITS OF LOYALTY

Adams's efforts to establish Japanese American loyalty effectively neutralized Japanese ethnicity, depriving people of their family histories.[73] He pre-

Figure 21. Ansel Adams photograph, "A United States Cadet Nurse," in *Born Free and Equal*, p. 100. Library of Congress, Prints and Photographs Division, LOT 10479-1, no. 14, LC-DIG-ppprs-00267 DLC.

sented readers with an extremely homogenized representation of Japanese Americans, in which he emphasized attributes such as work ethic and cleanliness and stressed similarities between the book's subjects and non–Japanese American readers: "Those who think of Japanese-American domestic relations as differing from our accepted patterns are in for a sharp disillusion-

Figure 22. Ansel Adams photograph, "In the presence of the ancient mountains the people of Manzanar await their destiny," in *Born Free and Equal,* pp. 101–2.

ment when confronted with the family life at Manzanar."[74] In addition to the neutralization of ethnicity, this picture of Japanese Americans also required the erasure of opposition. The very people who fought most vociferously for the re-implementation of their rights as citizens are missing from these photographs. Those who resisted and those whose sympathies were conflicted were not depicted, their stories were not told. Adams includes the portraits of three Japanese Americans who have enlisted for military service, but there is not one photograph of someone labeled as a conscientious objector. Nor is there a portrait of an adult who answered no to questions 27 and 28 of the leave clearance questionnaire. Only 174 people were inducted into the military from Manzanar, compared with 2,165 who were eventually segregated to Tule Lake as disloyals, but it is the soldiers and their families among the incarcerated who are emphasized in Adams's portrayal of the camp.

The government was not the only entity that abused the rhetoric of loy-

alty to control the Japanese American population. The Japanese American Citizens League (JACL) formed an unofficial alliance with the government to forward efforts to "Americanize" and assimilate the insulated pre-war communities of Japanese Americans. By 1942, three-quarters of the West Coast Japanese American population were American citizens by birth with a median age of twenty-one. About one-half of the incarcerated population was under the age of twenty-four, many without independent financial means or institutional resources to defend themselves against the exclusion orders.[75] Furthermore, as the first American-born generation, many Nisei were extremely patriotic and wanted to be accepted as loyal Americans, even if that meant their own imprisonment. The JACL asked Japanese Americans to comply fully with the government in the hope that accommodation would resolve the question of Japanese American loyalty once and for all.

A relatively small group during the war, the JACL derived its power from its leader, Mike Masaoka. Letters that Masaoka wrote to Milton Eisenhower, the first head of the War Relocation Authority, paralleled the tone of the text and images in *Born Free and Equal*. Masaoka informed Eisenhower, "We do not relish the thought of 'Little Tokyos' springing up in these resettlement projects, for by so doing we are only perpetuating the very things which we hope to eliminate: those mannerisms and thoughts which mark us apart, aside from our physical characteristics. We hope for a one hundred percent American community."[76] In *Born Free and Equal*, Adams presented a similar logic of assimilation: "One way for minorities to protect themselves is to scatter throughout the country—to avoid concentration in nationalistic groups in towns and rural areas. In taking the opportunity to prove themselves capable, cooperative citizens, the Japanese-Americans are placing themselves in a far stronger position than if they had drawn timorously together in the 'Little Tokyos' to sit out the war under the suspicion and possible persecution of their Caucasian neighbors. The next step was 'segregation'—the removal of 'disloyal' elements. . . ."[77] Both pointed to incarceration as a positive means to do away with insular minority Japanese communities, but neither acknowledged the policies and cultural climate in the United States that made life for minorities outside of those communities untenable.[78] Both also insinuated that concentration camps should play a key role in the assimilation process; rather than exceptions, camps were portrayed as integral to the process of Americanization.[79]

The JACL and Adams also portrayed Issei in similar terms. As the immigrant generation, Issei had been legally and culturally barred from full participation in American society, and they were prohibited from joining the

JACL as well. In *Born Free and Equal* Issei are also virtually absent. The very title of *Born Free and Equal* indicates that it is exclusively about American-born Nisei and their Sansei children. Historian Roger Daniels describes the relationship between JACL Nisei and their Issei parents: "The [JACL] . . . sought to disassociate the whole second generation from its parents by barring the Issei from membership because they were not American citizens. The JACL tried to surmount not just the Nisei dilemma but the whole Japanese American dilemma: how to avoid identification with Japan when one has a Japanese face."[80]

Like the JACL, Adams's objective was to disassociate the "Japanese face" from the connotations of the enemy Japanese. However, he did this by concentrating on the face via photographic portraits. In contrast to the stereotypes of the period, Adams used the face as a carrier of American values: style, integrity, and hard work. Although Adams provided an important alternative to these stereotypes, in his effort to defend the subjects of his photographs as loyal, he implicitly counterposed them to "disloyal" Japanese, whom he excised from his portrait of incarceration. In this sense, as Jan Zita Grover has argued, he left intact the central proposition of the government policy—which purported that the imprisonment was based on political allegiances rather than race—even as he provided plenty of evidence to suggest that the policy was conducted without any regard to Japanese Americans' actual politics.[81]

THE IMPACT OF THE BOOK

Adams ended *Born Free and Equal* with two quotations. The first was from Dillon Myer: "If we are to succumb to the flames of race hate, which spread with fury to every markedly different group within a nation, we will be destroyed spiritually as a democracy, and lose the war even though we win every battle."[82] The second quotation was taken from Walt Whitman: "To thee old cause! Thou peerless, passionate, good cause, thou stern, remorseless, sweet idea, deathless throughout the ages, races, lands, after a strange sad war, great war for thee. . . ." With these thoughts in mind, Adams's photographs and text reveal ambivalence, poignantly obvious in two images. One has a Pollyanna-ish title, "Departure on relocation is the great adventure," and the other is a penetrating portrait, which is the last image in the book (see figure 23). Adams's characterization of relocation as an adventure was an odd description of the ordeal that followed. Japanese Americans were not allowed to return to their homes in California until after the war, at which time approximately 60 percent went back to try to salvage their previous existences. Those who returned found a state that often remained openly hostile.

Figure 23. Ansel Adams photograph, untitled final image (of Yuichi Hirata) in *Born Free and Equal*, p. 111. Library of Congress, Prints and Photographs Division, LOT 10479-1, no. 12, LC-DIG-ppprs-00268 DLC.

The closing photograph in the book is as enigmatic as the other is falsely optimistic. Adams warned his editor, Tom Maloney, not to interfere with the order of the images, particularly the last portrait: "Now, if you go changing things around you approach the grave danger of confusing the basic approach . . . it has to be right. . . . The final picture—that of the man looking directly at you—creates the final impact of the book. . . ."[83] The camera closes in tightly on a young man's face. Unlike many of the other portraits in *Born Free and Equal*, this photograph of Yuichi Hirata does not depict an optimistic Ni-sei, proudly plying his trade or smiling eagerly for the camera, but a person

who leaves the viewer with a far more ambivalent feeling. Hirata looks at the viewer in a fashion completely self-possessed and self-aware and without the desire to compromise.[84]

The book project was, in the end, a source of frustration to Adams. A letter Adams wrote to Harold Ickes provides numbers concerning publication and cost: "It will be an excellent boost for the cause, as the first printing will be 25,000, it will have a wide distribution and the cost of the book will be only $1.00."[85] Adams expected to sell ten thousand copies to Japanese Americans alone. The book made it onto the bestseller list in San Francisco.[86] There are no exact figures as to how many sold or were actually printed, and it is likely that U.S. Camera never fulfilled the print run of twenty-five thousand copies to which Adams referred. Letters written from 1944 to 1945, after the book's publication, indicate Adams's disappointment with the unavailability of the book and the lack of promotion for it. Later in his life, Adams claimed that copies of the book were burned or removed from sale by the U.S. military and conservatives in California.

Sue Kunitomi Embrey had left Manzanar by the time *Born Free and Equal* appeared and remembered her excitement upon seeing it for sale at a Chicago newsstand. However, when she returned to purchase more copies, the book had disappeared. She too heard rumors that the publication had been removed by a "government agency."[87] It is also possible, however, that the sole printing was much smaller than Adams had anticipated and sold out quickly. A small consolation came from friends such as Beaumont Newhall, who complimented Adams on the book, writing, "You have succeeded in demonstrating that the impact of documentary photographs is increased by fine photography."[88]

With the signing and implementation of Executive Order 9066, Japanese Americans were deprived of their constitutional rights. In the tradition of the nineteenth-century photographers of geologic expeditions such as Timothy H. O'Sullivan, Adams celebrated the western landscape as something fundamental to the American consciousness. Deprived of their rights as citizens, the landscape was one of the few aspects of Americanism that the incarcerated at Manzanar could still claim. Adams's use of the landscape, the portrait, their combination, and their juxtaposition represented an attempt to retrieve Japanese Americans from the dehumanization of wartime propaganda and reverse that damage by linking Japanese Americans to a quintessential icon of the United States, the American West.

In the face of the anti-Japanese rhetoric that abounded at the time, the book could easily have been interpreted as a publication counter to military

interests because of its sympathetic portrayal of a group of people regarded by many as suspicious. Despite this potential for tension with official policy, Adams developed the project with the consent and approval of the War Relocation Authority and the head administrator at Manzanar. That partnership helps to explain the contradictions in reading *Born Free and Equal*—a book that at once criticizes and accommodates the government policy of incarceration. The text and photographs tried to persuade the reader to disavow prejudice by accepting relocating "internees" as loyal Americans, yet reproduces aspects of that prejudice by constructing a narrow definition of loyalty, one that excludes both Issei and those who protested the government action. In championing the individual over the group, Adams excised virtually everything about the prisoners that could be interpreted as Japanese.[89]

With Adams's meteoric rise to art fame in the second half of the twentieth century came the relative disappearance of *Born Free and Equal* from Adams's oeuvre. Despite the limits of *Born Free and Equal,* both in terms of its politics and availability, the book has been an important resource for acts of counter memory as it is one of the few wartime publications that represented Japanese Americans in a respectful manner. Although the large public remembrances of Adams in 2002 neglected this part of his work, a small California press bravely republished the images and text from the volume. Unable to receive sponsorship or endorsement from the Ansel Adams Publishing Rights Trust, they reproduced images by Adams that are in the public domain.[90] The new edition of the book includes introductory essays by Archie Miyatake and Sue Kunitomi Embrey, who were both incarcerated in Manzanar.

While at Manzanar, Adams participated in another photography project intended for a very different audience than that of *Born Free and Equal*—the incarcerated themselves. On one of Adams's visits, he supplemented the yearbook photography that was carried out in large part by Toyo Miyatake and his son, Archie. Adams's contribution to the yearbook was much more modest than Miyatake's, however. A page from the yearbook featuring the school theater group includes a small picture of Adams making photographs of a rehearsal. Adams himself referred only briefly to Manzanar High School and its theater in the pages of *Born Free and Equal*.[91] In the main text of the yearbook (titled *Our World*), there is no mention of the famous photographer, but at the end of the yearbook the editors thank Ansel Adams. The yearbook created the juxtaposition of photographs and text that represented Japanese Americans in a way that escaped Adams, whose agenda in *Born Free and Equal* had been to present a homogenized portrait of a hyper-loyal people addressed to an audience of prejudiced outsiders. In addition to the

yearbook collaboration, Adams also photographed Miyatake and his family for his own project. One such image, which depicts Toyo Miyatake with his wife and three children in their barrack, is the only photograph in *Born Free and Equal* that includes a recognizable Issei face. It is to the photographer most responsible for the images in that yearbook, Toyo Miyatake, that we turn in the next chapter.

3

The Right to Represent

Toyo Miyatake's Photographs of Manzanar

> Impressions of Manzanar most likely to wander through
> our memories after this is all over: . . . the arched panoply of
> the rugged blue-black etched by the craggy mountain ranges
> against the sky The dry, musty air in a room in Block 16
> during an 'unusual' afternoon's dust storm. In bed after the
> storm, after the windows stop rattling, after the wind stops
> moaning, with the windows open and the cool night air
> softly billowing across your face.
>
> —"Memories of Manzanar," *Manzanar Free Press,*
> September 10, 1943

Although photography was often put to repressive uses during the
incarceration, the camera was also used as a tool of resistance. In the past 15
years, exhibitions and markers that publicly represent the history of Japanese
American incarceration have invoked the camera as a symbol of the struggle
to preserve personal dignity in the face of humiliation, dishonor, and the de-
nial of citizenship rights. A bronze sculpture representing a large, weathered
view camera stands on the sidewalk outside the Japanese American National
Museum's historic building in Los Angeles (see figure 24). The camera focuses
not on the street, but on the museum, poised to photograph the building
in which Japanese American history is made public. Installed in 1993 by
artist Nobuho Nagasawa, the sculpture is an enlarged replica of the camera
used by Toyo Miyatake inside Manzanar, where Miyatake was imprisoned
with his family.[1] The sculpture was designed to house a slide projector that
displays Miyatake's wartime photographs against the window of the mu-
seum. The text panel accompanying the sculpture explains Toyo Miyatake's
significance to the Japanese American community of Los Angeles: "First-
generation Japanese American photographer Toyo Miyatake (1895) opened

Figure 24. Nobuho Nagasawa bronze sculpture, *Toyo Miyatake's Camera*, 1993, 18" h × 18" w × 21¾" atop 4' tripod. Japanese American National Museum, 369 East First Street, Los Angeles, Calif. (Photograph by Jasmine Alinder.)

his photography studio in Little Tokyo in 1923 and spent the rest of his life documenting his community's life on film. When Miyatake, his family, and 120,000 Japanese Americans were unjustly incarcerated by the United States government during World War II, Miyatake bravely smuggled . . . lens and film plate, considered contraband, into the Manzanar concentration camp in California. Using a secretly-constructed camera, he captured everyday life in Manzanar." The secretly-constructed camera has itself become a valuable artifact appearing in exhibitions that feature Miyatake. In 1998, the Japanese American Cultural and Community Center in Los Angeles displayed the small camera, beautifully carved from wood, in a retrospective exhibition of Miyatake's photography. Later, the Friends of Photography/Ansel Adams Center in San Francisco also featured the camera in an exhibition called Picturing Manzanar.

The emphasis on Miyatake and his contraband camera is prominent within the core exhibition of the Japanese American National Museum, Common Ground, in which he is pictured in Little Tokyo in the act of taking photographs.[2] Miyatake and his camera play an even more significant role in the new interpretive center at the Manzanar National Historic Site, where an entire display, including a replica of the camera, portrays Miyatake's Manzanar darkroom. Miyatake is one of a dozen former prisoners whose biography is featured on identification tags that museum visitors can detach from a wall and take with them.[3] By calling attention to the practice of photography itself, this exhibition challenges viewers to think more critically about the role of the camera in the representation of the past and the possibility of a redemptive photographic practice within the camp. The prominent focus on Miyatake in these recently mounted exhibitions in California is in contrast to his notable absence from earlier displays outside of the West Coast, including the exhibition A More Perfect Union: Japanese American and the U.S. Constitution, which was housed in the National Museum of American History in Washington, D.C., from 1988 to 2004 (discussed in the next chapter).

Across the street from the sculpture of Miyatake's camera in Los Angeles is a wall mural by Jerry Matsukuma titled Senzo that reproduces eight photographs of Japanese American life. Three of the photographs are by Miyatake, including one contemplative image of barracks and clouds. Text on the wall gives credit to those who survived wartime incarceration "undaunted . . . [to continue] the struggle to reaffirm the basic ideals of human dignity and freedom." This text closes by dedicating the wall to early Nikkei "whose lives, struggles and achievements make a full and moving picture . . . in the large American panorama." Although he died in 1979, Miyatake is still re-

membered on this block in Little Tokyo as the photographic chronicler of more than fifty years of Japanese American life. Miyatake's Manzanar camera and the description of its illicit entry into the camp have come to signify a kind of protest against the politics of incarceration that rests in the power of everyday acts of Japanese American self-representation.

The symbolic value attributed to Miyatake's camera today speaks to the importance of photography in the struggles over the meaning of the incarceration in the present as well as the past. Miyatake's Manzanar photographs are all the more extraordinary because the use and control of pictures was a key dimension of the United States government's denial of citizenship rights to Japanese Americans. While images in the popular press dehumanized people of Japanese descent, the confiscation of cameras and photographs curtailed the possibility of alternative portrayals of Japanese American life.

The Photo Studio

Until his wartime incarceration, Toyo Miyatake owned a successful photography studio in Los Angeles's Little Tokyo neighborhood.[4] The 1998 exhibition of Miyatake's photography at the Japanese American Cultural and Community Center demonstrated his range as an artist in the pictorialist tradition and as a working commercial, portrait photographer.[5] In addition to commissioned portraits, Miyatake photographed professional dancers and athletes, and he submitted art photographs to national and international salon competitions (see figure 25). As a professional photographer, he earned his living and supported his family with his studio work, and at the same time he built a solid reputation as an artist.[6]

During the 1920s, Miyatake became friends with the well-known photographer Edward Weston and convinced Weston to exhibit some of his work for the Japanese community. Weston exhibited for "a Japanese Club" on First Street in Little Tokyo in 1925 and sold several prints. In a letter to Tina Modotti, Weston wrote of this exhibition: "What a relief to show before a group of intelligent men! If Los Angeles society wishes to see my work after this, they must come to the Japanese quarter and rub elbows with their peers—or no—I should say their superiors!"[7] Weston admired the collectors of Japanese descent whom he encountered in Los Angeles because they seemed to appreciate and understand his work in a way that other Americans did not. Miyatake's artist collective, Shaku-do-sha, invited Weston to exhibit on three other occasions.[8] Miyatake's friendship with Weston may eventually have helped Miyatake obtain permission for his operation of a camera inside camp.

Figure 25. Toyo Miyatake photograph, "Michio Ito's performance of 'Pizzicato,'" 1928. Toyo Miyatake Collection.

Twenty years after he opened his studio, Miyatake was forced to close it and move his family into Manzanar. Japanese Americans were strictly forbidden to bring cameras into the camps. The government classified the camera as a weapon of war in the same category as guns, bombs, and ammunition.[9] Afraid that he would be accused of spying and separated from his family, the story goes that Miyatake did not mention even to his wife and children his plans

to smuggle a lens and a film holder into Manzanar. He later told his son, At-sufumi (Archie), that he took the risk because he felt that, as a photographer, it was his responsibility to make a record of their experiences for the future. Once in camp, Miyatake made a camera body from scraps of wood with the help of a carpenter and began covertly recording camp life.[10]

There are only a handful of publications that discuss Miyatake's photography in Manzanar. A few of these publications maintain that the Manzanar administration caught Miyatake with his camera.[11] I have found no record of Miyatake's apprehension or punishment in the archival holdings pertaining to Manzanar, and Miyatake's son Archie thinks it is possible that his father was never captured with his secret camera.[12] Regardless of whether or not the camp authorities detected the camera, however, Miyatake's decision to construct a camera clandestinely represented a courageous and highly risky act. But why did he feel so strongly about taking that risk, given that the photographs he made do not focus on particular acts of mistreatment or violence?

When Miyatake's images critique incarceration, they do so in more symbolic terms that call to mind the carefully rendered compositions of an artist rather than those of a reporter. For example, when the Japanese American National Museum needed photographs that depicted physical abuse, they did not turn to images that came from Miyatake's contraband camera but from attorney Wayne Collins's smuggled lens. Miyatake did not make images that depict stark brutality.[13] Given events in Manzanar, one can assume that this was not because sufficient acts of cruelty did not present themselves in front of Miyatake's eyes.[14] Instead, given his predilection for composition and the size of his view camera—which was much larger than a snapshot camera—it would have been impossible for him to remain unnoticed if photographing such events.

One year after Miyatake's arrival at Manzanar, his determination led to the creation of a photography studio in the camp. The origins of the studio lie in a more general set of reforms undertaken by the camp authorities after a series of violent conflicts between camp personnel and Japanese Americans during the first year of imprisonment. In December of 1942, a riot broke out in Manzanar and military police killed two Japanese Americans and injured at least ten others.[15] Two months later the War Relocation Authority began to administer the highly controversial leave clearance questionnaire (see chapter 2).

After the 1942 riot and during the removal of segregees to Tule Lake, Ralph Merritt, the director of Manzanar, attempted to achieve peace through a paternalistic system of camp government that allowed prisoners to expand

the services they provided for themselves. Initially these consisted of a few essential shops—such as a dry goods store and a canteen—to serve the prisoners own needs. The offerings expanded to include fourteen cooperative businesses by the fall of 1943, including the photography studio, a watch repair shop, a beauty parlor, and a fish market.[16]

The WRA attempted to make the concentration camps largely self-sufficient in terms of governance, labor, and material necessities.[17] Japanese Americans worked at low wages to produce food and services for themselves, reducing the government's financial burden. The WRA allowed prisoners to establish "community governments," although ultimate power resided in the hands of white officials.[18] Offices in the community government were only open to citizens, or Nisei, and not their Issei parents. The exclusion of Issei from these governments, as well as from other influential positions (such as camp newspaper editor), was another instance of the government's effort to shift the balance of power in Japanese American communities from the Issei to their children.

Earlier in 1943, the *Manzanar Free Press* announced the "approval for an establishment of a photo studio." The article indicated the limits of the studio's operations: "Although under the Army ruling only appointed personnel will be permitted actually to take pictures, all other work connected with the enterprise will be handled by Japanese personnel. . . ."[19] In other words, appointments could be taken, sitters arranged, lighting set, film developed, and prints made by Japanese Americans, but the actual release of the shutter—the taking of the pictures—had to be executed by "appointed personnel," meaning white appointees of the administration. Furthermore, the "appointed personnel" removed the lens from the camera at the end of the workday, secured it, and brought it back to the studio for the next appointment.[20]

The strict regulation of the studio reflected the power that the government attributed to photography.[21] With the confiscation of cameras, government officials believed that they were discouraging sabotage, but at the same time they also took away the ability for Japanese Americans to represent themselves photographically. During the years in the camps, significant rites of passage escaped photographic memorialization, and Japanese Americans were denied the ability to verify their mistreatment or harsh conditions. The site of power resided not in the positioning of the subject but in the release of the shutter. The government's regulation of control over who clicked the shutter was an exertion of power over the right to self-representation—a continuation of the legal efforts to control the Japanese American body that had their origins in nineteenth-century immigration legislation.

The extent to which this control was exercised and then subverted in Manzanar is striking. The camp administration in Manzanar recognized that there was a strong "community desire for personal photographs," and a lack of access to commercial photographers before the photo studio opened.[22] But an essay written by a woman who identified herself as a "Nisei mother" presented the issue in poignantly personal terms. After she described the discrimination and insults she faced following the bombing of Pearl Harbor, she lamented her inability to photograph her daughter:

> Since she was an infant, I had been keeping a photographic account of her monthly growth. We had a separate album just for her, and the confiscation of our camera prior to evacuation was one of the 'minor blows' which we received. In the course of daily events the confiscation of cameras may have been a minor matter, but to us, (especially to us, the doting mother with only one child) it was something we could not count in dollars and cents. Here our children are getting older, day by day, and once their childhood is gone, nothing on this earth can bring it back, and if we have no mementos of their growth, we feel cheated and a little bitter to think that just a snapshot now and then, even if it was taken in a 'concentration camp' is better than nothing at all.[23]

She then continued to explain that she refused to have any more children because the incarceration had threatened her sense of security, and she did not want to link a child's birth forever to a concentration camp. Her touching account of her losses places access to photographic representation at the center. Her other material possessions could be repurchased, and after her release she promised to "try to pick up the threads of our former life and live in the true American traditions." The only things she irretrievably lost were the photographs never made of her growing daughter. As her ironic use of quotation marks clearly indicates, the blow felt from the confiscation of her camera was far from minor.

The photo studio in Manzanar debuted in response to Japanese American desires to reclaim the camera as a part of their daily lives. After replacing the ironing room in Block 30, the studio was slated for a grand opening on April 12, 1943.[24] Miyatake's appointed assistant went to Los Angeles to buy used photographic equipment, and the head of evacuee properties wrote a letter so that Miyatake could get some of his own equipment out of storage.[25] Nine days later the camp newspaper ran a front-page article highlighting the talented staff of the newly opened photography studio: "Toyo Miyatake, manager of the photo studio, is formerly of Los Angeles where he was proprietor of the

well-known Toyo Studios. His efforts have been recognized by the London Salon of Photography, the Pittsburgh Photography Society and the Rochester Society of Professional Photography. He was selected by the Eastman Kodak Co. to represent them at the nationally known American Professional Photography Association. . . . Yes, Manzanar's photo studio is filled with professional artists that cannot be equaled in the majority of outside studios."[26] This last sentence in particular suggests the prestige attributed to Miyatake at the same time that it acknowledges the deprivation of imprisonment. The newspaper warned that a shortage of film and materials meant that not all orders for photographs could be met. The studio charged ten dollars for a dozen mounted 8" × 10" photographs of a wedding, nine dollars per dozen for family groups, and only eight dollars per dozen for funeral photographs. Club groups were charged twenty-five cents for each image, not including the mount.[27] As the price list suggests, the mission of the photography studio of Manzanar was primarily to commemorate important rites of passage, the progress of the family, and associations between people in educational and civic clubs.

Photographs made by the studio provided emblems of events whose meaning transcended the experience of wartime imprisonment. Figures 26 and 27 provide revealing points of comparison. Miyatake made the first portrait before the incarceration and the other from behind barbed wire. The pre-war formal portrait of bride and groom depicts seamless luxury afforded by the Los Angeles studio and its equipment. The glossy finish of the print echoes the smooth yards of wedding gown silk. In contrast, the wedding couple in camp wear their best clothes, cut a large cake, and have splurged on bottled Coca-Cola for their guests, but the surface behind them, with its pushpin wallpaper, betrays evidence of their shabby surroundings. Prisoners earned an average of seventeen dollars per month, so photography in camp would have been reserved for these kinds of special moments.

Less than two months after it opened, the *Manzanar Free Press* reported that the photography studio had to be "temporarily closed due to lack of photographer."[28] The problem lay not in the lack of a photographer, but rather the lack of a person authorized to click the shutter. Miyatake, whose talents the newspaper had celebrated only two months earlier, remained in the camp. As the newspaper continued, "Since Manzanar is in the Western Defense Area A, evacuees cannot operate cameras except for official WRA identification photographs. The last letter from National Director D. S. Myer to the Co-op indicates that this ruling cannot be extended so that an evacuee photographer may operate a stationary camera at the studio."[29] According to Archie Miya-

Figure 26. Toyo Miyatake photograph, "Wedding portrait of Mr. and Mrs. Toyama," December 7, 1941. Toyo Miyatake Collection.

take, Ralph Merritt eventually decided to hire camp administrators' wives to serve as chaperones at the studio so that picture taking could resume. By the end of the school year in June of 1943, the studio was back in business and the newspaper reminded high school graduates to make appointments to have their cap and gown pictures taken.[30]

Despite Dillon Myer's firm stance against "evacuee" operation of a camera, even within the confines of a studio, Ralph Merritt eventually gave Miyatake

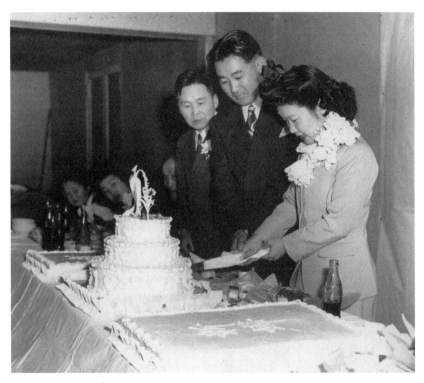

Figure 27. Toyo Miyatake photograph, "Dick Tani and his wife were married at the camp and held the reception at the assembly hall. One of the camp cooks made the wedding cake." Toyo Miyatake Collection.

clearance to photograph without supervision.[31] Contemporary Japanese photographer Eikoh Hosoe conducted interviews with Miyatake that shed some light on this matter. Hosoe described one of his meetings with Miyatake, during which Miyatake connected his friendship to Edward Weston with the granting of permission to photograph in Manzanar: "Toyo-san continued his story nostalgically and then suddenly stood up and went into the back of the studio. He returned with a large bundle and said, 'Thanks to Weston, I was able to take these pictures.' With that he showed me the photographs he had taken at Manzanar."[32] Miyatake then explained to Hosoe his theory of Weston's influence over Merritt. "One day at Manzanar, the director of the camp, Mr. Ralph Merritt suddenly summoned me to his office. I thought he'd found out about me taking pictures of the camp with my hand-made camera and went to his office prepared to be reprimanded. But when I got

there he didn't have anything in particular to say. As I started to leave, he said in a soft voice, 'Edward is worried about you.' Merritt and Weston were old friends so Weston might have approached Merritt but after that I was permitted to bring in cameras and film from outside and to take pictures inside the camp freely. I'm pretty sure Weston's influence had something to do with it."[33] According to Hosoe's interview of Miyatake, Miyatake's association with Weston conferred credibility in the eyes of the camp administration.[34] That photographer Edward Weston vouched for Miyatake may have carried special weight due to not only his own renown, but also because of his reputation as a formalist art photographer dedicated entirely to making art. Unlike his contemporaries—Ansel Adams, Dorothea Lange, and even Tina Modotti—Weston avoided focusing his camera's lens on any subject that smacked of politics.[35] Similarly, Miyatake's pre-incarceration work was either commissioned portraiture or highly artistic works that were aligned with pictorialism, not documentary. Weston's efforts likely conferred the understanding that as a fellow dedicated artist, Miyatake's separation from his camera would have been unbearable.

Although some of Miyatake's photographs suggest that he did eventually take advantage of a certain degree of photographic latitude, it seems that whatever understanding existed between Merritt and Miyatake was not a part of official policy. The "Final Report" of the Manzanar Relocation Center makes no mention of Miyatake or the photo studio under the subject "Project Photography." According to the report, "To prevent indiscriminate and unauthorized photography, the Report Office was designated official photographer for the Project. All photography at the Center was done either by him [the officer of Reports, Robert L. Brown], his authorized representative, or by someone under his supervision. . . . Memorable events, unusual occurrences, returning Japanese American veterans and noted persons who visited the Center were photographed for documentary purposes."[36] The report is vague on the subject of project photography, implying that Miyatake would only have been able to photograph under supervision so that the photographs made for Japanese Americans in the photo studio could be categorized under "memorable events." However, it is also possible that because the photographs made in the studio of wedding couples and school groups were taken by a Japanese American for the private use of the subjects, the images were not considered significant to the official documentation of Manzanar. A third possibility is that Merritt and the other camp administrators did not want to report the license given to a Japanese American photographer.

According to Archie Miyatake, after the camp administrators' wives quit

their chaperoning, no one came to inspect what his father was doing. He was able to take his camera and tripod around the 550–acre grounds of Manzanar and take pictures without any overt strictures on his subject matter. Although Archie Miyatake did not know of any regulations placed on his father's photography, certain parameters were probably understood. In a June 1943 issue of the *Manzanar Free Press,* "internees" were warned not to "wander outside of the fenced area of the project," and that such a violation would lead to a $5,000 fine or a prison term.[37] Miyatake needed to photograph in areas that would not have been terribly risky because he was working with a view camera on a tripod. Setting up the shot and making the exposure would have taken a substantial amount of time—minutes instead of seconds—and the equipment would have made him highly visible during the process.

"Boys Behind Barbed Wire"

In addition to the studio photography, Miyatake also made images on his own. One such image, "Boys Behind Barbed Wire," may be the most frequently reproduced photograph of the incarceration (see figure 28). It is a poignant image in part because it pictures the gap of power between defenseless youths and the extensive amount of force mobilized to contain them.[38] Reproduced in newspaper articles, museum exhibitions, and government publications, the black-and-white photograph of three boys standing in desert brush behind a barbed wire fence has come to symbolize the injustice of the incarceration. An examination of the ways in which this photograph has been reproduced reveals how the perceived veracity of documentary photography has been manipulated and exploited to tell versions of history that often elide complex experiences and smooth over the contradictions of the past.

"Boys Behind Barbed Wire" has been reproduced in a wide variety of contexts, ranging from the cover of a teacher's guide for the Bill of Rights to an exhibition announcement for the Manzanar photography show at the Ansel Adams Center. In the teacher's guide, the photograph is placed over an image of a page from the Bill of Rights set in Old English script. Both images are reproduced in sepia tones that, along with the antiquated font and textured paper, connote their status as historical documents. Specifics are obscured; in the photograph the boys, barbed wire, and guard towers are visible, and in the Bill of Rights only the title and subtitle are legible. The captions do not appear with the images, and are instead found in the front matter of the guide: "Cover: Foreground: c. Toyo Miyatake photo, Manzanar, 1943. Background: The U.S. Bill of Rights at the time submitted for ratification."[39] The

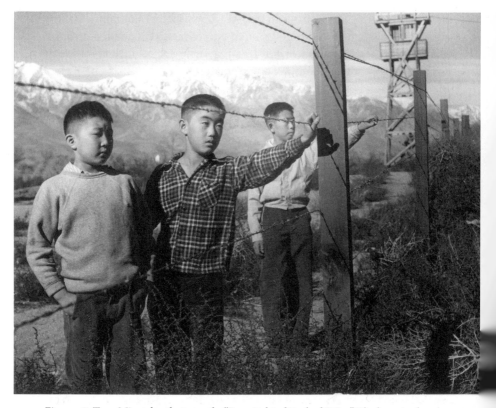

Figure 28. Toyo Miyatake photograph, "Boys Behind Barbed Wire." The boys in the picture are, from left to right, Norito Takamoto, Albert Masaichi, and Hisashi Sansui. Toyo Miyatake Collection.

captions reflect the manner in which the images are reproduced, limiting information to the general and historical.

When the photograph appeared as the cover image for an Ansel Adams Center exhibition announcement, however, it was returned to black-and-white and detail was highly emphasized so that the viewer could make out the snow-capped mountains in the background and each twisting branch of scrub brush in the foreground.[40] The caption was placed underneath the image flush with its right side according to the practice for identifying works of art in museums: "Toyo Miyatake, '3 Boys and Barbed Wire,' 1943." The title is descriptive and the odd decision not to spell out the number of boys indicates an artistic choice that ignores grammatical convention. The detail of the image and the tonal range place it stylistically with work by the other artists listed on the right side of the announcement: Ansel Adams and Dorothea Lange.

As these two examples make evident, this photograph by Miyatake shifts easily between contexts that emphasize its status as historical document and others that underscore its artistic merits. Both examples also suggest a strange dynamic in which the specific historical circumstances of the photograph's production, including the identity of the author, recede from view as the photograph takes on status as a historical document. This dynamic resurfaces again in the reproduction of "Boys Behind Barbed Wire" in a 1997 issue of the *San Francisco Chronicle*.

In the newspaper, "Boys Behind Barbed Wire" illustrated a brief article entitled "Manzanar—Bittersweet Tourist Park" (see figure 29).[41] The title of

Manzanar — Bittersweet Tourist Park

World War II-era internment camp opens to public

By Michael Fleeman
Associated Press

Independence, Inyo County

Equipped with water, apples and a cellular phone — if he can find one — Richard Stewart started work yesterday as the lone tour guide in a lonely place: Manzanar.

The first-ever daily tours of the World War II internment camp for Japanese Americans are seen as a modest sign of progress in the long, thorny campaign to build a full-service national park out of a desolate site commemorating an era many Americans would rather forget.

"It's something," said Sue Kunitomi Embrey, 73, who was interned at the camp at age 18 and now lives in Los Angeles. "At least somebody will be there and do something so people won't come there and find nothing there, except an empty lot and rusted cans."

This marks the first summer the National Park Service has complete control of the 800-acre Manzanar National Historic Site, where 10,000 people of Japanese ancestry were put behind barbed wire by a nervous nation after the bombing of Pearl Harbor.

But in an indication of the U.S. government's limited role in devel-

oping the site, the tours by Stewart, an elementary school art teacher in Bishop, are being funded by a $3,500 grant from the Eastern California Museum here, with no money from the Park Service.

Stewart, 53, a local Paiute Indian who developed an interest of Japanese culture while studying Japanese pottery, will lead visitors on one-hour, 45-minute walking tours that explore the long history of the site.

His tour includes a look at the time Indians lived there through the settlement of white farmers who displaced the Indians; the water wars with Los Angeles that dis-

placed the farmers; and the internment of the Japanese Americans there from 1942 to 1945.

Manzanar is located about 220 miles north of Los Angeles in the shadow of Mount Whitney on the rugged eastern slope of the Sierra Nevada. The camp site is just off Highway 395 halfway between Independence, the Inyo County seat, and Lone Pine. A dirt driveway leads from the highway to the camp, and the site is identified only by small historical markers.

"This is an aspect of American history that a lot of people aren't aware of," said Stewart. "What we're doing is trying to present

people with maybe visual clue[s] what it was like here."

It is a history, many say, has made the government slo[w] get involved in Manzanar. camp was one of 10 that held 1[0,]000 people, about two-thirds them American citizens. Manza[nar] was designated to represent al[l] the camps because it was the [best] preserved.

The total Park Service staf[f] Manzanar remains at its curr[ent] level of one: Superintendent [Ross] Hopkins, an outspoken advoc[ate] for the site, who works out of [an] office in Independence.

"I think it's pretty pathetic you want my honest opinion," s[aid] Hopkins, who keeps an unlis[ted] number because of the threat[s] ing calls he still receives. "But tours are a real tribute to the E[ast]ern California Museum. Priv[ate] citizens are taking their own ti[me] and energy to do something t[hat] really the federal governm[ent] should be doing."

Although a small group of lo[cal] residents, chiefly World War veterans, continue to object to American — the fate of Manza[nar] is shaped more by budget c[on]straints at the Park Service, s[ays] Hopkins.

The Park Service formally t[ook] title of the site on April 26, the [day] of the internees' annual pilgr[image] age, from its previous owner, city of Los Angeles, which [ac]quired the land in the 1920s for water rights.

BY ASSOCIATED PRESS

A historical photo shows unidentified children during World War II at the Manzanar internment camp, which has opened up for tours

Figure 29. "A historical photo shows unidentified children during World War II at the Manzanar internment camp, which has opened up for tours." This photo caption accompanied Michael Fleeman's article, "Manzanar—Bittersweet Tourist Park," in the *San Francisco Chronicle* July 29, 1997 (p. A18). The newspaper mistakenly listed the Associated Press as the source for this alternate version of Toyo Miyatake's "Boys Behind Barbed Wire."

the article connotes destinations such as Disneyland, but these boys, unlike tourists, were not free to leave their "tourist park" environs. The newspaper's caption for the photograph reads, "A historical photo shows unidentified children during World War II at the Manzanar internment camp, which has opened up for tours." The newspaper then mistakenly gives the byline as "Associated Press."[42]

In an interview, the photographer's son, Archie Miyatake, expressed anger regarding the misattribution, which effectively erased his father's connection to this image.[43] This error brings to the foreground a greater tension between photographs and the narration of history that often appears in popular media. Despite academic scholarship that analyzes documentary photographs in a critical manner, such images are often deployed by newspapers and displayed in museums as transparent windows to another time. It is as if the photographs possess a one-to-one correspondence with their subjects, and are rarely considered to be historical subjects themselves. The repercussions of this error are many. Most importantly, it hides the very possibility of a Japanese American photographic practice during incarceration by disassociating the photograph from the particularities of its making, thus encouraging viewers to make improper assumptions about the photographer.

The newspaper's misattribution also obscures the differences between Miyatake's work and incarceration photography sponsored by the government or produced by outside documentarians. Ansel Adams' *Born Free and Equal,* for example, hinges on the reader identifying with the position of the author and not with those pictured. The text and images made clear that they were produced for a public in which Japanese Americans were excluded. Adams's photographs sought to demonstrate to this audience that Japanese Americans could be productive and hard working—people who needed to be reintegrated into America's wartime economy. Adams's authority, his ability to convince his audience that his photographs portrayed Japanese Americans accurately, rested primarily on his whiteness.

In contrast to the approach of Miyatake, the work of Adams participates in the genre of documentary photography, which frequently derives its power from a purported divorce between the photographer and the people portrayed. One of the most common assumptions made about documentary photographs is that the photographer is not a member of the pictured group. This assumption sets up a hierarchy between photographer and subject—between those with the power to represent and those resigned to subjectification.[44]

How much do viewers rely on the implied contrast between subject and photographer for meaning?[45] Photographs reproduced in the news media

often identify subjects as victims incapable of self-representation. Photographers are represented as outsiders who are uninvolved in the subject's victim status and act as impartial, or even heroic, observers.[46] The photographer's authority as an objective observer derives from his or her distance and difference (racial, ethnic, class, gender, social, cultural, national) from the subject.[47]

A closer look at this assumption of objectivity uncovers some of the more elusive forms of racism that still appear in so-called objective sources, such as newspapers. In the case of the *San Francisco Chronicle,* the photo editor seems to have assumed that a photograph of Asian boys during World War II—an ethnic and racialized subject—necessarily implied a white photographer. Perhaps the editor made this assumption knowing of the camera's contraband status, but given the misidentification and the lack of specific information in the caption, including the names of the subjects photographed, that more generous reading seems unlikely. The newspaper's misattribution effectively consigns "Boys Behind Barbed Wire" to the genre of ethnographic documentary photography—a blunder that implies that the boys in the image, and Japanese Americans more generally, were passive victims. It also suggests that the photographer was necessarily an outsider, an anonymous AP photographer unimplicated in the lives he or she portrayed.

The fact that Miyatake was a member of the group he photographed, however, complicates this hierarchical relationship between photographer and subject. The distance between self and other collapses as his own subjecthood is represented in each image he made. Miyatake's insider status does not necessarily mean that his photographs authentically portray incarceration.[48] However, his status as a prisoner shifts the typical relationship between photographer and subject, creating the possibility for a more dialogic process of image making. Furthermore, although his images have increasingly been shown in mainstream museums, it is important to recall that his photographs were originally produced for the community in which they were made. In contrast to the Manzanar images produced by Ansel Adams, Miyatake was not trying to prove a case to the general American public. Rather, he was providing a community with photographs that told the stories of their daily lives, ranging from banal to joyous to heart-rending. He worked as a professional photographer representing this world, picturing Manzanar self-consciously, making images meant to be seen as products of his skill, intellect, and artistry rather than as a body of evidence for disinterested observers.

Unlike his commissioned work of portraits and special events, "Boys Behind Barbed Wire" was a subject chosen by the photographer—not an image

of daily life but an allegory of the incarceration experience—signifying at once confinement, despair, and hope. That more than one version of this image exists (in the alternate version, reproduced in the *San Francisco Chronicle,* only the boy on the right holds onto the fence) reinforces its constructed nature, which makes it all the more difficult to view the photograph as a transparent document of the past. Miyatake was posing his subjects (in effect, his models) very consciously in an effort to achieve a composition that forcefully communicated the injustice of imprisonment. He achieved this by positioning his lens sympathetically, at their level, and by maximizing the discrepancy between the boys' diminutive stature and the oppressive height of the guard tower, which he visually connected to the position of the boys through the recessional lines of the barbed wire.

A key aspect of the photograph is the position of Miyatake's camera, which stands on the opposite side of the fence from the boys. This suggests that either the photographer or the boys were actually standing outside the camp. According to Miyatake's son, Archie, however, the boys were positioned on the outside of the fence while his father had set up his camera on a tripod inside the camp.[49] Miyatake may have posed children outside the fence in "Boys Behind Barbed Wire," not only because they connote innocence, but also because standing at the perimeter of the camp may have been less dangerous for youths than for grown men.[50]

Thus the boys are not looking wistfully out into the vast desert, but in toward the camp—their facial expressions are produced purposefully for the photographer rather than spontaneous expressions of sorrow or expectation. That the Miyatake photograph is highly staged, however, does not detract from its efficacy as a symbol of the gross injustice of incarceration or its importance as a historical document. On the contrary, an understanding of the photograph's production helps the viewer to see Japanese Americans as something more than objects of pathos and points to strategies they developed to represent themselves.

Abigail Solomon-Godeau has argued that documentary photographs commit a "double act of subjugation," in that they re-trap the subject in the social world that produced their victim status.[51] But when control of the image resides in the hands of a member of the group represented, as is the case of "Boys Behind Barbed Wire," photography offers an alternative to the status of victim, if only figuratively. Miyatake's "Boys Behind Barbed Wire" suggests the possibility of escape or transcendence at the same time that it highlights their incarceration. The placement of the lens coupled with the self-possessed gazes of the young boys creates a visual trajectory that leads the viewer to the boys and then from the boys' gazes out past the fence and frame and—as a viewer

unfamiliar with the actual circumstances of the taking of the photograph—beyond the boundaries of their physical confinement. Miyatake's photograph highlights persecution at the same time that it allows the boys a complexity that marks them as more than objects of pity. It creates an alternate space in which the Japanese American consciousness is characterized by despair and emasculation as well as defiance, determination, and hope.

As "Boys Behind Barbed Wire" exemplifies, a photograph can serve as the terrain on which multiple identities, memories, and histories compete. In the framework that the newspaper provided, the photograph could not serve as historical evidence because it failed to acknowledge Miyatake's role in the image's production. In this instance, history became a shallow version of the past and the documentary photograph was the unwitting accessory.

Once recuperated from the genre of supposedly disinterested documentary photography, "Boys Behind Barbed Wire" suggests how photography, when taken up by the oppressed, can be used to assert identities, resist stereotypes, and commemorate events in ways that oppose or are in tension with the policies of the powerful. The framing devices used by the newspaper to present "Boys Behind Barbed Wire" rewrote the image's history. The article did not present the caption and byline as contemporary interpretative frameworks but as objective facts generated by the image itself. Such mistakes present obstacles for viewers who hope to think about this photograph in a critical, discursive fashion. It also obscures a question that this image begs: how was it possible for a prisoner in a wartime concentration camp to make a photograph that criticized the government? When "Boys Behind Barbed Wire" is recovered as a work made from within the camp, a different photographer emerges, as well as a different photograph and a different set of subjects.

Our World and the Valediction

In addition to "Boys Behind Barbed Wire," Toyo Miyatake created many other lesser-known, more conventional images. The vast majority of his photographs fall into more predictable categories of representation, including portraiture, event commemoration, and high school yearbook illustration.[52] Miyatake and his staff were responsible for producing the photographs for two consecutive Manzanar High School yearbooks—*Our World* and the *Valediction*. The pictorial representation in these yearbooks along with the student writing provide a revealing look at the tensions involved in the production of a published project of self-representation.

Flipping through the pages of *Our World,* one is struck by how familiar it looks—the conventions of yearbook prose, layout, and photography have

changed little over the decades. As figure 30 depicts, seniors were given individual portraits while the younger classes pose in groups. Thespians, athletes, service club members, and class officers were all featured with pictures and text describing their accomplishments. At first glance the yearbook appears exactly like any other yearbook produced in those years.

But the normality of the yearbook, with its high school enthusiasm leaping off of the pages, raises important questions. Why, during such a time of upheaval, with an uncertain future in a country that had disregarded their rights as citizens, did the students of Manzanar High School represent themselves as a normal American high school? What were the stakes involved in such an act? What does the yearbook tell us about how Japanese Americans used photographs to their own ends? Upon closer inspection, the text and images reveal a dislocated normality in which photographs simultaneously deny and call attention to the gap between the lives of other teenaged Americans and the reality of the Japanese American existence behind barbed wire. It is precisely this construction of normality that poignantly betrays how high the price would have been for public displays of despair.

Our World opens with a photograph looking down on groups of students, books clutched in their arms, as they walk in small cliques on their way to and from the barrack classrooms. Although the Sierra Nevada mountains in the distance are still snowcapped, the students walk about in skirts and light-colored pants. Yet a conspicuous row of barracks and their repetition in the background troubles the high school idyll. The contradictions facing a student of Manzanar High School were great. Promise mingled with sacrifice, intellectual growth with physical confinement. The yearbook's foreword calls attention to the difficulties inherent in any attempt to make sense of this situation: "The new friends one made and the new work experiences one enjoyed stand out sharply against the realization that such a thing as evacuation could actually take place."[53]

The main text of the yearbook reveals the apparent normality of the photographs to be fraught with contradictions. A close reading reveals that the semblance of conventionality in the yearbook represented what was in fact a hard-fought if at times tenuous victory over the dislocation and destruction of incarceration. The book's first section profiles the camp and school administrators and teachers. Director Merritt offers a message of strained optimism written from Washington, D.C., where he was working on relocation plans with the WRA. He concludes his letter with the exclamation "NEVER WAS YOUR FUTURE SO BRIGHT AS NOW!" The student-written text following the director's letter, however, makes it clear that the present community

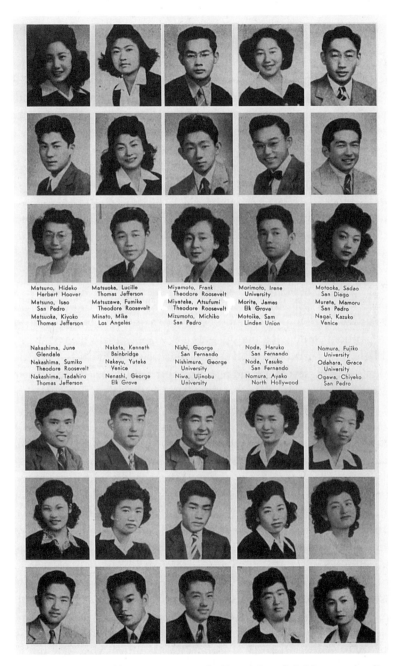

Matsuno, Hideko
Herbert Hoover
Matsuno, Isao
San Pedro
Matsuoka, Kiyoko
Thomas Jefferson

Matsuoka, Lucille
Thomas Jefferson
Matsuzawa, Fumiko
Theodore Roosevelt
Minato, Mike
Los Angeles

Miyamoto, Frank
Theodore Roosevelt
Miyatake, Atsufumi
Theodore Roosevelt
Mizumoto, Michiko
San Pedro

Morimoto, Irene
University
Morita, James
Elk Grove
Motoike, Sam
Linden Union

Motooka, Sadao
San Diego
Murata, Mamoru
San Pedro
Nagai, Kazuko
Venice

Nakashima, June
Glendale
Nakashima, Sumiko
Theodore Roosevelt
Nakashima, Tadahiro
Thomas Jefferson

Nakata, Kenneth
Bainbridge
Nakayu, Yutaka
Venice
Nenashi, George
Elk Grove

Nishi, George
San Fernando
Nishimura, George
University
Niwa, Ujinobu
University

Noda, Haruko
San Fernando
Noda, Yasuko
San Fernando
Nomura, Ayako
North Hollywood

Nomura, Fujiko
University
Odahara, Grace
University
Ogawa, Chiyeko
San Pedro

Figure 30. *Our World* senior portraits, by Toyo Miyatake's Manzanar studio, 1943–44. Toyo Miyatake Collection.

owed its bright prospects not to the administrators pictured on the pages but to the work of the people imprisoned.

In contrast to Merritt's patronizing benediction, Japanese Americans emerge in the yearbook as bruised but self-possessed and, above all, self-sufficient.[54] As the students wrote, "It [the camp] is a composite of a hundred other cities, yet like no other one in the world. Manzanar is the expression of self sacrificing and determined people. It shows the marked influence of two generations in a program devoted to furthering the betterment of community." The paragraphs continue to point out that the goal of Manzanar was to become "self-sustaining" and that all of the institutions and services found in other cities—such as a newspaper, a hospital, libraries, theaters, and schools—are found in their community. What is stressed under the heading "Administrators" is not the abilities and accomplishments of the three white administrators who are pictured but the cooperative administration of Japanese Americans to forge their own "self-sustaining" community.

Next to photographs of the high school administrators, under the title "Friends," the text describes the year's events and recalls the squalid conditions under which the high school began: "With no chairs, books, or customary classroom equipment, the students carried on." Again the text does not highlight the careers of the white authorities pictured but instead credits the students with perseverance and resourcefulness. Nor does the text dwell on how inadequate the high school facilities were. In fact, Manzanar High School was substandard in almost every way.[55] According to an official report to the director dated May 31, 1945, the principal, Rollin C. Fox, wrote that it had been difficult to hold teachers (who often did not have California credentials) because salaries and housing were inferior to schools on the outside.[56] As for the facilities, Fox reported that "things are very inconvenient. . . . Our heating problems have at times been most perplexing, our windows have been loose and rattling, our floors have been cold, our lighting has been poor."[57]

The school principal evaluated the student body as follows: "In social adjustment our students are in need of continued significant help. . . . Industry has been good but spotty, initiative generally weak, classroom participation poor. The students who went to Tule Lake are not unlike, in the areas tested, those who remained here." Fox levels his critique without acknowledging the psychological trauma to which each student at Manzanar would have been subjected. He evaluates their performance as if everything were normal, with plenty of books, weather-safe classrooms, and students who were not forcibly confined. He mentions the segregation of students to Tule Lake but does not reflect upon how their removal might have affected the students under

his authority. His pessimistic tone does not seem to correspond to the faces and voices of the students presented in *Our World,* who continually adopt the theme of determination in the face of extreme adversity and instability.

The yearbook authors refer to the removal of segregees to Tule Lake in several places. In the first section they mention that the students were "saddened" by the departure of classmates to Tule Lake but continued planning events for the spring. In the section on "Boys' Sports," the writer laments that the intramural baseball league could not complete its season due to "weather and segregation." The impact of their classmates' departure was felt in terms of friends and teammates lost; the question of loyalty went unbroached. The only mention of loyalty occurs in the context of interclass sports competition: "As in any school there was heated rivalry among the classes. During assemblies and rallies much loyalty was demonstrated by the classes. Inter-class games in sports were played, and it was here that loyalties were seen to be the strongest. But when school activities needed support, the whole student body came out to make them successful."[58] It would be hard to imagine that the authors could have used the word "loyalty" without reflecting upon its usage in wartime rhetoric or how their own loyalty as Americans had been challenged.

As is often the case in yearbooks, upper-level students received more attention than did the younger students. Each senior was allowed an individual portrait, and was identified both by name and by the high school attended prior to evacuation. The addition of this detail served as a reminder of their lives before the executive order and of the continued existence of those schools purged of their Japanese American students.[59] Toyo Miyatake's son was a senior in 1944. Archie Miyatake was photographed in his coat and tie, his shoulders cocked to the side and his head facing forward. The caption lists his given name as "Atsufumi Miyatake" and his previous high school as "Theodore Roosevelt" (see figure 30).

Archie Miyatake's father was also pictured within the yearbook's pages. The yearbook staff thanked him and reproduced two photographs of him in the process of making pictures. The students of the journalism class—responsible for both the yearbook and the school paper, "the Campus Pepper"—thanked Toyo Miyatake "for his excellent pictures of the classes, organizations, and the campus. Every student at one time faced the shutter of his camera, smiled and prayed that the picture would turn out good." On the page facing this expression of gratitude are four photographs: three of the young journalists and a fourth of Miyatake standing next to a view camera set on a tripod. He is not in a studio but outside by a barrack, a car, and a sign reading "school

zone," indicating that he was in the environs of the high school. He stands with his weight shifted to the right, one hand on his head as he thinks about the shot he is setting up. A photograph, which was probably made at the same time, is reproduced later in the yearbook in a collage of photographs of school life. The school zone sign is visible from behind, and Miyatake crouches under his black cloth framing a view beyond the edge of this image. Miyatake is thanked again on the second-to-last page of the yearbook in a caption that reads, "To our photographer Toyo Miyatake and his staff, Hisao Kimura, Timothy Saito, George Shiba and Satsumi Igarashi, we can only say that without their untiring efforts this book would not have been possible." Although he was not named in Manzanar's official report, Miyatake is given substantial credit within the pages of the yearbook. He is depicted as a photographer operating without the close supervision of administrators, composing and taking pictures on his own. The warmth with which Miyatake is acknowledged within the yearbook underscores the intimacy of his collaboration with the students.

The yearbook was a space that the high school students used to reflect on the serious issues they faced, albeit guardedly. The conventions of yearbook representation disguised critique at the same time that the extraordinary circumstances of their production make the students' efforts to create some semblance of normality seem almost heroic. Perhaps one of the most poignant entries in the yearbook is in the "Girls' Sports" section. The editors described the beginning of the baseball season as follows: "The girls became very enthusiastic about the game. With limited equipment and without a baseball diamond girls enjoyed playing with a make believe diamond." As in "Boys Behind Barbed Wire," incarcerated youths had to rely largely upon their imaginations to carve out a space within which they could operate as self-determining human beings.

In addition to the inclusion of photographic formulae, the teenaged editors of the yearbook inserted more concrete, critical commentary on incarceration. The editors thanked those who contributed to *Our World* and pointed the readers to the last page of the book with these words: "As you turn to the last page in this book, we hope that you will do so with a satisfied feeling. For it is very important to us that you will find in this story an accurate picture of the school and community life that you are living." Figure 31 illustrates the last page of the yearbook, a photograph of a guard tower and barbed wire fence—a subject that outside photographers such as Ansel Adams were forbidden from picturing. That the yearbook closes with a symbol of incarceration serves both to remind the viewer of the circumstances of coercion

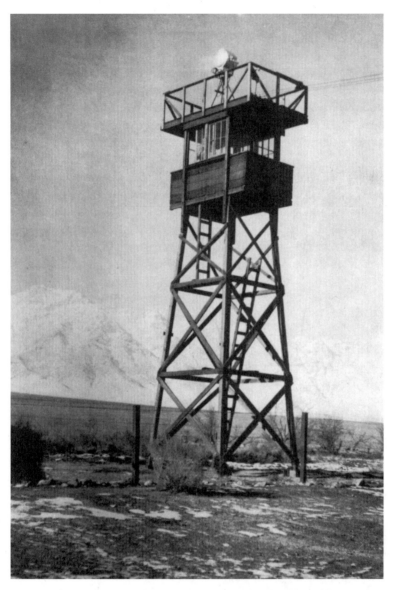

Figure 31. *Our World* image of guard tower and fence, by Toyo Miyatake's Manzanar studio, 1943–44. Toyo Miyatake Collection.

under which this high school existed and to temper what is by its nature an effusively optimistic genre of publication.

One of the opening images of the 1944–45 yearbook, the *Valediction*, is even more sharply critical. It shows a hand poised with a pair of pliers ready to cut through the confining barbed wire. According to Archie Miyatake, Toyo Miyatake gave him the pliers to hold up to the fence as his father took the picture.[60] Next to that image is a photograph of a young couple with packed suitcases walking out of Manzanar. These two seniors make more than the traditional departure from high school—they leave their lives as prisoners for the world outside.[61] The images and text depict an idealized representation of freedom in which the end of incarceration is not portrayed as the result of a government decree but as a provocative, and potentially transgressive, act of self-liberation.

As one of the yearbook staff members explained later, the editors purposefully used Miyatake's photographs to both support and contradict the

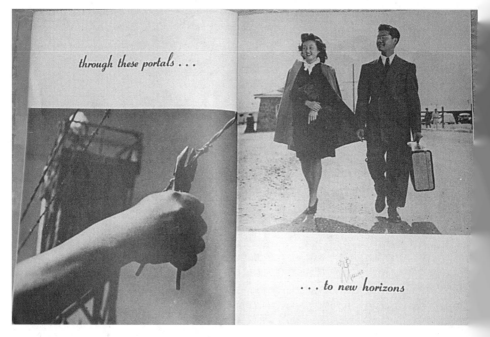

Figure 32. *Valediction* opening images, "through these portals . . . to new horizons," by Toyo Miyatake's Manzanar studio, 1944–45. Toyo Miyatake collection. (Photograph by Jasmine Alinder.)

idea that theirs was a normal community.[62] At a time when the capability of Japanese Americans to be loyal Americans had been denied, photographs of weddings and school portraits served not only as intimate, private registers of personal rites of passage, but also as politically charged assertions of their Americanness.[63] As one former prisoner recalled of his incarcerated adolescence, "We were looked upon as untrustworthy, disloyal, sneaky, etc., and perhaps most of all, not really as someone with an identity—only a number."[64] Miyatake's photographs emphasized the individuality of Japanese Americans at a time when racist discourse was obsessively rendering people of Japanese descent as an indistinguishable, homogenous mass. Creating a representational space that asserted normality was a political act.

Toyo Miyatake's photographs enabled Japanese Americans to present a vi-

Figure 33. Toyo Miyatake photograph, "A soldier tells his parents good-bye before leaving for the front." Toyo Miyatake Collection.

sion of themselves that was not predicated on their incarceration, and also to structure what would become their memories of wartime imprisonment. At family gatherings, a yearbook or wedding photographs could be shared with grandchildren, and the subject of the photograph could exert some control over how his or her image would be read, offering the appropriate degree of explanation about a painful topic. As one of the yearbook editors recalled, "The pictures Toyo Miyatake took of us, the camp activities, the life and daily routine recorded in photographs brings back all those years in sharp focus. *Our World* really was a photographic chronicle of life in Manzanar"[65]

Representation is a fundamental concept in American visions of citizenship. It is intimately connected to public narratives that express the core values of democracy, as in "taxation without representation." Although the term used in that sense refers specifically to elected representation in government, by the mid-twentieth century photography had become one of the more important ways in which Americans represented themselves to themselves and others. If voting is a means for citizens to voice their political will, by the late nineteenth century photography had become a way to visually articulate citizenship, used to assert one's unsuitability or fitness as a member of the nation. In other words, taking away the right to photographic representation was tied to the deprivation of other citizenship rights, even if there is not a specific right to photograph in the Constitution.[66] Miyatake's photographic practice at Manzanar constituted both an assertion and a recuperation of that right in the face of an onslaught against the constitutionally guaranteed rights of Japanese Americans. One Miyatake photograph (see figure 33) shows parents and a son, whose uniform reveals that he is on leave from the U.S. military, as they sit in their Manzanar barrack and look at photographs. The family activity of passing photographs back and forth realizes the possibility created by Miyatake's Manzanar photography, that of the victory of personal memory and self-representation over the depersonalizing, dehumanizing experience of incarceration.

4

Art/History

Photographs of Japanese American Incarceration in the Museum

Rather than authorities, we at the Museum
are catalysts. We seek to join you and ask you
to join us in the ongoing process of coming to grips with
the incarceration, learning more about its many issues and
nuances, and applying its lessons for now and the future.

—Karen L. Ishizuka, curator of America's Concentration
Camps: Remembering the Japanese American
Experience, Japanese American National Museum,
November 1994–October 1995

In the decades since Executive Order 9066, museum exhibitions have been the primary sites for the public display of images of Japanese American incarceration. This chapter considers how photographs made by the three photographers discussed in the previous chapters—Dorothea Lange, Ansel Adams, and Toyo Miyatake—have been displayed in two major museums: the Museum of Modern Art (MoMA) in New York City and the National Museum of American History in Washington, D.C.[1] Photographs were used in these two highly constructed spaces to produce new versions of incarceration history. Within the context of these exhibitions, the images were used to assert, project, and at times erase racial identities, and also to delimit what constitutes history and what constitutes art.

Photographs of Japanese American Incarceration in the Museum of Modern Art

During the 1940s, the Museum of Modern Art in New York became a theater of war, both literally and figuratively. Curators and museum administrators

fought over two issues. First, they disagreed over how photographs should be displayed. Second, they argued over what should be the proper role of the museum during wartime. These two conflicts converged in the controversy surrounding the planning of MoMA's 1944 exhibition of Japanese American incarceration photographs titled Manzanar: Photographs by Ansel Adams of Loyal Japanese-American Relocation Center.

As discussed in chapter 2, Ansel Adams first traveled to the Manzanar concentration camp in 1943 to document "loyal" Japanese Americans on the eve of their relocation from Manzanar to begin new lives in the country's interior. In addition to the publication of Born Free and Equal: The Story of Loyal Japanese-Americans, Adams twice exhibited prints from the project at Manzanar for those imprisoned. Adams then exhibited selected photographs from Born Free and Equal at MoMA during the winter of 1944. The process leading to their installation in the museum proved to be a difficult one, fraught with threats of cancellation and accusations of racism.

The museum exhibition was part of Adams's attempt at a three-pronged media circulation of his Manzanar photographs. The other two dimensions included the book and newspaper articles. Over a very productive three month period, from November 1943 through January 1944, Adams wrote a rough draft of the text for the book, contacted newspaper editors about publishing an article based on his photographs, and sent a telegram to a curator at MoMA offering the prints for exhibition. Adams thought that a newspaper article would enable a shortened version of his story to reach a broader public while he worked to realize the book and exhibition.[2] His requests for a newspaper story, however, were met uniformly with rejections.[3] The idea of the museum exhibition received a warmer welcome, although Adams soon encountered his share of obstacles there as well.

THE PHOTOGRAPHY DEPARTMENT

When the idea to exhibit the Manzanar images first struck him, Adams's impulse was to contact Nancy Newhall, his friend and acting curator of photography at MoMA. In a telegram from January 19, 1944, he excitedly suggested the exhibition: "Would you be interested in exhibit of photographs of loyal Japanese Americans at Manzanar Relocation Center? Striking set of about 50 pictures of environment and people Subject very hot out here. Must stress people are loyal American citizens of Japanese descent. It is a question of fair dealing with racial problems. No truck with Axis sympathizers. Keep confidential until confirmed through WRA. Greetings, AA."[4] Nancy Newhall had replaced her husband, Beaumont Newhall, as curator

of photography at MoMA after he enlisted in the Army Air Forces in 1942.[5] A Harvard-trained art historian, Beaumont Newhall had started at MoMA in 1935 as the librarian. Two years later, Alfred Barr, the museum's director, offered him the opportunity to curate a major exhibition devoted exclusively to photography. That exhibition became Newhall's well-known look at the first hundred years of photography and spawned his publication on the history of photography, which has been reprinted and revised several times and is still used today as a textbook.[6] Adams had been friends with the Newhalls since their first meeting in 1939. Subsequently, he and the Newhalls cooperated in the formation of an official Department of Photography at MoMA. They accomplished this task at the end of 1940 with the financial backing of David McAlpin, who offered valuable support as a Rockefeller relation, amateur photographer, and collector of photography.[7]

As chairman of the advisory committee to the new Department of Photography, McAlpin brought in Adams to serve as his vice-chairman and Beaumont Newhall was appointed curator. With the department's first publication, a slim pamphlet, they established their goals and defined their exhibition philosophy: "The Department of Photography will function as a focal center where the esthetic problems of photography can be evaluated, where the artist who has chosen the camera as his medium can find guidance by example and encouragement and where the vast amateur public can study both the classics and the most recent and significant developments of photography."[8] Sensing the need to establish aesthetic standards for a medium that was being deluged by the mediocre efforts of camera club members and other amateurs, the department established itself as a place where high standards would be set and the practice of photography as art could be studied.[9]

Adams and Newhall's first exhibition—Sixty Photographs: A Survey of Camera Esthetics—was a testament to their idea of photographic quality. They displayed images meant to demonstrate the "possibilities of photographic vision," including different technical processes and different representational genres. According to Newhall, "Each of the prints is an individual expression, but all of them are common in their clear evidence of their understanding of the qualities, limitations and possibilities of photography."[10] Adams and Newhall hung the photographs in much the same way as paintings were displayed in the museum—as works of art individually framed with adequate separation between prints. They gave attention to the quality of the print and the exhibition highlighted the creative expression of the artist.[11] Newhall and Adams were forging a history of photography on the museum's walls that included explanations of camera technology and photographic pro-

cesses. Their first priority, however, was to establish the aesthetic boundaries of photography as an art form. This attitude towards curatorial practice was in keeping with Alfred Barr's own strategies of display for paintings.[12]

THE ART OF WAR

In 1942, two short years into the life of the Department of Photography, the wartime exhibitions of Edward Steichen challenged the display style that Adams and Newhall had established. After the United States entered World War II, MoMA began to organize exhibitions that were meant to have relevance to a nation at war.[13] The museum called in Edward Steichen, then a lieutenant commander in the United States Naval Reserve, as a guest curator. Soon thereafter, the curatorial practices for photographs that Adams and Newhall had established in their fledgling photography department gave way to Steichen's vision of photography as the ideal vehicle to communicate epic narratives to a mass audience.[14] The MoMA administrators invited Steichen to mount a large exhibition about the war titled Road to Victory. Steichen combined forces with his brother-in-law, poet Carl Sandburg, who wrote the exhibition's text, and together they created a popular propaganda piece meant to evoke patriotism in the viewer. According to the press release, the exhibition was "a dramatic presentation of this country's mighty resources and the power of its people in their struggle towards victory."[15]

Taking over the second floor of the museum, photographs from agencies of the U.S. government and popular magazines were enlarged to mural size and juxtaposed with Sandburg's iconic words. Although Sandburg's text made the exhibition's message very clear to the viewer, the real power of the display lay in the photographs. Steichen selected the photographs while Herbert Bayer, a graduate and former master instructor of the Bauhaus in Germany, constructed the exhibition's layout. He had previously designed one exhibition in MoMA, the 1938 show on the history of the Bauhaus. The Bauhaus exhibition had received mixed reviews, and some critics complained that the layout was confusing.[16] Bayer's exhibition design for Steichen continued to utilize Bauhaus principles, but, in contrast to his earlier MoMA exhibition, the design was used to strengthen its propagandistic message rather than question the authority behind the presentation of museum display.[17]

From El Lissitzky's Leipzig and Cologne exhibitions in the late 1920s, Bayer borrowed concerns with scale, innovative materials, the interaction of the viewer with the display, and "fluidity of design."[18] He conceived of viewers as embodied eyes and used this notion of physical vision to dictate his design. Viewers traveled through the exhibition by following a specific path that was marked on the floor, by the position of the hanging panels,

and a ramp. Photographs were displayed in multiple sizes, were rarely flat against the wall, and never framed. Images jutted out at angles, were hung in midair by thin wires, and were juxtaposed in such a way that they created new contexts, often completely unrelated to those of their original making. As Christopher Phillips writes, Bayer's technique combined with Steichen's image selection "broke new ground by combining a complicated sequence of enormous photomurals with a careful consideration of the way in which mobile spectators would encounter the material."[19]

Only one photograph in Road to Victory contained identifiably Japanese faces. Taken from a photograph printed in *Life* magazine, the exhibition reproduced the image of Japanese Ambassador Nomura and Peace Envoy Jurusu sitting in over-stuffed chairs and laughing. This image was paired with a photograph of the attack on Pearl Harbor and preceded an image of a man who looks back at the photographs of the sneak attack and the two diplomats (see figure 34). Marked by his location outdoors, his tussled hair,

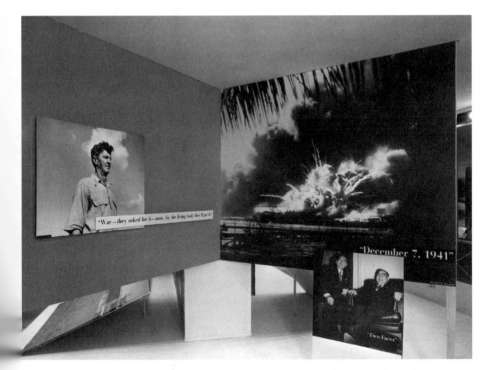

Figure 34. Pearl Harbor section of Road to Victory, 1942. The Museum of Modern Art, New York, N.Y. Digital image © The Museum of Modern Art/licensed by SCALA/Art Resource/NY.

and rolled-up shirtsleeves, the man in the photograph appears to be a farm worker. Picturing the man from below, the portrait monumentalizes him, and the Sandburg text served as a caption for his thoughts: "War—they asked for it—now, by the living God, they'll get it."

The positioning of these three photographs, made by different photographers under very different circumstances, illustrates Bayer and Steichen's methodology of display. Steichen and Bayer used photographs as potent graphic material that could be easily detached from their original social and rhetorical functions and reinserted into a narrative constructed by the designer. Photographs, in a sense, were their amnesic dupes—they could be made to project meaning without retaining the residue of their previous contexts. Dorothea Lange, for example, made the photograph of the man when she was working for the Farm Security Administration. The original caption for the photograph was "Industrialized agriculture. From Texas farmer to migratory worker in California. Kern County. November, 1938."[20] The photograph was a part of her "American Exodus" series of images that chronicled the movement of displaced Dust Bowl farmers to the West. It was made well before the bombing of Pearl Harbor and certainly had nothing whatsoever to do with sneak attacks or anti-Japanese sentiment. However, placed in this new context, it functioned iconically in the exhibition as the image of the hard-working, white American male standing up to challenge Japanese aggression.

When Adams and Newhall launched their photography department with the goal of "intimate" exhibitions of "pictures that are personal expressions of their maker's emotions," Road to Victory was hardly what they had in mind. Their exhibition agenda relied on established models of the display of other fine arts, which emphasized authorial intention. Thinking of attributes such as focus and depth of field, Newhall wrote that the new department intended to display photographs that "have made use of the inherent characteristics of the medium."[21] Edward Steichen, however, had a very different definition of photography's inherent characteristics. Referring to the photographs of the FSA, Steichen said, "Pictures themselves are very rarely propaganda. It is the use of pictures that makes them propaganda. These prints are obviously charged with human dynamite and the dynamite must be set off to become propaganda; they are not propaganda—not yet."[22] The "human dynamite" described by Steichen was emotional content derived from the manipulation of the image by the curator and had nothing to do with the photographer's intention or purpose. For Steichen, the inherent characteristic of the photograph was that its meaning could be determined by whatever context

it was given. Although Steichen himself was a well-known photographer, his exhibition technique made the photographer irrelevant in the construction of the photograph's meaning within the exhibition. This represented a direct contradiction to the approach of Ansel Adams, a photographer who had worked tirelessly to promote his photography as an expression of his particular artistic sensibility. Although Steichen did not include any of his own photographs in Road to Victory, ultimately he assigned himself the role of the artist, using photographs as elements in a grand scale montage of his creation.

Although the use of photography in Road to Victory had a popular precursor in magazines such as *Life,* the handlers of publicity for the exhibition took into account that this manner of presentation was not conventional by art museum standards in the United States. From the press release for Road to Victory: "Although approximately 150 photographs have been used as the basic material, the exhibition is not one of photography in the ordinary sense. Huge, freestanding enlargements, many of them life size or over, are juxtaposed dramatically with one another or with the murals . . . affixed to the walls."[23] The new mode of display proved very popular with viewers and critics.[24] Reviews were typically glowing, with one critic calling the exhibition "a genuine contribution to the American war effort."[25] Following Road to Victory, Steichen was asked to mount similar exhibitions in MoMA, including Airways to Peace (1943) and Power in the Pacific (1945).[26]

ROAD TO MANZANAR

Neither Adams nor Newhall respected Steichen's approach to the exhibition of photography. In a letter written during the run of the show, Newhall communicated his disgust to Adams, criticizing Road to Victory for being too popular and for not having anything to do with photography, "like a Stowkowski orchestration of a Bach fugue: very spectacular, very tuneful, very popular but it ain't Bach and it ain't good taste."[27] He went on to say that the exhibition was "stinking of Hype." Adams similarly complained about Road to Victory in a letter to Alfred Stieglitz: "I am however personally fed up with the self-conscious Sandburg Americanism; . . . I don't like Rockwell's posters, Hollywood war movies, Roads to Victory, Free Verse in Praise of Sacrifice, etc. . . . I have talked to a lot of men who have been in the middle of it—the fighting—and what they say rings true—not what the professional 'social chanter' constructs. . . ."[28]

The exhibition of Adams's *Born Free and Equal* photographs was to be a response to the populism of Steichen—Adams's attempt at conveying a war-

time message that did not sacrifice the individual expression of the artist nor
the sanctity of the work of art. Adams's motive for the exhibition, however,
was not only to counter Steichen. Adams had a grander intention, which
was to contribute to the cause of racial justice. He hoped that the museum
would serve as a launching pad for the exhibition to travel to other cities.
One of the original precepts of the MoMA photography department was to
make exhibitions "available to camera clubs, schools, colleges, and museums
outside the city."[29] In a letter to Adams, Harold Ickes, then secretary of the
interior and author of the introduction to *Born Free and Equal,* suggested
arranging a showing in Washington, D.C., and later added several cities to
this list, including Denver, Detroit, Chicago, and Philadelphia.[30]

The first exhibition of Adams's Manzanar photographs commenced the
summer of 1944 within the confines of the concentration camp. Manzanar
director Ralph Merritt wrote Adams that the second exhibition was to open
on July 24th, and within a few days of the opening Adams returned to Man-
zanar.[31] Two installation proof prints, archived in the Adams Papers at UCLA,
depict one of the small exhibitions within the confines of a barrack. A hand
calligraphied sign introduced the exhibition as "Photographs of Manzanar
by Ansel Adams First Series made for a proposed picture book." A notice
pasted to the board offered the prints for sale to those incarcerated, charg-
ing two dollars for an 8" × 10" mounted print and fifteen cents for a contact
print. In the exhibition space, some photographs were mounted on board
tacked up on the wall and others were laid flat on a table under glass. The
prints were nicely mounted, but were neither spotted nor signed. The mount
boards contained the label "Ansel Adams Display Proof" along with the im-
age's title.

The two Manzanar exhibitions were expressly for Japanese Americans
themselves and the display strategy makes this apparent. For the Manzanar
exhibitions, photographs were given simple titles that often identified those
in the photograph by their proper names. In contrast, the captions in the
book focused not on individual identities but rather abstract ideas such as
"Americanism is a matter of the mind and heart." The photographs were
not arranged and captioned in such a way as to tell the story of the camp to
outsiders. Instead, they plainly identified subjects so that friends and family
could view themselves, and even purchase their photograph if they wished
and if they had the money. Within the camp, Adams's photographs functioned
as a kind of album, logging the faces and activities of Manzanar Nisei.

Although it was important to Adams to exhibit the work in Manzanar,
the photographs were made primarily to change the minds of prejudiced

outsiders. The realization of this plan at MoMA seemed well on its way by June 1944 when Nancy Newhall received a museum memo warning of the postponement and possible cancellation of the Manzanar show due to concerns about budget and an overall museum policy of exhibition reduction.[32] The brewing conflict over the exhibition came to a head in August, although Adams was not directly involved. An argument erupted between Ralph Merritt and Elodie Courter, director of the Department of Circulating Exhibitions at MoMA. Courter had understood that Merritt was a possible funding source for the traveling of Born Free and Equal and wrote to him explaining why the museum was considering canceling the exhibition. Her reasons included the admission that the museum was wary of exhibitions that focused on racial minorities. Merritt took this excuse to be thinly veiled racism and responded forcefully: "Your point . . . which is the fear of unfavorable reaction by Museums and the public toward the racial minority question is, I judge, the actual basis for the shift of position of the Museum. That such a possibility exists in America that might dominate the conclusions reached by the Museum of Modern Art will cause many of us to pause and consider the purpose for which we fight a war against Hitlerism which is dedicated to the belief of a superior race."[33] Merritt forwarded a copy of the letter to Adams, who quickly replied, "My Dear Ralph, Your letter to the Courter lady was a masterful job."[34]

The response from Courter addressing Merritt's accusations insisted that financial concerns and the decrease in the overall number of exhibitions were the chief reasons for the exclusion of the Born Free and Equal exhibition: "[T]he cancellation of the Manzanar show had nothing whatsoever to do with the racial question and I regret exceedingly that I apparently misled you by telling you of our experiences circulating the show on the negroes. . . . [S]ince the importance of the show is that it reach people within the cities where the problem of discrimination is greatest it seems to me you would be more certain of reaching these communities than we, offering the show as an art exhibition to the art museums."[35] Certainly, wartime financial problems burdened cultural institutions and often resulted in the streamlining of programs at MoMA and other museums, making the exclusion of the Manzanar exhibition plausible on those grounds. Courter's letter to Merritt, however, mischaracterized the nature of the objections to the exhibition. The exhibitions committee's reconsideration had nothing to do with the notion that the photographs lacked status as art but rather with a more general uneasiness about devoting an exhibition solely to pictures of a single minority. As David McAlpin wrote to Adams, the exhibitions committee thought that

the museum should deal with the issue of racial intolerance, but not in such a specific manner as Adams proposed. McAlpin wrote, "Mrs. David Levy commented that the whole question of racial tolerance was a very broad one, pertaining not solely to the Japanese but also to the Negro etc. and that such an exhibition should be considered in that light."[36]

As someone who was very invested in the significance of the specific event of Japanese American wartime incarceration, Adams may have been frustrated to read McAlpin's letter. It was not, however, news to him. Two months earlier, Nancy Newhall had written to Adams that the director of exhibitions and publications, Monroe Wheeler, had also preferred that Adams's show dealt with the concept of racial intolerance in general.[37] Although Adams did consider initiating future projects on racial prejudice against other minority groups, he held firm to his conviction that the Born Free and Equal exhibition was a coherent, whole statement: "I would not want the Manzanar series reduced, or mixed with other photographs. Its impact depends upon the subject, the unity of the approach, etc. . . ."[38]

Courter's letter also did not acknowledge that non-art, propaganda exhibitions such as Road to Victory had been extremely successful. MoMA, the art museum, had for the last two years been in the business of exhibiting images of the war. According to scholar Russell Lynes, "[MoMA] was a minor war industry," entering into thirty-eight contracts with government and war related offices, including the Office of War Information, which totaled $1,590,234.[39] A Central Press wire service article titled "The latest and strangest recruit in Uncle Sam's defense line-up is—the museum!" quoted the president of the museum's board as describing the "museum as a weapon in the national defense" which could "strengthen the hearts and wills of free men in the defense of their won freedom."[40] When it came to the potentially controversial Manzanar images by Adams, however, the museum hid behind the cloak of art.

After the exchange between Merritt and Courter, Adams angrily considered abandoning the museum project. He sent a telegram to Nancy Newhall expressing his displeasure: ". . . Museum's timidity on racial angle is inexcusable. Can you clarify? I feel no further interest in Museum on my part justified. But much love and sympathy for you as always."[41] It was probably the friendship between Adams and Newhall that salvaged the showing of his Manzanar photographs. Just two months earlier she had joined Adams for a trip to California that included a short visit to Manzanar. Newhall wrote to a museum staff member that "today we're seeing everything about this

incredible place. Ansel hit the mood of it right on the head."[42] The trip had strengthened her resolve to see the exhibition through its MoMA showing.

In September, Newhall went to work to try to secure an exhibition space in the museum. Now that Courter had been offended by Merritt's accusations, however, sending the show on the road seemed less likely than ever. Newhall discussed matters with Monroe Wheeler. She suggested the title Born Free and Equal: Appeal for Justice for the exhibition and thought that the third floor would be appropriate for a show to run from November through January. Each one of Newhall's suggestions was amended. The title was changed first to Manzanar: The Loyal Japanese Americans, Photographs and Text by Ansel Adams, and finalized to Manzanar: Photographs by Ansel Adams of Loyal Japanese-American Relocation Center. Ultimately, the show would last for eight weeks, not twelve, and instead of the regular third-floor exhibition space for photography, the show was banished to the basement auditorium. Furthermore, Adams was asked to radically change the content of his text, despite the fact that he was using precisely the same words the WRA had approved for publication.[43]

In the fall of 1944, Nancy Newhall broke the news to Adams about the changes in the show's title and location. The publication Born Free and Equal opened powerfully by quoting the 14th amendment of the United States Constitution and the 1855 letter written by Abraham Lincoln to Joshua Speed. Adams closed Born Free and Equal as he opened it, with a pair of quotations— one from Dillon Myer, and the final text from Walt Whitman: "To thee old cause! Thou peerless, passionate, good cause, thou stern, remorseless, sweet idea, deathless throughout the ages, races, lands, after a strange sad war, great war for thee. . . ."[44] These words functioned to bring attention to the hypocrisy embedded in the government project of incarcerating citizens based on their ancestry. The degree of irony that the placement of these quotes conveyed was apparently too politically controversial for the museum, however, and Adams was asked to remove them from the exhibition. Adams complied, noting his distress to Newhall.[45]

With the terms of the exhibition finally agreed to, Newhall typed the labels and released a statement to the press. The display was billed as a documentary exhibition of sixty-one photographs that showed "the life and activities at a relocation center." The release emphasized the loyalty of those pictured and included Newhall's assessment of the significance of Adams's work in regard to the social role of the photographer and the relationship between the documentary image and its caption: "With the coming of peace, photographers will

undoubtedly play an increasingly significant role interpreting the problems of races and nation to one another all over the postwar world. In such visual communication, the integration of photographs and text is of importance. In this exhibition, photographs and text [were] conceived and executed as a whole by the photographer and attain thereby a high emotional quality. Avoiding the formulae that have developed in documentary and reportage photography, Ansel Adams has approached his subject with freshness and spontaneity."[46] Newhall's evaluation was also included in an amended form in the introduction to the exhibition. Although it certainly was not a direct attack, Newhall's praise for Adams's approach by implication condemned Steichen's exhibitions, which were all based on formulaic documentary and reportage photographs without any regard for the individuality of the photographer. A fraction of the size and much less popular, Adams's exhibition was in many other ways the antithesis of Road to Victory. Most importantly, instead of depicting the United States as the uncomplicated moral and physical victor, Manzanar forced viewers to confront a portion of the citizenry who because of ancestry had endured extreme prejudice and made large sacrifices.

Figure 35 depicts the layout of the exhibition, which followed the same kind of narrative strategy as the book. Photographs were grouped, usually in threes, and mounted on dark panels that hung against the white museum wall.[47] The title panel of the exhibition contained the same photograph of the Japanese American man staring off into the mountainous landscape that appears on the title page of Born Free and Equal. The next panel set the scene with three landscapes, and the third set began to introduce the people incarcerated in Manzanar: school girls, men standing outside the Office of Reports, and a close-up portrait of Roy Takeno, the editor of the Manzanar Free Press. As in the book, Adams stressed individual people, the family, professionals at work, Nisei in the military, agricultural productivity, religion, and recreation. The text for the exhibition was based on the captions used in the book, and the labels retained the use of ellipses to give the viewer a sense of seriality as they moved from one image to the next. Compared with the narrative force of the photographs and text in Road to Victory, however, Manzanar must have seemed woefully static and conservative. The exhibition ended as did the book—with the tight, close-up portrait of the uncompromising face of Yuichi Hirata.[48] With the Whitman quote excised, however, the exhibition closed without the irony of the book and instead ended with the words of President Roosevelt: "Americanism is a matter of the mind and heart."

Manzanar: Photographs by Ansel Adams of Loyal Japanese-American Relocation Center opened without much fanfare or controversy. Adams himself

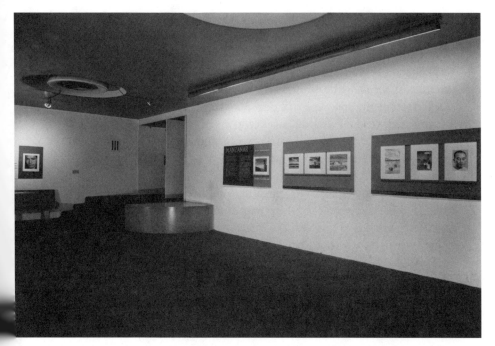

Figure 35. Installation of Ansel Adams's exhibition Manzanar: Photographs by Ansel Adams of Loyal Japanese-American Relocation Center, 1944. The Museum of Modern Art, New York, N.Y. Digital image © The Museum of Modern Art/licensed by SCALA/ Art Resource/NY.

did not make it back to New York to see the exhibition, but he received a glowing account from David McAlpin: "The show is stunning. I was enormously pleased. There was a big crowd and they seemed very much interested. I wish I could pass along the comments. Most of them were John Q. Public and not photographers. They all seemed pleased and surprised. Most of them started looking at the pictures without reading the introduction. About one of every three would look at about ten and then go back and read the text. The rest wandered on wondering what it was all about but liking it. Personally I thought the show told a simple direct and convincing story and the net result was a big impact."[49] Despite the enthusiasm voiced by McAlpin and others, Adams complained to Beaumont Newhall that the museum failed to advertise the exhibition.[50]

The biggest blow to the Manzanar project came later the same week. In Adams's reply to McAlpin, Adams acknowledged his belief that the Man-

zanar exhibit was his best work to date.[51] Yet Adams goes on in the letter to describe his continuing frustrations and disappointments with the course of the project. Adams had just met and lunched with a "WRA man" who informed him that, after speaking with Nancy Newhall in New York about circulating the show, he was told that the museum publicity office "killed the idea." Despite the complete withdrawal of travel support from the museum, Adams and Newhall continued to try to locate sponsorship. However, with the exception of the $200 donated by McAlpin and the support of Harold Ickes, they were unsuccessful. Adams replied to Beaumont Newhall's praise for *Born Free and Equal* by thanking him and then voicing his disappointment that the book was not more readily available, and that the museum was unable to have any copies of the publication for the run of the exhibition.[52]

After two years of work on the Manzanar project and with the war over, Adams turned away from social documentary and the Museum of Modern Art back to the images of the land for which he is best known. Edward Steichen was asked to become the director of MoMA's Department of Photography in 1947 and continued in that role until 1962. Beaumont Newhall, who had wanted the directorship himself, refused to work under Steichen and left the museum for the George Eastman House, becoming its director in 1958.[53] Steichen's montage technique for the exhibition of photography culminated in the 1950s with the world-famous exhibition The Family of Man, in which the photograph was again represented as an available, duplicable, authorless image.[54]

AMERICAN PHOTOGRAPHY

Since Adams's Manzanar exhibition, photographs of Japanese American incarceration have only occasionally made it back onto MoMA's walls. In the late 1990s, curator Peter Galassi mounted a large exhibition entitled American Photography 1890–1965, which included a photograph by Dorothea Lange of the forced removal of Japanese Americans from the Bay Area in 1942 (see figure 11 in chapter 1). This exhibition traveled through Europe and then settled on MoMA's walls in 1997. Featuring photographs by Walker Evans, Edward Weston, Paul Strand, and Edward Steichen, as well as Lange, the exhibition attested to the strength of the department's collection of modern American masters of photography, but it also revealed how MoMA's curatorial strategies served to obscure the history that Lange's photograph meant to document.

In contrast to Steichen's curatorial style, which the museum abandoned after his departure, curators hung the 170–photograph show in a traditional,

fine art configuration—along a straight line that was occasionally broken by double hangings, with ample space between each image. The exhibition grouped images in a roughly chronological and thematic fashion. American Photography included a total of six photographs by Dorothea Lange: four from the 1930s, including the hallmark photograph "Migrant Mother" (see figure 5 in chapter 1), and one image each from the two following decades. Instead of being grouped together, the Lange photographs appeared with other images of similar theme and chronology.

Alongside these documentary photographs, the American Photography exhibition also included better-known masterworks of modern photography such as Edward Weston's formal study, "Pepper #30."[55] The overall effect of the exhibition was to homogenize these photographs by extracting them from anything resembling a historical context and subjecting each of them to the same presentational treatment. Displayed in this manner, photographs appeared as exotic, visually striking products of artistic sensibilities. As Carol Duncan argues in *Civilizing Rituals: Inside Public Art Museums,* the philosophy of twentieth-century art museums was rooted in old notions of the primacy of aesthetic experience.[56] Everything about the exhibition—the elegant framing, the blank walls, the clean lines, the captions that emphasized the artist and how the piece was collected—was meant to connote art, which in this exhibition suppressed the crucial social circumstances behind the making of each photograph.[57]

Lange's photograph of the man boarding the bus was grouped with other photographs from the same decade. The surrounding images included a U.S. Army Signal Corps photograph titled "Russian Slave Laborer Points out Former Nazi who Brutally Beat Prisoners," Gjon Mili's "Cafe Society, New York" from 1943–47, and Gordon Parks's "Harlem Gang Wars" taken in 1948. This set of 1940s documentary photographs pictured marginalized groups and placed the Lange image temporally, suggesting a link to World War II, as well as to the general concept of war. Yet in the absence of any information regarding the making of the photograph, the gestures of the hands coming at a tagged civilian cannot easily be decoded.

Instead of providing contextual information, the caption given by the museum served to further divorce the photograph from the circumstances of its making. The museum captioned the Lange photograph of the Japanese American man boarding the bus "Dorothea Lange 1895–1965, San Francisco, c. 1942. Gelatin silver print by James Welcher, 1965, purchase." The image's cursory label, with a geographic location for a title and an approximate date, failed to offer an explanation for the image's content. The label's date, "c. 1942,"

further de-emphasized historical access to the photograph—which Lange had dated to the very day of its making—by suggesting that precise knowledge about the image was either unknown or unimportant. The forced removal of Japanese Americans happened in 1942. There is no mystery about the date.[58] The Lange photograph labeled "San Francisco" by MoMA pictures the humiliating process of evacuation during which Japanese Americans were made to wear tags with numbers assigned by the U.S. government in place of names. Without the means to reconnect the Lange photograph to the circumstances of its making, the image's subject remained reduced to the number on his tag.

Mounted on the exhibition wall in MoMA, this photograph was trapped in an aesthetic discourse that obscured its original function in the wartime rhetoric of racism that Lange meant to question. In MoMA's de-racialized aesthetic arena, the viewer is neither encouraged to understand nor empathize with the photographic subject or question one's own relationship to what is pictured. Neither of these goals should necessarily be important to an art museum, but because the history of incarceration is a story that too often has gone untold, the ahistorical display of the Lange photograph in the American Photography exhibition serves as a reminder that Japanese American history remains outside of the purview of dominant cultural institutions. An exception to this absence was an exhibition at the National Museum of American History.

Photographs of Japanese American Incarceration in the National Museum of American History

On October 1, 1987, a decade before American Photography opened on MoMA's walls, a new exhibition, titled A More Perfect Union: Japanese Americans and the United States Constitution, opened on the third floor of the National Museum of American History in Washington, D.C. The exhibition commemorated the two hundredth anniversary of the Constitution, and did so in an unexpected fashion: through the history of Japanese Americans. Slated for a five-year run, the exhibition remained open for more than fifteen years and currently has an afterlife as an online exhibit.[59] Originally the exhibition was to have been a military history titled Citizen Soldier, a presentation of the history of the volunteer army since the revolutionary war. Museum officials decided, however, that Citizen Soldier would be too expensive and historically unwieldy. Furthermore, Congress, which controls exhibition funding, was pushing for exhibitions that would celebrate

the bicentennial of the Constitution. The idea of focusing on a problematic moment in constitutional history occurred to one of the museum's curators, who happened to travel to California in the early 1980s and was impressed by a Bay Area exhibition called Go For Broke.[60]

Go For Broke opened in the Bay Area's Presidio Army Museum in 1981. The title of the exhibition refers to the nickname of the 442nd Regimental Combat Team and 100th Infantry Battalion; the all–Japanese American combat units who saw heavy fighting and casualties in the European theater of World War II. *Go for Broke: A Pictorial History of the Japanese American 100th Infantry Battalion and the 442d Regimental Combat Team,* published one year after the exhibition, combines two hundred and forty photographs of the 100th/442nd with text describing the history of the formation of the units, their training, combat campaigns, and testimonials from the soldiers. The story of the Japanese American soldiers was a compelling subject for the National Museum of American History because it captured military history and the experiences of individuals. It could also be linked to an analysis of the Constitution because many soldiers volunteered from concentration camps where their friends and family remained with their citizenship rights abridged even as the soldiers risked their lives in battle.

According to curator Jennifer Locke, who was the first person hired in 1985 to begin work on Citizen Soldier, the exhibition team made decisions over time to expand the story of the 442nd chronologically to begin with the immigration of Japanese to the United States in the mid-nineteenth century.[61] A year and a half after Locke had initiated work, Tom Crouch began to head the project and the exhibition shifted again to include an overall historical treatment of Japanese Americans with a focus on World War II, using the Constitution as the exhibition's framing device. Although the exhibition retained a title that emphasized the Constitution and devoted a large section to the service of the 100th/442nd, a significant amount of space and some of the exhibition's most striking visual elements were devoted to the imprisonment of Japanese American civilians.

Both Locke and Crouch undertook research trips to California to look for artifacts that could be used as visual evidence to support their historical text. Although there were no institutional collections of such objects at that time, they received some donations from Japanese Americans who had been incarcerated, including old suitcases taken to concentration camps that still had the government family tag adhered to the leather. As objects were scarce, the curators turned to photographs to flesh out the visual quotient of the exhibition.

Traditionally, historical exhibitions had displays built around artifacts, but more recently there has been a shift away from artifact-oriented exhibitions to "idea" exhibitions in which photographs are generously used as evidence to back up a detailed account of events given in label text. Spencer Crew and James Sims, two historians at the Smithsonian, theorize that this shift has taken place as history museums have attempted exhibitions on under-represented subjects whose material culture has not been well preserved.[62] Entire history museums are now built with very limited collections of objects but with large reserves of photographic material that act as the visual component of text-heavy exhibitions. In addition to their content, the photographs divide the space, move viewers through an exhibition, and provide a respite from the lengthy text panels.[63]

Crouch hired a researcher to pull and photocopy every "internment" photograph that could be found in the National Archives. Crouch then worked much like Edward Steichen had, by plucking out the photographs that would correspond to his narrative. In addition to accumulating the visual elements of the exhibition, the curators had to construct the written text (the script). The curators were aware that their exhibition might appear compromised by the fact that their funding was coming from the same government that had legislated the incarceration. To combat the appearance of pro-government bias, they sent the script as it was developed to an advisory panel that included historian Roger Daniels and others. Curators ended up with a 360–page script, 500 images and objects, and five videos that they handed off in June 1987 to the exhibition designer, Dru Colbert.

Although the curators at the National Museum of American History were very careful to have the text approved by respected scholars of Japanese American history, they did not have the same concern for the histories of the photographs they deployed. This decision was strategic. According to Crouch, they did not want to include the histories of the photographs or information about the photographers who made them because that could detract from the narrative of the script.[64] With this reasoning, they chose neither to name any photographer responsible for making the images on which the exhibition relied nor to describe any of the circumstances behind the making of the images.

PHOTOGRAPHS AS THE SPACE OF THE PAST

Photographs by Dorothea Lange of the days leading up to the forced removal of Japanese Americans from the West Coast were particularly prominent in A More Perfect Union. In Crouch's opinion, Lange took every powerful

photograph in the exhibition.[65] Ascending the escalator from the second floor to the third, the viewer was confronted with the first image of the exhibition, Lange's photograph of young schoolgirls reciting the Pledge of Allegiance (see figure 8 in chapter 1). Although the image was of immense proportions (twice as large as life-size), it was obscured behind a glass wall that was overlaid with the script of the U.S. Constitution. Lit by a spotlight that faded in and out, this patriotically charged image and text connoted the pre-war loyalty of Japanese Americans.

The designer of the exhibition often used the same image repeatedly in different contexts. The pledge image, for example, was reproduced at the end of the exhibition in a section on postwar justice for Japanese Americans, along the bottom of the wall. The photograph was also used on the cover of the informational brochure that accompanied the traveling version of the exhibition. The title of the show was allowed to impinge upon the photograph, as does the brochure's fold. In fact, a curator at the Smithsonian received an angry call from a Bay Area museum curator claiming that this reproduction transgressed copyright laws by violating the sanctity of the image. Unlike current practices at the Museum of Modern Art, which exhibits photographs as discrete, auratic, collectible works of art, the National Museum of American History's exhibition strategies are more similar to those of Steichen, using photographs as plastic objects that can be reduced, enlarged, cropped, and reproduced to heighten the visual impact of the display. To borrow art historian John Tagg's words, photographs were displayed in the exhibition to "transform the flat rhetoric of evidence [in the written text] into the drama of experience [in the visual image]."[66]

The sense of the dramatic that the exhibition strived for in its display was heightened in its representation of a Lange photograph taken of a Bay Area store front (see figure 6 in chapter 1). The "I am an American" photograph was reproduced twice in the A More Perfect Union exhibition. At the beginning of the exhibition, it ran along the top of the wall as part of a montage of images that included text of constitutional amendments. Below the image of the grocery, at the viewer's eye level, was a photograph of a uniformed white man searching the pockets of an Asian American man in a suit, recalling the illegal searches and removals of Japanese Americans after the bombing of Pearl Harbor. In this context, the "I am an American" photograph reiterated the loyalty of Japanese Americans in a manner similar to the opening image of the schoolgirls—the gesture of the hand over the heart paralleled the placement of the sign in that both are overt, unmistakable symbols of loyalty. Together, the photographs of the storefront sign and the search set

up the Japanese American as the unjust victim of white aggression. With this context in mind, the viewer then moved to the display in the next hall that shifted back in time to the migration of Issei to Hawaii and California.

The next major section of the exhibition focused on the treatment of Japanese Americans during World War II. The "I am an American" image appeared again in the beginning of this section, which was devoted to the evacuation of Japanese Americans from the West Coast. As figure 36 reveals, the flat, two-dimensional surface of the photograph gave way to three-dimensional space. The viewer was no longer merely looking at pictures of the past but was walking down the sidewalk outside of Grocery Wanto, able to open the flap of the mail box, sit on the curb, or read the posted exclusion order, a reproduction of which had been glued around an electricity pole. The exhibition designer actually constructed a stage set of the Wanto store and sidewalk depicted in the Lange photograph. Photography here was not just used as the window onto history but as the actual, physical space of the past.[67]

The curators, however, used the Lange photograph as a source rather than as a literal script by replicating some of the essential elements of the image while omitting others. The "sold" sign, for example, was not reproduced. The whitening of the grocery's windows, however, implied a sense of absence, as if the business was vacated. The automobile in Lange's photograph was not a part of the stage set, but the historical time that the car evokes had already been established by the chronological progression of the exhibition itself. The corner of the street included in Lange's photograph was excised from the stage set; instead the designer created a stoop, door, and neon sign for the "Hotel Fuji." Placing the two Japanese American owned businesses side by side suggested to the viewer that this section of street was located in a Japanese American neighborhood or a "Little Tokyo." The exhibition designer actually combined two photographs for the stage set. Another photographer for the War Relocation Authority, Clem Albers, photographed the Fuji Hotel while documenting the evacuation in San Francisco.[68] Making the next-door business a hotel conjured further images of displacement and migration echoed by the whitened windows of the grocery.

The powerful juxtaposition in the Lange photographs of the American flag with the Japanese characters was left out. It is likely that the curators did not mine the photograph for that level of detail and the left edge of the Lange print was probably ignored. That section of the photograph, however, asserts a central theme that occurred throughout the exhibition—the comparison between the symbolic expression of national loyalty and personal identity.[69]

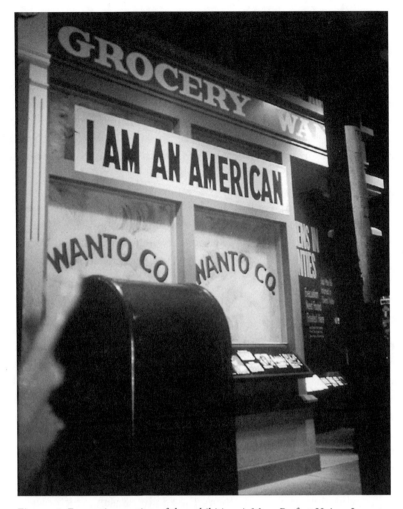

Figure 36. Evacuation section of the exhibition A More Perfect Union: Japanese Americans and the United States Constitution, featuring stage set based on Dorothea Lange photograph of Oakland storefront. Tom Crouch, curator, and Dru Colbert, designer. National Museum of American History, Washington, D.C. (Photograph by Jasmine Alinder.)

The exhibit made viewers an active part of the display, placing them seemingly in the subject position, encouraging the viewers to situate themselves in relation to the history of incarceration and the misrepresentation of Japanese Americans. The exhibition used photographs to construct a particular representation of history, but the display strategies for the photograph operated in

a way that obscured or denied the constructedness of that representation by creating the illusion of transporting the viewer to another time and place.

However, the stage set was not a literal replication of the photograph, which was itself a representation. Furthermore, the display immediately prior to the Grocery Wanto stage set included war propaganda posters with demeaning caricatures of Japanese faces. The display also reproduced an article from a popular 1940s magazine that told readers how to distinguish Japanese facial features from Chinese features. Instead of situating the viewer on the sidewalk outside of Grocery Wanto in California, the viewer was placed inside a representation of the past that was itself an interpretation of another representation.

Design elements such as the Grocery Wanto stage set made the viewer's identity relevant in the historical narrative of the exhibition. The ethnicity of those photographed, which was deemphasized in the American Photography exhibition at the Museum of Modern Art, was recognized in the National Museum of American History.

Art/History

Although the practice of photographic display at the National Museum of American History was contrary to current curatorial practices at MoMA, the display of the history museum recalled the Steichen and Bayer exhibitions of the 1940s and 1950s. Both used comparable modes of display, including breaking the plane of the wall, floating images, and differentiating image sizes to denaturalize the status of the photograph as a work of art and thereby erase the distance between the image and the viewer. By detaching the image from its maker and specific context, curators used photographs to back up the authority of the text. However, unlike the sweeping theme of MoMA exhibitions such as Steichen's The Family of Man, which sacrificed individual difference under the umbrella of one global family, the National Museum of American History was concerned with recovering the experiences of one particular group of people and articulating them to viewers whose own identities were elided by the exhibition's efforts to return them to a moment in the past when distinctions based on race led to the incarceration of Japanese Americans.

The strategies employed by the A More Perfect Union exhibition came with a price, however successful they may have been at making history relevant to the viewer. In the exhibition's introductory video, the image cut between

the narrator's authoritative face and documentary photographs. While the narrator discussed the constitutional context of the exhibition, noting that the framers did not believe that a perfect union was possible, a photograph of three Japanese American boys standing behind a barbed wire fence filled the screen. As discussed in the previous chapter, Toyo Miyatake made this photograph (see figure 28) while he was incarcerated in the Manzanar concentration camp. Like Lange and Adams, Miyatake remained unnamed in the National Museum of American History. His erasure from the version of history presented by this exhibition is particularly problematic, however. In contrast to the sculpture of Miyatake's camera outside the Japanese American National Museum, which celebrates Japanese American acts of self-representation, the National Museum of American History obscured the fact and significance of Japanese American photography, portraying "internees" instead as largely passive victims. Although A More Perfect Union succeeded in providing multiple subject positions for the viewer, it did not succeed in doing so for the Japanese Americans that the exhibition represented. By providing a historical context for the Toyo Miyatake photograph and other images it deployed, the exhibition could have made an even more powerful statement—one that might have complicated the objectifying nature of the documentary photograph and enriched its portrayal of incarceration by acknowledging how Japanese Americans used photographs to represent themselves. The Museum of Modern Art and the National Museum of American History offered a false choice between dehistoricized art and artless history. In the next chapter, I consider how two contemporary photographers have sought to complicate the dichotomy between art and history through their own images of the concentration camps.

5

Virtual Pilgrimage

The Contemporary Incarceration Photography of Patrick Nagatani and Masumi Hayashi

> How is one to talk to a woman, a mother who is
> also a stranger because the son does not know who
> or what she is? Tell me, Mother, who are you? What is it
> to be a Japanese? There must have been a time when you
> were a little girl. You never told me about those things.
> Tell me now so that I can begin to understand.
>
> —John Okada, *No-No Boy*, 1957

> The gulf I write against is not just my parents' silence,
> but the political and historical and cultural silence induced
> by the camps, a generational wound and amnesia buried
> in so many of the bodies and psyches
> of Japanese America. . . .
>
> —David Mura, *Where the Body Meets Memory:
> An Odyssey of Race, Sexuality and Identity*, 1996

In the quotation above, David Mura renders tangible the links that connect him to a historical event that he did not directly encounter. If Issei and Nisei experienced the trauma, deprivation, and humiliation of the wartime incarceration directly, Sansei bear a much different burden. Because of the reluctance of many older Japanese Americans to communicate their experiences of incarceration, many Sansei must piece together their own pasts from divergent sources. According to Elena Tajima Creef, the incarceration "continues to stand as the defining moment of the visual and psychic colonization of the Japanese American body that has yet to be fully resolved."[1] While Mura does connect the silenced history of the incarceration to an anxiety located in the body, some Sansei artists have tried to forge a connection with this past through other sites of memory.

Photographers Patrick Nagatani and Masumi Hayashi have explored the psychological and emotional connections between memory, cultural/ethnic identity, and place through landscape.[2] These two artists focused their lenses on the sites where the camps stood. Their images create bridges across generations and participate visually in a larger ongoing debate about the significance of an event that they did not know much about until they became adults. In addition to creating transgenerational links, these artists used the camera to open the gate of memory and reveal a world that had been obscured, forgotten, and repressed within their own families.

Memorial Ground

Despite their peripheral locations, the sites that housed the wartime concentration camps are at the center of significant debate on a range of political, social, and cultural issues, including questions of site preservation and site designation.[3] The transformation of Manzanar, for example, has been remarkable. The dry, desolate site marked by cracked concrete foundations and shards of pottery has been reinvented. Now an interpretive center rises from the parched earth, renovated from the old auditorium and run by the National Park Service. To its south a large parking lot can accommodate busloads of summertime travelers looking for a slice of history along the stretch of road between Death Valley and Los Angeles. The renovation was so new when I made my first visit during the summer of 2004 that the blinding sun reflected off of every newly installed and painted exterior surface. Inside, the visitors center supplied immediate relief from the brightness and heat, and the relative remoteness of the place was belied by newly installed amenities: air conditioning, uniformed park rangers, bathrooms, and a gift shop. But it is the extensive exhibition space devoted to telling the story of Japanese American incarceration that claims the site as newly sanctified, official historical ground.

Over the past four decades, the recollection of incarceration has taken many forms, including the fight to obtain an official government apology and receive redress payments,[4] and reunions of Japanese Americans, including annual pilgrimages to the sites themselves. Japanese Americans have been making pilgrimages back to Manzanar and other incarceration sites since the late 1960s.[5] Manzanar is visited annually by hundreds who make the journey not as tourists but as people whose identities are bound up with the cracked concrete foundations and ruined stone gardens wasting away in the arid desert climate. They return to what Pierre Nora characterizes as

a "lieu de mémoire," or a "site of memory"—a place where personal history and experience are made tangible by the "visible signs of what has been."[6]

A 1998 *New York Times* article on the development of Manzanar as a National Historic Site by the National Park Service discussed how the denial of the trauma that incarceration caused continues to affect perceptions of the incarceration experiences of Japanese Americans. The article quoted a retired banker from the nearby town of Bishop who had begun a letter-writing campaign against Manzanar's official status: "My objection is it's not being recognized truthfully. The Japanese were free to come and go—all it was was an assembly center. They were escorted there not to keep them under control, but just to protect them. It did have a loose barbed wire fence, but I saw them sneaking out all the time to go fishing."[7] It is striking that the man quoted continues to use the same rhetoric, such as the verb "sneaking," that demonized people of Japanese descent after the bombing of Pearl Harbor. The article then quoted Sue Kunitomi Embrey, who was herself incarcerated at Manzanar, and who clarified the impact that deniers of incarceration have on Japanese Americans: "Those kinds of comments . . . help explain why even now, many elderly survivors are deeply ashamed about their camp experiences and why it has taken so long to get the park up and running."[8]

Silences and Conversations

Because many Sansei could not turn to their parents for explanations about the incarceration, the sites on which the camps stood became all the more important in efforts to connect with and anchor that history. During the 1990s, Nagatani and Hayashi began to explore incarceration as it related to problems of transgenerational communication between Nisei and their Sansei children. Photographs by these two artists confront the political history of incarceration, the social and cultural history of Japanese American identity, and the art history of landscape photography. Nagatani came to the subject of incarceration through an effort to better understand his Nisei parents, who were both U.S. citizens by birth and both incarcerated during the war. Nagatani's journey took him back to his parents' formative years, to the period of their incarceration, which proved to be a watershed in their lives and also in the lives of Japanese Americans in general.

In 1995, Nagatani completed a portfolio of photographs titled *Japanese American Concentration Camp*. The photographs are large format color images, mostly landscapes made over the course of two years. They depict the remains of the ten central sites of the incarceration. Visually striking, the

images range in subject from grand landscape to small found object. The remains of concrete foundations and scattered nails left from the hastily erected wartime structures function in the images as poignant memorials to a government policy of institutionalized racism justified as wartime necessity. The title of the portfolio expresses Nagatani's endorsement of a historical and political position that does away with the government's predilection for euphemism.

Patrick Nagatani's mother and father were imprisoned in different camps. After the war, neither returned to their homes in California. Instead, they relocated to Chicago, where they met and married. Like many other Sansei, Nagatani recalls that his Nisei parents rarely spoke of "camp." But as the Sansei reached adulthood beginning in the 1960s, many began to challenge their parents' psychological need for silence with their own desire to discuss and debate incarceration within the family and Japanese American communities, as well as to confront the United States government for its past actions.[9]

Patrick was born in Chicago in 1945, less than two weeks after the Enola Gay's atomic bomb obliterated Hiroshima.[10] The family moved to Los Angeles from Chicago in 1955, and John and Diane Nagatani have lived in the same house since then. Patrick promised me that he would call his parents and, if they agreed, he would arrange our meeting. Then Patrick mumbled, almost as if he was joking, that his father would say that "camp was good." Patrick did arrange the meeting, and his parents graciously welcomed me into their home.[11] The Nagatanis brought up "camp" first, but the subject quickly shifted back to talk of family. Mr. Nagatani launched into a story that turned out to be a kind of explanation. He spoke about the increasing violence in their neighborhood. He described shootings at the nearby school where they had sent their children. Mr. Nagatani used this description of the neighborhood to explain why events in the present have led them to focus on the here-and-now rather than the past. Because of this emphasis on current events, they did not talk about their experiences of the war very often with their children—nor did they dwell on them now.

In their reluctance to speak openly about incarceration, the Nagatanis are similar to many other Nisei. The word "silence" has been used more than any other to describe the collective reluctance of Nisei to discuss their wartime experiences with their children and in public fora. According to research conducted by Donna K. Nagata, the psychological impetus for this unwillingness includes several factors: post-traumatic stress disorder; shame; denial; Japanese cultural values; past government proscriptions against Japanese Americans congregating in groups; and a lack of broader recognition of in-

carceration by the government, other Americans, institutions, and history text books.[12]

As Karen Ishizuka explains, Nisei often invoke the Japanese term "shikata-ganai," which implies "get over it" or "make the best of it," to explain why the majority of west coast Japanese Americans went peacefully into concentration camps. What may appear as compliance, however, can also be read as fortitude.[13] Either way, the word operates as a surrogate explanation because there is no easy way to make sense of what happened or describe the feelings of anger, shame, embarrassment, and guilt that are linked to the event. Lili Sasaki, who was incarcerated in Amache, offers her own explanation: "I don't think that you can actually tell people how awful it was at that time. . . . And how embarrassing. . . . We didn't know what to do. . . . The trouble was, we were all for Roosevelt. We voted for him. . . . We didn't want to, but we said, 'If that's what Roosevelt said, I'd be willing to go into camp.' . . . So what would you do? They had the gun and you had to go. We had no choice. . . ."[14]

The relative silence of many Nisei has been fueled in part by a more general reluctance or outright resistance among other Americans to acknowledge the history of incarceration. Although public attention to this period of history has increased, it is still possible to find documentary films, history books, and museum exhibitions on World War II that fail to mention the concentration camps in the United States. In even more extreme cases, one can still find people who deny the incarceration ever happened.[15]

A closer look at the experiences of Japanese Americans, however, reveals that silence was not the only response to wartime incarceration. Although many Nisei may have avoided speaking of their incarceration while they raised their children, some Issei and Nisei did make both visual and textual records of their camp experiences. In 1946, Miné Okubo, who worked before the war for the Federal Arts Project making mosaic murals for the army, published *Citizen 13660,* which features drawings that are often critical of the incarceration and a text that recounts her experiences in Tanforan and Topaz. In the 1950s, John Okada and Monica Sone both published novels on wartime incarceration.[16] Okada's fictionalized account of a young Nisei resistor, *No-No Boy,* was not widely read until it was republished in 1976. Sone's autobiography, *Nisei Daughter,* republished in 1979, enjoyed a substantial readership after its original publication in 1953 as an Atlantic Monthly press book published by Little, Brown and Company.[17] Jeanne Wakatsuki Houston's *Farewell to Manzanar* reached perhaps the largest public audience when the novel was made into a television film that aired in 1976. In 1972, four years before *Farewell to Manzanar* aired, NBC premiered a documentary film on

the incarceration titled *Guilty by Reason of Race*. In that same year, the California Historical Society presented the exhibiton Months of Waiting, which featured paintings and other art created by Japanese Americans inside the camps, and was intended to complement the photographic book and exhibit by Richard and Maisie Conrat, *Executive Order 9066*.

When the Nagatanis returned to the topic of camp, Patrick's father, John, said that he remembered it as "good," as Patrick had guessed he would. John's family had owned a farm near Fresno, California, in the town of Hanford. His father had never taken a day off in his life, but in camp he was given food and shelter and did not have to work. It was his first vacation, John said. "Yes," Diane interjected, "but it killed him." John gave a sad look—not of full agreement, but of concession. His father had died in camp. John continued his story, saying that his mother returned to Hanford after the war to the house that he had boarded up himself. Luckily, their neighbors had kept watch for them so their property was maintained, but she returned without her husband or her son, as John had left camp for Chicago.

Diane said that she was too young to suffer during the incarceration. She was out of high school, about 19 or 20, when the forced removal of Japanese Americans began. Her father had served in the Japanese army, so, the night after the attack on Pearl Harbor, the FBI came with flashlights and took him away without warning and without a warrant. The experience had scared her a great deal, especially because her father was a single parent. Because of her father's status as a Japanese veteran, the family was split up. He was sent to a Justice Department incarceration camp in Santa Fe, New Mexico, about an hour from where Patrick now lives, while she and her brother were sent to Manzanar.

In 1993, Diane Nagatani went to the annual Manzanar reunion, and has tried to talk John into going to a reunion at Jerome. John Nagatani is fairly dismissive about this topic. "I've never gone back to visit the place I used to work," he says, "why would I want to go back to camp?"

Mrs. Nagatani brought out the family photo album, and she leafed through the thick, plastic-covered pages until she came to the one picture she has of herself in Manzanar. The black-and-white image depicts her with a few dozen other girls in dark skirts and white blouses with hair in 1940s styles—puffy bangs and curls. Then she pointed to a small figure in the background—an armed guard. He would be easy to miss otherwise, as the smiles of the girls for the camera command visual attention. However, there he was, mistakenly a part of the picture and now unmistakably a part of her past. Below the old photograph she had placed a color snapshot of a much smaller group of some

of these same women at the 1993 reunion. These two photographs, separated by 50 years, interrupted the chronological flow of the album as a whole. On this page she allowed herself as a young woman to meet her older self.

There were several photographs in the family album from the camp in Jerome, Arkansas. John Nagatani's brother had joined the military, and the pictures were made during his visit to see his family back in camp. As cameras were contraband, many of the photographs made within the camps now in family albums were taken by Japanese American soldiers visiting their families. John Nagatani's brother probably brought the camera with him on furlough and took the photographs. There is a picture of John on the stairs of their barrack with his father. There is one of his brother with his wife, and his brother with their mother. There is an image of his father with white hair sitting on the barrack steps, one of the last photographs taken of him.

THE *JAPANESE AMERICAN CONCENTRATION CAMP* PORTFOLIO

The sites of the concentration camps, so carefully mapped by Frank and Joanne Iritani in *Ten Visits*, play fundamental roles in memorializing Japanese American incarceration and transmitting that event to generations of Japanese Americans who did not experience it themselves.[18] Concerted efforts have been made by imprisoned Japanese Americans and their descendents to erect monuments at all ten of the main camps. At many of the sites, however, behind the official monuments, the evidence of the wartime incarceration still remains. Those remnants—water tanks, root cellars, shards of china— also function as memorials, or in James Young's terms as informal "counter monuments."[19]

In the summer of 1993, Patrick Nagatani began making pictures in Jerome, where the U.S. government had imprisoned his father. On one of the last days in the typically humid month of August, Nagatani searched for evidence of his father's incarceration fifty years earlier. He found growing crops, train tracks, dirt roads, storage structures, and a sky ranging from pale blue to gray, but he found few visible signs of the concentration camp. The photographs that he made on August 28, 1993, represent a topographic account of contemporary Jerome seen by a probing, concerned eye, as well as a Sansei's search for tangible links to his parent's past—as if the land could serve as a surrogate for his father's own telling of his wartime experiences. In terms of the larger project, this first group of images marked the tentative beginning of what would become a comprehensive photographic survey of all ten camps.

The first photograph that Patrick made in Jerome (see figure 37), like several other photographs in the portfolio, encourages the viewer to consider

Figure 37. Patrick Nagatani photograph, "Jerome, Japanese American Concentration Camp, Arkansas, August 28, 1993/J-1-6-45." Black-and-white reproduction made from original color photograph. Courtesy of Patrick Nagatani.

how memorial monuments function within a site.[20] Just to the left of center sits a memorial marker titled "Jerome, Relocation Center." Its gray marble suggests the heroics that accompany history significant enough to be chiseled into solid rock. Framing the marker are utility poles; their wires follow the dirt road into the background and create a rhythm of parallel lines. In the right foreground an orange and black sign, the metaphorical marker of the picture, spells out "Warning." Nagatani included this sign placed by the telephone company within his frame to call the memorial marker into question and to encourage the viewer to read it with suspicion. As the counterpoint to the official marker, the warning sign offers the promise of a different version of history.

To read the official marker's text, which attributes incarceration to "wartime hysteria," the viewer must engage the photographic surface up close and squint so that the minute letters come into focus.[21] The text, general enough to be appropriate on a marker at any of the incarceration sites, clearly acknowledges the local civic bodies responsible for the placement of the marker (the Jerome Preservation Committee and the Japanese American Citizens

League), but it is much less clear in assigning responsibility for incarceration itself. In the marker's text, the army is described as constantly surveying those in the camps, robbing individuals of privacy. President Roosevelt is recorded as having signed Executive Order 9066, which legislated incarceration. Although the marker is highly critical of the executive order, it fails to note that the Japanese American Citizens League, one of the groups responsible for placing the marker, discouraged rebellion against the order during the war and vigorously encouraged its members to relocate peacefully to prove their loyalty.[22] This monument, oriented toward the entrance of the camp, marks the land in an official capacity. Though its text reflects an increasing consciousness that this was not a proud moment in United States history, it provides a very limited narrative of historical events.

The conscious contrast between the official marker and the warning sign in the Jerome photograph is particularly poignant in light of the last line of the marker's text, which encourages the reader to be "more alert in the safeguarding of the rights of all Americans." The marker's placement—on the perimeter of a private farm, off a minor road, in southeastern rural Arkansas—lends an ironic, impotent edge to this plea. The monument is one that a person would not be likely to come across by chance, and anyone who bothered to look for it would likely be aware already of the injustices committed there. Monuments that have been erected at incarceration sites typically state that their purpose is to "serve as a constant reminder of our past so that Americans in the future will never again be denied their Constitutional rights. . . ." as the memorial at Poston, Arizona proclaims. Nagatani's work comments on the monument's concealment from general view at the same time that he increases its visibility by photographically reproducing it.

This and other images in *Japanese American Concentration Camp* bring to the foreground the negotiations between monument and viewer, establishing the influence of the environment in the construction of memory and meaning as a central theme. These memorials establish a dialogue, if not directly with visitors (although that is their stated intention), then with the sites themselves. As James Young has pointed out in his analysis of Holocaust monuments, "memorials tend to concretize particular historical interpretations . . . a monument becomes a point of reference amid other parts of the landscape, one node among others in a topographical matrix that orients the rememberer and creates symbolic meaning in both the land and our recollections."[23] The clash between the monuments and the sites, between newly poured concrete pedestals and ruined concrete foundations, is evocative of the contrasting experiences and histories of incarceration. Nagatani

makes that dialogue explicit in his portfolio by serially arranging his images to juxtapose the monuments with the ruins.

After Jerome, in 1994 Nagatani journeyed to Manzanar, California, where his mother had been incarcerated. He first photographed the official markers before moving deeper into the environment in search of the remains of the camp. He scoured the ground, moving past newly erected memorials, recording the earth's efforts to swallow up what was left of the structures, so hastily erected and then disassembled, in search of a different kind of memorial marker. His fourth image from Manzanar (see figure 38) is particularly remarkable. The photograph leads the viewer away from the roadway up two steps built within a short stone retaining wall. These steps now lead to nowhere: they are the tangible remnants of incarceration now set against the sweeping landscape. A tree whose branches split into vein-like tributaries stands dead and dark against the blue band of mountains along the horizon.

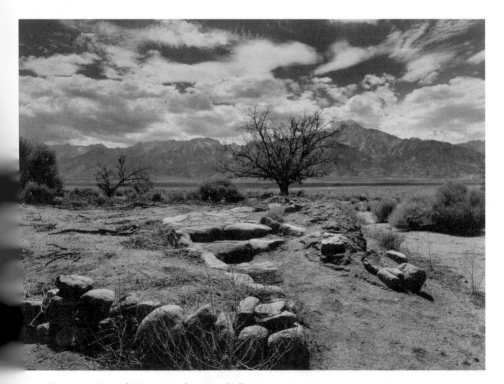

Figure 38. Patrick Nagatani photograph, "Manzanar, Japanese American Concentration Camp, California, August 13, 1994/MA-14-20-63" (steps). Black-and-white reproduction made from original color photograph. Courtesy of Patrick Nagatani.

A smaller tree to its left also appears in the next photograph, indicating that it was made near the previous image. The mountain range has shifted slightly to the right and the cloud formations have conjoined or separated, signaling a small temporal change. This image also focuses on an object stripped of its utility: round and hollow with a charred exterior, it appears at first to be a large tree trunk. The light that illuminates the object's core, however, reveals regularly placed red squares like the ends of bricks, not enough information to disclose its original function. In other photographs of Manzanar, Nagatani travels the camp in search of more structural remains: old storage containers, stone markers, and dry stone ponds. These all seem to be evidence of past habitation, durable relics of ephemeral structures, simultaneously foreign to and integrated with the natural landscape. The objects seem at once to grow out of the earth and to disintegrate into it.

The last photograph of Manzanar (see figure 39) moves the viewer away from the ruins back to memorialized ground. A tall, white obelisk inscribed with Japanese characters stands on the earth.[24] This marker is protected by

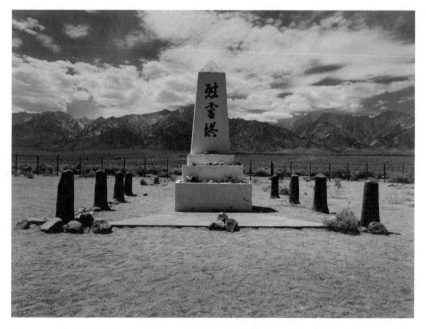

Figure 39. Patrick Nagatani photograph, "Manzanar, Japanese American Concentration Camp, California, August 13, 1994/MA-18-20-68" (Ireito monument). Black-and-white reproduction made from original color photograph. Courtesy of Patrick Nagatani.

rusting sentinels, pierced to accommodate a restraining rope that has disappeared. Behind it, a thin wire fence keeps visitors from penetrating the land any farther. This small fenced area on the north side of the site was the camp cemetery. A photograph from 1945 by Toyo Miyatake depicts a memorial service at this cemetery for those who died in the camp. In Miyatake's photograph, a long line of Japanese Americans, shading themselves with umbrellas, slowly make their approach to the memorial marker. Sitting stolidly in the back of the site, geographically opposed to the camp entrance, this obelisk has functioned as a memorial for more than sixty-five years, vividly communicating the loss experienced by Japanese Americans.

In his explorations of Manzanar, Nagatani has thus brought us in through the front and then taken us along the side and out the back. The photographic survey of Manzanar allows the viewer to participate in a phenomenological journey through the camp's environment.[25] The act of moving visually among the photograph's different elements, such as the stone steps, replicates the photographer's movements over the ground and his perceptual encounters with the artifacts of the sites. The images visually describe the relationship between place, object, and Nagatani's lens. Serially arranged in the portfolio, the photographs also read as a narrative accumulation of those perceptions, constructing the experiences of the photographer for the viewer.

Although they are not bird's eye views or schematic representations of the land, Nagatani's photographs function like pictorial maps in ways similar to those identified by Svetlana Alpers in her study of Dutch landscape paintings and maps. Alpers writes, "The map allowed one to see something that was otherwise invisible. . . . Like lenses, maps were referred to as glasses to bring objects before the eye. . . . The reach of mapping was extended along with the role of pictures, and time and again the distinctions between measuring, recording, and picturing were blurred."[26] Even though this is an observation about northern European visual culture well before the invention of photography, the overlapping of representational functions articulated by Alpers resonates with the character of Nagatani's images and his working method at the sites. In his artist's statement included with the portfolio, Nagatani writes, "My approach to this work allowed me to be part historian, archeologist, geologist, cartographer, photographer, and the Japanese American Sansei investigating what has long been a part of my cultural identity." For Nagatani, the act of picture making is the marshaling of technologies of knowledge for the camera, ranging from archival research to archeological surveys. Like maps, his photographs make histories, politics, and memories visible through the representation of topography. By bringing the remains of

the camps in front of the eye, Nagatani's images render the layers of buried past as visible as the concrete foundations he photographs.

Manzanar is probably the best-known Japanese American concentration camp for many reasons, including the stunning natural beauty of its location, frequent representation in photographs, proximity to Los Angeles, and status as an official National Historic Site. Dorothea Lange, Ansel Adams, and Toyo Miyatake are most responsible for Manzanar's photographic representation during the 1940s. As a professor of fine art photography, Nagatani is acutely aware of these photographic predecessors. While a graduate student in photography at UCLA, he collaborated on a book project that juxtaposed Ansel Adams's photographs of Manzanar with those made by Toyo Miyatake. In the book, *Two Views of Manzanar,* he celebrated both photographers' work.[27] This project expressed Nagatani's early interest in the photography of incarceration camps, but as a student he was not yet prepared to deal with the topic of incarceration as it directly related to his own artistic production.

In contrast to the time when Miyatake made "Boys Behind Barbed Wire," the fences that Nagatani encountered at Manzanar had mostly fallen down, their wires strewn on the dry ground, no longer able to confine anyone's movement but still able to stop the searching eye and remind the viewer that the posts once stood tall with barbed wires pulled taut. Nevertheless, Nagatani's work has important continuities with that of Miyatake. Both photographers searched the incarceration site for evidence of ruin—markers of the by-products of life in unjust, cramped conditions. Two of Miyatake's photographs, one of car wreckage abandoned in the desert and the other of a camp garbage pile, seem to be closest in spirit to Nagatani's color landscapes. Even while Manzanar was in full motion, Miyatake found evidence of decomposition. In one of Miyatake's images, the metal frames of cars that once belonged to Japanese Americans litter the foreground; the rusting metal is juxtaposed with the impressive expanse of snow-covered mountains in the background.[28] Even in his composition of a garbage pile, Miyatake does not forsake the majestic mountain range. The repetition of the cans and bottles piled one on top of another, some with torn labels allowing bare metal to reflect the bright sun, seems to foreshadow Nagatani's images of the camp's remains.

Two of Nagatani's images made in Topaz, Utah, illustrate one of his central thematic focuses—the decaying object in the desolate landscape. In both images Nagatani tilts his lens down toward the ground, denying the image its horizon but allowing for a close examination of the earth's surface. From its microscopic orientation, his lens discovers a rusting toy truck lodged in scrub

brush. Its wide fenders mimic trucks in style during the 1940s, suggesting that it has been left behind by an incarcerated child. Another photograph of the ground (see figure 40) reveals a scattering of old bent and brown nails resting on the cracked dirt. These nails presumably held the camp together, attaching board to board in the long barracks-style housing or fastening wire to post in the miles of fencing.

Indeed, these building materials made for very spartan, thinly walled living quarters. Descriptions of the camp at Topaz, near the town of Delta, reveal that the harsh desert winds ripped through the minimal structures provided by the War Relocation Authority. In *Jewel of the Desert: Japanese American Internment at Topaz,* Sandra Taylor describes the layout of the place: "The camp consisted of tarpaper barracks, twelve to a block; there were thirty-four blocks for housing and the remainder for administration. At its high point there were a total of 408 buildings at Topaz. The construction was

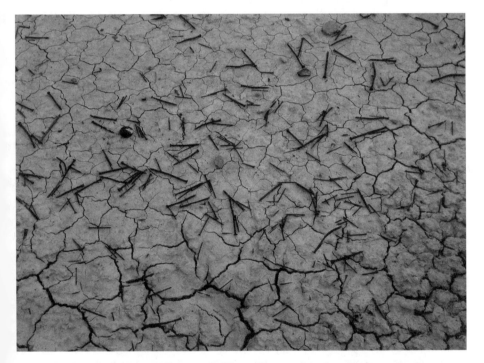

Figure 40. Patrick Nagatani photograph, "Topaz, Japanese American Concentration Camp, California, October 14, 1994/T-6-15-104" (scattered nails). Black-and-white reproduction made from original color photograph. Courtesy of Patrick Nagatani.

pine board sheeting covered with tarpaper. Even the Deltans noticed the shoddiness."[29] The tools of incarceration—the old fences and nails in Naga-tani's photographs—obviously do not retain the same kind of potency they once had. They are no longer threatening because they have lost their power to detain. Now they generate a different kind of power, predicated on the experiences of those incarcerated who imbue the otherwise ordinary objects with the memory of their historical function.

The compositions of Nagatani's *Japanese American Concentration Camp* photographs also have a contextual basis in the broader history of landscape photography. Any photographer who points his or her lens toward the land of the western United States automatically inherits a sizable tradition rang-ing from the nineteenth century forward, including Timothy H. O'Sullivan, Carleton Watkins, Eadweard Muybridge, Ansel Adams, Edward Weston, and many other great names that together read like the list of an exclusive men's club.[30] Their imagery has provided Americans with a conception of self that is defined by the grandiosity of the nation's environment.

Nagatani's work is informed by the tradition of heroic landscape pho-tography. In his artist's statement, he describes himself as an archeologist, surveying, exploring, and mapping territory much like the photographers of the early geologic surveys. T. H. O'Sullivan's "Sand Dunes, Carson Desert, Nevada" from 1867 offers an interesting comparison with one of Nagatani's photographs from Gila River. Both photographers subtly imprinted them-selves upon the land they photographed in order to implicate their presence in the image. O'Sullivan turned his darkroom/supply carriage so that it of-fered its silhouette to the camera. His footprints in the desert sand record his progress from the carriage to his vantage point as photographer. Nagatani arrived at the memorial of Gila River soon after its completion. Two promi-nent tire tracks leading to the photographer's vantage point indicate that Nagatani reversed his truck to take a fuller view of the monument. These traces call attention to the status of the photographer as one who journeys to a site and then actively frames it to produce its representation.

Historians of photography such as John Szarkowski have charted the prog-ress of landscape photography, linking the nineteenth-century explorers such as O'Sullivan to modernist photographers such as including Stieglitz, Adams, and Weston.[31] In *The Photographer and the American Landscape* from 1963 and *American Landscapes* from 1981, Szarkowski described the heroic mode pictured by these photographers as the essence of American landscape photography: "[T]he word [landscape] is used here . . . to denote a family of pictures concerned with two issues: the formal problems of picture making,

and the philosophical meaning of the natural site—those places where man's hegemony seems incomplete. . . . This idea [the modern idea of landscape] was that the natural site is not merely an ideal setting for beautiful and heroic acts, but that it is in itself a primary source of meaning, and an original pedagogue."[32] Nagatani's images complicate this romantic notion of landscape because they often use a heroic mode to picture what remains of unheroic acts, pointing to the evidence of hegemony in even the remotest places. The land in Nagatani's work, therefore, does not function as an "original pedagogue," to borrow Szarkowski's term. It is rather a surface imbued with layers of history and memory that interacts with the photographer and viewer to produce meaning.

Among the photographs that Nagatani makes implicit reference to is "Winter Sunrise, The Sierra Nevada, California 1943," made by Ansel Adams as part of his work at Manzanar, and a recognized masterwork of grand landscape photography (see figure 22 in chapter 2). The mountains in the distance recall the heroic tradition of nineteenth-century photography that culminates for many in Adams's dramatic depictions of western landscapes. Many viewers do not realize that this image was part of Adams's documentation of the environs of Manzanar and was a crucial component of his book *Born Free and Equal*. The political impetus behind the making of this landscape has vanished, however, in its numerous reproductions outside of *Born Free and Equal*. Because Adams's image has been praised for its beauty and formal arrangement, the photograph has become defined by the line of trees, shafts of light, repeating peaks, sky, and clouds, discounting the political implications of the forced removal of Japanese Americans to this remote site during World War II. Part of Nagatani's project is to recreate the link between Manzanar's striking landscape and the sinister purpose to which that land was put during the war. Nagatani introduces his portfolio with factual text, including a map of the sites, statistics on incarceration populations, an artist's statement, and a list of image titles. The formal qualities of Nagatani's photographs pay homage to earlier representations of the camps by artists such as Adams and Miyatake, but the framing information makes the contrast between heroic landscape and their wartime function all the more jarring.

In addition to heroic western landscape photography, Nagatani also links his images to the oppositional representational strategies of Lewis Baltz and other "New Topographic" photographers who came to prominence in the 1970s with purposely anti-heroic, black-and-white photographs of suburban structures such as tract homes.[33] Because the viewer often brings expectations of spectacular beauty to landscape images, photographs that picture a prosaic

environment devoid of natural beauty undermine viewers' assumptions of representational categories. Nagatani challenges these same expectations in his photographs of Jerome and of Tule Lake, for which he chose a seemingly unremarkable vantage point that in no way accentuates the natural beauty of the pictured environment. While Baltz's images of suburban sprawl emphasize the generic and anonymous, Nagatani includes significant details that allow the composition, even though it initially reads as banal, to signify on more complex levels.

Nagatani's photographs from Amache, Colorado, for example, clearly evoke the banality of New Topographics. The horizon line bisects the photographs, separating blank blue sky from sagebrush-covered earth. In one image an abandoned structure sits isolated. In another, strong weeds have begun to poke through the cracks of a cement foundation. The trees that line the concrete floor look out of place, and in fact they are not indigenous to the environment. The concrete and imported flora connect the viewer to the time when Japanese Americans were uprooted from their homes and replanted in these desert environments. The single structure in the center of the empty desert is perhaps a more poignant memorial than the official markers, but it is ambiguous, as it is not inscribed with a text that explains its function. A third photograph, taken within the camp's cemetery (see figure 41), reveals a grave marker for "Evacuees Unknown" resting at the bottom of the image, referring specifically to the historical event in which the site is implicated but incapable of naming those whom it commemorates. The strong horizon line is reinforced by a wire fence, which cuts through the image like staff lines, converting a windmill in the distance into a musical note. Reading these photographs sequentially, the viewer sees the continuum of habitation, desertion, and utter emptiness. The photographer's implied presence, like the offering of pink lilies on the grave, serves as a small consolation in the otherwise bleak, lonely environment.

When Nagatani first conceptualized the project, he planned to adopt the same working method he had used in his previous work, the *Nuclear Enchantment* series. Instead, Nagatani's *Japanese American Concentration Camp* portfolio represents a significant departure from his earlier work. His *Nuclear Enchantment* series (1991) consisted of photographs of elaborate stage sets that self-consciously called attention to the manner in which they were assembled. In contrast, these new photographs seemed to fall more straightforwardly into the tradition of landscape photography. The *Japanese American Concentration Camp* portfolio also belongs and makes specific reference to a larger genre of incarceration imagery—a group of images that have never been examined as a whole.

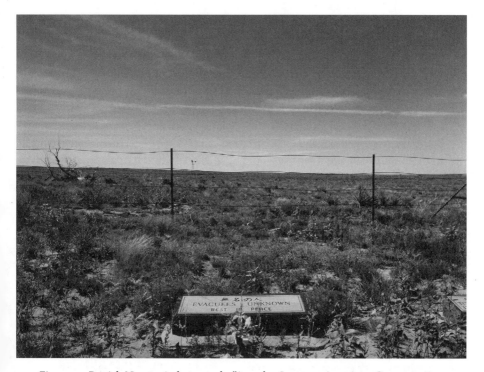

Figure 41. Patrick Nagatani photograph, "Amache, Japanese American Concentration Camp, Colorado, July 29, 1994/A-10-10-10" (grave marker reading "evacuees unknown"). Black-and-white reproduction made from original color photograph. Courtesy of Patrick Nagatani.

The methodology he used for the *Nuclear Enchantment* series values photography as both the beginning and ending point in a continuum of highly manipulated artistic processes. In the *Nuclear Enchantment* series, an enlarged black-and-white landscape photograph served as the backdrop onto which he painted. In front of this backdrop, he used strings to hang other objects such as model airplanes and life-sized, cutout photographs of people. After completing the stage set, Nagatani then photographed the tableau. This final image democratized the varied textures and crafted surfaces with the smooth, glossy finish of a chromogenic print. The presence of the strings in the image as well as the painted surfaces left telltale evidence of the manipulation that brought the image into being. The final photograph created a completed piece of art capable of being hung on a gallery wall.

With this type of artistic process, it becomes impossible to speak of "image" in the singular, because the process of making and manipulating mul-

tiple images is itself the central subject of the work. Nagatani uses this act of layering images as a theme: the strings and brush strokes are visible in a way that the photographic process itself is not. In a sense, such photographs for Nagatani serve to sandwich layers of artistic gesture. They act as the canvas-like surface receiving the image(s), as well as the transparent window through which the images are seen.

After Nagatani completed his cross-country journeys to visit and photograph the two United States concentration camps where his parents had been imprisoned, he decided that he would have to take a different approach than he used in *Nuclear Enhancement*. For this project he would instead make more straightforward, color landscape photographs. Nagatani also changed from his typically large format, high-gloss color prints to basic color paper (Kodak Supra Ektacolor with a matte surface) and to a relatively small format (11 × 14 inches, mounted to 16 × 20 inches). He made these technological changes because he wanted the places themselves to be more important than the process.[34]

The images he produced for the *Japanese American Concentration Camp* portfolio appeared to be an aberration in relation to his larger oeuvre, so much so that, after he exhibited the photographs at the Japanese American Cultural and Community Center in Los Angeles in 1995, he was unable to secure further exhibition space or generate any publicity in art journals.[35] The lack of critical attention may have derived from the fact that at first glance these images look like simple, almost decorative landscape photographs. They do not seem to fit with art photography, which from the 1980s through the 1990s has run under the banner of postmodernism, a term more applicable to Nagatani's earlier images, which clearly emphasized their own construction.[36]

At first glance the incarceration site photographs might seem to be a methodological regression for Nagatani. The actual color of the landscapes and the artist's refusal to highlight technical complexity have perhaps led critics to neglect them. Even though Nagatani's portfolio addresses political concerns consistent with the agendas of recent, critically-acclaimed art photography, contemporary critical discourse leaves little space for work such as this. Not only do the images fail to conform to postmodern notions of art, they also make overt reference to the heroic landscape photographs of the medium's now unfashionable modernist master, Ansel Adams. A closer look at Nagatani's work, however, reveals a more complicated engagement with the past.

VIRTUAL PILGRIMAGE

Nagatani's desire to make a pilgrimage to the incarceration sites and to represent his journey photographically to an audience were important factors

in his methodological break from his previous work. The photographs Nagatani produced by going to the incarceration sites describe the places and represent his experience, but because Nagatani often traveled alone and did not have access to his parents' memories, he could not infuse the images with past personal narratives.

Thus the photographs emerged out of the gulf of silence surrounding incarceration that separates Nagatani's generation from that of his parents. At the same time, the photographs offered an opportunity to bridge that gulf. When Nagatani exhibited the images at the Japanese American Cultural and Community Center, former prisoners used the pictures as descriptive links to memory. People who had been in the camps recognized the environments, pointed to the images, and told stories.[37] The ease with which viewers took to the photographs explains in part the strategy behind making clearly unmanipulated color landscapes. The absence of overt manipulation, signifying apparent artlessness, contributed to their accessibility and legibility so that those who had been most directly affected by incarceration could feel welcome to contribute to the images' meanings. The very reasons why the images may have failed to garner critical attention in the art press are precisely those that allowed the photographs to facilitate dialogue amongst former prisoners.

By helping Japanese Americans tell stories and share remembrances with others who had not experienced the sites first hand, the photographs function as a means of virtual pilgrimage. Pilgrimage, as theorized by Jack Kugelmass in his analysis of American Jewish tourism to Poland, can be a type of "secular ritual" in which certain groups journey to a particular site to link themselves to a collective past, to confirm identity, to encounter symbols of group experience, to reclaim territory, and to sensualize history.[38] These motivations for pilgrimage rely on the site to serve as a space where the group can perform the work of memory.[39] The experience of virtual pilgrimage offered by Nagatani's *Japanese American Concentration Camp* portfolio allows these issues to be remembered and discussed by those for whom travel to the actual sites is not an option.

Thinking of the viewers as participants in a virtual pilgrimage allows us to see the relationship between this portfolio and Nagatani's previous work. His *Japanese American Concentration Camp* photographs, like the *Nuclear Enchantment* images, required extensive reconnaissance work, layer multiple experiences, and serve as photographic theaters. However, the photographs of the incarceration sites do not act as items manufactured in a studio. With viewers in front of them exchanging stories and histories, the *Japanese American Concentration Camp* images transform into stages on which memory actively negotiates the relationship between past and present.

Masumi Hayashi's *American Concentration Camps*

Like Nagatani's photographs, Masumi Hayashi's photographs of the incarceration sites foster and exhibit conversations, as well as create personal links to an event that is integral to her identity yet external to her own memory. Hayashi was born in September of 1945 and spent the first month of her life in the Gila River concentration camp located in south central Arizona, approximately halfway between Phoenix and Tucson.[40] She did not return to the site of her birth until 1990, when she made a brief visit in the course of a cross-country drive. Nevertheless, the experience of being born into incarceration has influenced her choice of photographic projects throughout her artistic career. A crucial moment occurred in 1995 when she returned again to Gila River for a reunion of former prisoners. Hayashi recalled:

> That reunion . . . became a very special experience. I had phoned my mom and uncle and talked to them while I was there . . . many people wanted to know what block we lived on. From that phone conversation with them I found out we were on block 36 of Butte Camp and that both my father, Tomio, and uncle, Rakuo, had built a pond for water under the barracks to cool the barracks down. It was a surprisingly inclusive feeling to be back at the site a second time. This time with a community of Japanese Americans trying to help me identify the sites, sharing their memories both good and bad, and to share a memory with my mother and my uncle of their past.[41]

After her return to Gila River, Hayashi began a photographic project exclusively on the incarceration sites. Since 1985, Hayashi had photographed damaged places, beginning with a series titled *The Post-Industrial*. Hayashi joined the art faculty at Cleveland State University in 1982 and soon thereafter became artistically drawn to the environment in which she lived. Cleveland in the late twentieth century afforded impressive views of industrial decay, including networks of old pipes, rusting shafts, and windowless warehouses. With this first series of forsaken environments as her subject, Hayashi developed her stylistic and technical mode of working—the panoramic photo collage.

Similar stylistically to the images of David Hockney and related conceptually to the photography of Robbert Flick, Hayashi's photo collages are large-scale works made up of dozens of prints, each from separate negatives. Placing her camera on a tripod and keeping the horizon constant, she photographed in a full, 360–degree circle so that often the same visual element is repeated at both the left and right edges of the final work.[42] Each tripod set-up took

as long as two hours to shoot and used two to three rolls of film. After the session, she would sketch out how the series of images would fit together. She then had the prints processed in a color lab, taking care to ensure that all of the prints for a single collage were processed in the same batch of emulsion so that the color would not vary. Finally, she arranged the prints according to her sketch and dry mounted them onto an eight-foot long panel of foam core board. The final works range in size from 24" × 44" to 48" × 90".

Hayashi's working method makes space the theme, focusing on how it is organized and how it unfolds for the viewer. The composition of her panoramas is insistently horizontal. Lines run through the center, dividing the work into two equal rectangles. Along the horizon, the image holds true, meaning that objects are represented as continuous in space. For example, in "Manzanar Relocation Camp, Monument," a panorama consisting of about sixty-five separate photographs, the center is dominated by the Ireito monument and the band of Sierra Nevada mountains in the distant background (see figure 42). As the viewer's eye travels from the horizon up to the top of the image or down to the bottom, the image's coherent center gives way to disorder—clouds are discontinuous and the pavement in front of the monument is fractured. Within the work, however, each row and column of photographs is arranged along straight lines so that the seams between images create a kind of organizing grid. Space is both disjointed or highly organized in different sections of the same image, and it is this tension between chaos and order that gives the images their visual power.

Contradictory representational practices, expressed in the spatial arrangement of Hayashi's work, have been an overriding theme of the projects she has chosen. In 1988–89, Hayashi began to photograph Superfund sites—extremely toxic waste areas that the Environmental Protection Agency has singled out as the highest priority for clean up. Hayashi made panoramic photo collages of twelve Superfund sites, including Elyria, Ohio, and the infamous Love Canal in Niagara Falls, New York. She was initially drawn to the project by what she perceived as the anxiety between the toxicity of the sites and their beauty. Elyria, for example, looks like an innocuous country setting with trees and a pond. The photograph's conventionally picturesque terms belie the site's malignancy. Although Hayashi referred to her panoramic photo collages as "panopticons" because the panoramas present such an all-encompassing view, one message of her work is that photographs capture only surfaces, and that beneath the deceptively pretty veneers lurks corruption.

After her *Superfund Sites* series, Hayashi began work in 1989 photographing abandoned prisons—first the Workhouse in Cincinnati and then Alcatraz

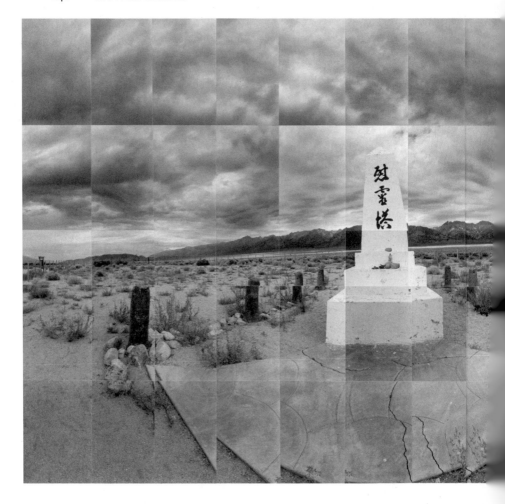

in San Francisco. With the prison series, Hayashi connected her method of image making with the theme of incarceration, creating a more direct link to her use of the term "panopticon" in relation to her art.[43] It was while working on the prison series that she decided to return to Gila River for the first time. Initially, she thought of the photographs during this visit as a part of her prison work. After an invitation to exhibit images that specifically dealt with incarceration, however, she began to think of the Gila River work as part of a project dedicated just to the concentration camps. She then traveled to all ten of the concentration camp sites to make panoramic photo collages.

Figure 42. Masumi Hayashi's "Manzanar Relocation Camp, Monument," from the series *American Concentration Camps,* 1995. Black-and-white reproduction of a color, panoramic photo collage, 48" × 80". Courtesy of Dean Keesey.

In the *American Concentration Camp* series, Hayashi's exploration of the interplay between surface and depth finds its most effective expression. Whereas the *Superfund Sites* images revealed their beauty but rarely their toxicity, the subject matter of the concentration camp work—with its combination of beautiful landscapes and haunting relics of past injustice—is as disjointed as the collaged photographs that appear along the bottom of her panoramic images. For example, in her panoramic photo collage of Tule Lake (see figure 43), the horizon line separates a partly cloudy sky from a dark ground covered with light-colored grasses, while an abandoned structure

occupies the middle of the image. The structure is one of the few overtly visible remains of the camp. In the panorama, the building is viewed from one of its corners so that the lines of the roof recede at sharp angles, and the orthogonals that the roof lines generate lead the viewer to two distant mountains in the far recesses of the collage's horizon, which echo the building's form. The blue of the sky complements the yellow of the sun-dried grasses. The surface of the image is animated both by the striations of the clouds and the errant blades of grass that seem to be revolving around a vortex created by the building. Indeed, it is the structure that anchors both the image's composition and meaning, bringing the troublesome function of this landscape to the photograph's surface. In addition to the building, a fallen fence post marks the image's foreground, as does the shadow created by the photographer's tripod. These elements inhabit the disjointed space of

Figure 43. Masumi Hayashi's "Tule Lake Relocation Camp and Segregation Center," 1995. Black-and-white reproduction of a color, panoramic photo collage, 32" × 59". Courtesy of Dean Keesey.

Hayashi's collage and co-exist with her formal concern for color, composition, and structure.

Part of the purpose of Hayashi's project is to educate the viewing public about Japanese American incarceration. Hayashi did not learn about incarceration herself until her older sister chose the topic for a college paper. Before reading her sister's essay, Hayashi had assumed that whenever her parents mentioned "camp" that they were speaking of a "vacation camp."[44] In order to provide contextual material that would ground the display of her photographs in the history of incarceration, Hayashi incorporated text and audio in exhibitions of her work—a technique she began with the *Post-Industrial* series. In 1992, Hayashi began to interview Nisei. She edited the tapes and included excerpts from nine conversations to play in the gallery. In addition to providing testimony that connects the images back to their wartime func-

tion, the interviews are meant to exemplify the variety of attitudes towards incarceration and its effect among Nisei.

During slide presentations of her work, Hayashi also played the audiotape as she advanced through images that shifted between her own panoramic photo collages and 1940s documentary photographs. She used documentary photographs by the WRA and others to tell the story of incarceration. Hayashi had seen only one photograph of her own family in this period, and explained that even that image, which she once glimpsed in a family album, has since disappeared.[45] Much of her research is preserved on her website, www.masumihayashi.com. This site includes her extremely valuable "Family Album Project" in which Hayashi collected rare, informal, family snapshots taken in camp.

Hayashi's multimedia presentation is a strategy often employed by video artists in their work on incarceration. In Janice Tanaka's *Who's Going to Pay for these Donuts Anyway?* and Rea Tajiri's *History and Memory*, for example, both artists combine contemporary images and documentary photographs from the period to create a kind of montage effect that mimics the piecing together of shards of the past to create a whole memory.[46] Both video artists attempt to forge a relationship with a distanced parent, and both use incarceration and the parent's subsequent difficulty in narrating their experiences of incarceration as defining moments in the parent–child relationship. When asked about how her work fits in with other Sansei visual work on incarceration, Hayashi said, "There is a recent reinvestigation, reconstruction of memory, of interest by artists one or two generations removed from the original experience. The links and ties to their own ethnicity, history and collective consciousness is as strong as salmon swimming against a current to spawn. Their explorations are a range of artwork that is strong and varied and each a personal statement about how the camps affected them and their families. . . . I think we all create another piece to that puzzle of camp experience, we all add to that collective memory."[47]

Hayashi's introductory text to her exhibition is a twenty-nine–page document that includes an artist's statement, statistical information on each of the ten concentration camps, and photocopies of original documents relating to incarceration history, including the exclusion orders and the apology she received from President Bill Clinton.[48] The artist's statement itself is a brief history of incarceration concluding with a question that acts as an appeal: "Less identifiable with each generation, the Sansei (third generation) and the Yonsei (fourth generation) are marrying out of the community more frequently. Will the inevitable assimilation by the Japanese Americans, of both

physical characteristics and mindset, cause a waning of curiosity and indifference to Japanese American culture and history?"[49] The anxiety expressed by Hayashi describes the predicament of many Sansei. As children of Nisei, they have lived through a period in which assimilation has been a key theme in Japanese American life. At the same time, they are the generation who has fought most openly and effectively for Asian American rights, including the recognition of their claim to a Japanese American cultural identity and the relevance of Asian American cultural production to academia.

Nisei, Sansei, Yonsei

By making the decaying ruins the central focus of their photographs, Nagatani and Hayashi confront the viewer with the possibility that the memory of incarceration itself might vanish if it is not nurtured or remade. The concentration camps are powerful reminders of the ways in which Japanese Americans have been excluded from the body politic. With the erosion of the actual camp sites, a danger arises that the lessons of incarceration may be forgotten. Photography here serves to preserve not the actual sites but rather the memory of those sites and of the injustices committed there.

For these two artists, making photographs of the incarceration sites represents an attempt to communicate the legacy of their parents' generation to their children. Both have incorporated relationships with their own children in the incarceration projects. Nagatani took his son with him on some of his incarceration site pilgrimages, while Hayashi and her son collaborated on her website dedicated to her incarceration photography.[50] Such acts of remembering incarceration through images bring together Nisei, Sansei, and Yonsei, offering the possibility of repairing some of the generational damage caused by the wartime incarceration to Japanese American families.[51]

Epilogue

When the war is over
And after we are gone
Who will visit
This lonely grave in the wild
Where my friend lies buried?

—Keiho Soga

Rather than endpoints, photographs represent points of departure for the creation of meaning. As Judith Fryer Davidov has written, "Photographs are artifacts with a continuing life."[1] Viewers of incarceration images have often been tempted to look upon photographs as apertures open to the past, as if the images existed outside of the history they portray. Others have been tempted to ignore the circumstances of the photographs' making and have argued instead for their timelessness as works of art. In contrast, the chapters of this book have insisted that photography did not exist apart but rather as a part of incarceration as it was lived by those both inside and outside of the camps.

Despite the thousands of photographs taken during the incarceration process and the increased attention that incarceration history has received both in academia and in popular culture over the past three decades, none of the images discussed in this book has penetrated the collective American visual consciousness in the manner of other images of World War II that have taken on iconic status. As Marita Sturken has written of incarceration photographs, "these images are, for the most part, absent from the litany of World War II images that comprise its iconic history."[2] The photographs that have come to stand for World War II in the national memory of the United States include heroic military images, such as Joe Rosenthal's photograph of the marines raising the flag at Iwo Jima, and photographs from the Holocaust, visually recalled by Margaret Bourke White's image of prisoners behind a barbed wire fence at Buchenwald. These images figure prominently in the

collective visual consciousness of the United States precisely because their iconic status has divorced them from the particular circumstances of their making. As icons they come to stand for the events they portray writ large, or for human qualities that appear to transcend the moment they depict. These photographic icons both seem commensurate with and, in fact, generate public understanding about the war. It is not so much that they capture essences of these conflicts, but rather that the images have themselves helped to shape popular understandings of the war.

Single Holocaust photographs, for example, are rarely able to stand for the specific moment they depict and instead are much more likely to stand for the total event, robbed of any precise indexical status. According to Barbie Zelizer, even at the time of their initial publication, Holocaust photographs were mined more for their symbolic rather than indexical value, and they were often reproduced interchangeably.[3] The same photograph of murdered prisoners, for example, was published with captions locating the image in Buchenwald and Ohrdruf.[4] Historic specificity did not matter as much as communicating the scale of death.

Whereas heroic U.S. military and traumatic Holocaust photographs are often trapped by their iconicity, Japanese American incarceration photographs are defined by their indexicality. According to Sturken, in contrast to the icon of the marines raising the flag on Iwo Jima, "the internment of the Japanese Americans ultimately can find no such traditional narrative—of either conflict, resistance, or brutal injustice. Its images are overwhelmed by their sense of the ordinary and the domestic, outside of the discourse of war."[5] The photographs that the U.S. public tends to associate with World War II, in contrast, illustrate a narrative of a war with clear victors and clear victims. Photographs of the incarceration of Japanese Americans compromise the view of the U.S. military as wholly honorable. Furthermore, they do not offer a clear sense of victimhood, particularly if Holocaust photographs provide the basis by which one understands the representation of suffering. Yet there are a few images that one could argue have taken on iconic status among those who remember the incarceration and strive to recall its history to others.

Other Icons

Along with "Boys Behind Barbed Wire" by Toyo Miyatake, a photograph that pictures a mother holding a child during the forced removal (see figure 44) is probably the most often reproduced image of incarceration. Fumiko

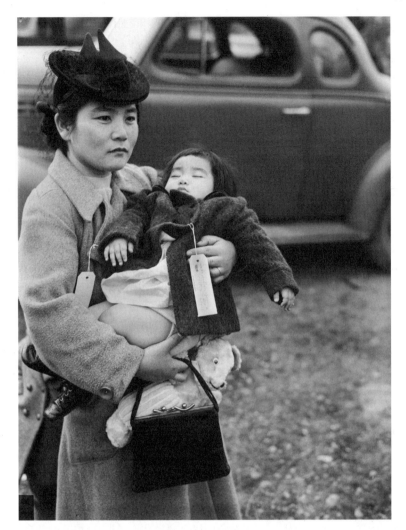

Figure 44. "Fumiko Hayashida and her Daughter." Photographer unknown, 1942. *Seattle Post-Intelligencer* collection. Museum of History and Industry, Seattle, Wash.

Hayashida, now in her mid-90s, does not remember being photographed on the day she was forced to leave her home on Bainbridge Island.[6] However, the image of her carrying her sleeping daughter as they depart for camp has become a powerful symbol of the injustice of incarceration within Japanese American communities. In the photograph made by an unknown photog-

rapher for the *Seattle Post-Intelligencer,* Hayashida and her daughter appear dressed for travel. They wear heavy coats that have both been tagged with their family numbers, and Hayashida has a dark hat with a short veil around its brim. In addition to her daughter, Hayashida carries a purse and a stuffed animal. The sleeping child and the blank stare of the animal contrast with the intentful gaze of the mother. The seriousness with which she focuses her eyes and the strength of her arms hold the viewer to this photograph. As an image of a mother and child, it produces an effect that resembles that of Dorothea Lange's famous Depression-era photograph "Migrant Mother," evoking both strength and determination as well as pathos (see figure 5 in chapter 1).

Nevertheless, my research indicates that the newspaper did not publish the photograph of Hayashida during the war. The *Seattle Post-Intelligencer* ran many stories with photographs during the last week of March 1942 on the evacuation of Bainbridge Island, as it was the second place after Terminal Island to be evacuated. The photograph probably appeared in public for the first time in 1972 in Richard and Maisie Conrat's photographic history of the incarceration, *Executive Order 9066.*[7] Four years later, on April 4, 1976, the photograph of Hayashida made the cover of the *Post-Intelligencer's* Sunday magazine. Since then the photograph has been included in exhibitions and countless publications, including the cover of the brochure for the National Japanese American Historical Society in San Francisco and a 1981 lithograph by Roger Leyonmark titled "An American Nightmare," which was used to raise money to support the national redress effort.[8] This photograph is an important example of how images that become significant vehicles for telling history change as historical focus and interpretation changes.

In 1993, the photograph was featured in an exhibition sponsored by the Smithsonian Institution's traveling exhibition service called Strength and Diversity: Japanese American Women 1885–1990. The exhibition celebrated three generations of Japanese American women, and the photograph of Hayashida was selected for the poster, transforming her into a kind of apotheosis of Japanese American womanhood. After the publication of the Strength and Diversity poster, interest in Hayashida herself increased. Curators at the Smithsonian spent months trying to figure out who the woman in the photograph was. After finally locating Hayashida, they asked her to make a guest appearance at the exhibition's opening in Bend, Oregon, in March 1993. The Seattle newsletter *Tomo no kai* (Widowed Americans of Japanese descent) recounted the experience as follows:

> Fumi Hayashida had a thrilling experience in March. She was featured as the 'mystery woman' in the ceremony initiating the Smithsonian Institution's trav-

eling exhibit. . . . It started because of a photograph taken of her holding her baby. . . . Many people are familiar with this picture through books and TV documentaries. . . . People had expressed curiosity about her identity, if she were still alive, what happened to her children. It took the museum people 3 months to locate and contact her. . . . After her identity was revealed, many from the audience wanted her autograph. . . . Congratulations, Fumi![9]

Hayashida signed many posters at the opening. Subsequently West Coast newspapers such as the *Post-Intelligencer* and *Rafu Shimpo* ran stories on Hayashida, often publishing the wartime image next to a contemporary photograph of Hayashida and her adult daughter. A friend of Hayashida's from Los Angeles sent her a clipping of one such story with a note attached that read, "Here's the article in the newspaper *Rafu Shimpo*. . . . Hope you like it. You're getting to be a regular 'poster girl.'"[10]

What did people see in this photograph of Hayashida and her daughter that led them to transform it from one of thousands of documentary photographs of incarceration to one of the most frequently reproduced images of Japanese American history? Most of the photographs produced of the process of incarceration were made by obtrusive photographers under the extreme conditions of the evacuation and incarceration, while the project of documentation was such that it purposefully attempted to deny those conditions and instead depict fair treatment and orderly "evacuees." In the photograph of Hayashida, however, we see an image of someone apparently unaware of the camera's presence and so her expression appears to be genuine, produced not under the directive of the photographer or by the imposition of the camera, but by the circumstances of the forced removal. The failure of the photograph to conform to official conceptions of the incarceration when it was made probably explains why the photography editor passed it over. Hayashida's face portrays a poignancy that communicates the inhumanity of the government betrayal, and it is precisely this expression that would have kept it out of the newspaper in 1942.

While this photograph of Hayashida recalls "Migrant Mother" in formal terms, the story of the quest for Hayashida's identity is starkly different from the revelation of the key subject in Lange's famous image. Although the magazine *American Photographer* revealed the identity of Dorothea Lange's "Migrant Mother" in the late 1970s, it was not because there was any public expression of interest in her personal identity.[11] The revelation of Florence Thompson indicated that she had believed that, by becoming Lange's model, she might in-turn receive help, which she never received. In her influential 1989 essay on documentary photography, Martha Rosler retold the story of

Thompson's reappearance in *American Photographer* and in the *Los Angeles Times*. Subsequently, Thompson slipped back into obscurity, although her image remains ubiquitous. In 1998 the U.S. Post Office issued "Migrant Mother" as part of a 1930s collection of postage stamps. According to Elizabeth Partridge, Thompson's two surviving children, who are in the famous photograph, traveled to Cleveland, Ohio, for the release of the stamp only to be ignored by officials during the ceremony.[12]

In contrast to Florence Thompson, interest in Fumiko Hayashida's identity has led to her minor celebrity, and her autograph is sought after as is her life story. Her personal experiences are now a part of the public record of history; for example, her story has been recorded by the Densho project and other oral/digital histories. How can this discrepancy be explained? Because the photographer is unknown and Hayashida's presence in the photograph seems so assertive, Hayashida's name has become indelibly linked to the image. She is a symbol, but not an anonymous one. By contrast, in "Migrant Mother," authorship rests squarely on the shoulders of Lange, and Thompson acts as Lange's vehicle of documentary expression. In the photograph, Thompson represents broad human themes such as suffering, unmoored from the specific historical circumstances of her own personal condition.

Hayashida's ultimate status as an icon, however, is qualified by race. She can act as an icon of Japanese American womanhood as she does in the poster for the Smithsonian exhibition, but in a popular culture where Americanness is still often coded as white, non-whites are commonly excluded from the realm of the iconic. Hayashida and her daughter cannot wholly transform into a contemporary version of the Madonna (Lange's "Migrant Mother" has often been referred to as "Migrant Madonna") because they are racialized as external to dominant American culture, outside the unmarked category of whiteness.

Whereas Hayashida's image is seen as a part of history, Thompson's image has been largely detached in the public consciousness from the context of its making. Unlike Lange's "Migrant Mother," which has been endlessly reproduced in any number of contexts, the photograph of Hayashida, though also reproduced with frequency, is always placed within the context of incarceration. The place of Asians within U.S. racial discourse denies the image's ultimate iconic potential and grounds it in the historical context of its making, marking her as a participant in the incarceration. In other words, Hayashida can stand iconically for the category of Japanese American prisoners but not for broader categories such as Americans or mothers. Although Florence Thompson was very poor, her perceived membership in the racial

majority transcended her poverty—her image can exist iconically because she is coded as white. Ironically, according to Rosler, Thompson was actually Native American. Her perceived whiteness allows her a kind of universal significance that is rarely permitted to people of color in dominant U.S. visual culture.

The incarceration of Japanese Americans during World War II continues to bind together the histories of all Japanese Americans. To remember incarceration as a group is to acknowledge racism as a shared, group experience. To reproduce and look at the photograph of Fumiko Hayashida is to participate in remembering the history of incarceration. That her image cannot breach the boundaries of its time and place is a reminder of the underlying racism that bolstered anti-Asian legislation since before the turn of the twentieth century, and the racism that continues to keep Japanese Americans at the periphery of popular representations of Americanness.

However, one also should not overvalue iconicity. True iconic status comes at a very high price; one in which the lives of the human beings depicted are overshadowed by abstract themes that mute specific histories. At the same time that photographic icons play an important role in constructing our relationship to past events, they also can lead to misunderstanding and myopia as other images are neglected, overlooked, or eclipsed by the powerful testimony of the icon. As Marita Sturken argues, "Forgetting can also be produced through the presence of images. A single image-icon can screen out other images of a historical event."[13] Borrowing from Freud's theory of screen memory, she asserts that images too can literally conceal the less desirable or more complicated past with a more palatable representation.

The celebrity of Fumiko Hayashida at the beginning of the twenty-first century suggests photography's role not only in conveying images of the past but also in constructing the future. Hayashida symbolizes dignity, determination, and bravery—an experience of incarceration without a directed smile. That her photograph has not been allowed to transcend the boundaries of a racially marked history reminds us of the long history of conflicts between race and citizenship that many photographs of incarceration describe. It also points to prevailing discourses of Americanness and race that continue to conflate Americanness with whiteness. As in the past, photographs of incarceration continue to portray history at the same time that they participate in its making.

Notes

Introduction

First epigraph. Quoted in Leighton, *The Governing of Men*, 32.

Second epigraph. Bulletin no. 126 from the Japanese American Citizens League dated March 24, 1942. Bulletin no. 135 from March 30, 1942, gives instructions for the move to assembly centers, including "No contraband items as described . . . may be carried." See Box 1:11 MSS 97/145C, Dorothea Lange Papers, Bancroft Library, University of California, Berkeley. It was not until February of 1945 that Manzanar's project director issued bulletins that revoked the contraband regulations. The return of the right to use a camera, however, applied only to citizens. Bulletins 74 and 75, February 19, 1945, Folder 13, Box 7, Collection 122, Manzanar Relocation Center Records, Department of Special Collections, University Research Library, University of California, Los Angeles (hereafter cited as Manzanar Records, Special Collections, UCLA).

1. These home movies, including Dave Tatsuno's moving images of Topaz, were hidden from public view until Karen Ishizuka and Robert Nakamura used them to create a powerful montage titled *Something Strong Within* (1995). See Ishizuka, *Lost and Found*, 118–38. For an online gallery of some of the amateur snapshots made in camps, see masumihayashi.com.

2. Chalfen, *Turning Leaves*, xvii.

3. See Tagg, *The Burden of Representation*; Sekula, "The Body and the Archive"; Rosler, "in, around, and afterthoughts"; Maxwell, *Colonial Photography and Exhibitions*; and Berger, *Sight Unseen*.

4. See Foucault, *Discipline and Punish*.

5. Letter to Ralph Palmer Merritt from unspecified prisoner, 18-2-3, April 23, 1945, located in an unbound copy of Final Report, Manzanar Relocation Center, Volume 1, Project Director's Report supervised by Robert L. Brown, Folder 1, Box 4,

Manzanar Records, Special Collections, UCLA. Elena Tajima Creef discusses this tension between the Japanese American self and body, which she argues is rooted in the incarceration. Creef, *Imaging Japanese America*, 18.

6. E. Lee, "The Chinese Exclusion Example," 36–62. See also E. Lee, *At America's Gates*.

7. E. Lee, "The Chinese Exclusion Example," 41.

8. Pegler-Gordon, "Chinese Exclusion, Photography, and the Development of U.S. Immigration Policy," 55.

9. Pegler-Gordon argues that applicants themselves often manipulated images using the presumption of indistinguishability to their advantage and at times provided alternate meanings for the photographs themselves that blurred their honorific and repressive functions. Ibid., 70, 73–74.

10. Daniels, *Prisoners Without Trial*, 36.

11. Daniels, *Concentration Camps*, 36.

12. Quoted in Leighton, *The Governing of Men*, 19.

13. Quoted in Dower, *War without Mercy*, 81.

14. Daniels, *Concentration Camps*, 44–45.

15. Daniels, *Prisoners Without Trial*, 38.

16. Ibid., 29.

17. Daniels, *Concentration Camps*, 75–77.

18. Daniels, *Prisoners without Trial*, 53.

19. Daniels, *Concentration Camps*, 104.

20. See, for example, Daniels, *The Politics of Prejudice*; Kitano, *Japanese Americans*; and Weglyn, *Years of Infamy*.

21. Daniels, *Prisoners Without Trial*, 3.

22. Daniels, Taylor, and Kitano, *Chronology*, xv.

23. Ibid. For more on Ozawa, see Haney Lopez, *White by Law*, 79–110.

24. Commission on Wartime Relocation and Internment of Civilians, *Personal Justice Denied*, 8.

25. Daniels, *Prisoners Without Trial*, 46.

26. Daniels, "Words Do Matter," 183.

27. For commentary on official attitudes towards naming, see Drinnon, *Keeper of Concentration Camps*, 6–7; and Daniels, *Prisoners Without Trial*, 27.

28. Okamura, "The American Concentration Camps," 101. Unlike the presidentially mandated executive order, the exclusion orders specifically and solely targeted "all persons of Japanese ancestry . . . both alien and non-alien." In the exclusion orders, the military purposefully avoided using the word citizen when referring to Japanese Americans born in this country and instead labeled citizens as "non-aliens."

29. Agamben, *Homo Sacer*, 166–80.

30. Iritani and Iritani, *Ten Visits*.

31. On the uses of the word "camp" and patterns of communication between Nisei and Sansei regarding incarceration, see Nagata, *Legacy of Injustice*, 75–102.

32. Thomas and Nishimoto write, "It was required that these sites be on public land, where improvements would become public assets; that they be large enough to accommodate minimum populations of 5,000 each; that they be suitable for work projects throughout the year; that they be located 'at a safe distance from strategic points'; and that transportation, power, water supply, etc., be satisfactory." Thomas and Nishimoto, *The Spoilage,* 26. A WRA/Department of the Interior publication confirms that the military distrusted the "internees" and looked for sites with no strategic importance. See United States Deptartment of the Interior, *WRA,* 20.

33. Iritani and Iritani, *Ten Visits,* 4.

34. Ibid., 10.

35. The histories of the concentration camps in Rohwer and Jerome have become more visible thanks to a multimedia, educational website called "Life Interrupted." A collaboration between the University of Arkansas at Little Rock Public History Program and the Japanese American National Museum, the partnership has produced curriculum plans, conservation efforts, and a documentary film. See www .lifeinterrupted.org.

36. In addition, the War Relocation Authority stated that the locations were chosen for their arable land "since about 45 per cent of the evacuees were engaged in agriculture before the war. . . ." United States Department of the Interior, *Relocation Communities,* 2. The peak population of the incarceration camp at Rohwer was 8,475.

37. Once out of the camps, forgetting or suppressing the past became a strategy of survival; one that has been used by many immigrant groups to distance themselves from the past and assert their Americanness. See Antze and Lambek, eds., *Tense Past.* For an excellent documentary film on forgetting as a strategy for survival, see Lichtenstein, *Andre's Lives,* Lumiere Productions, 1999.

38. It was feared at the time that Title II might be used against African Americans who were engaged in the struggle for civil rights. As they had experienced the injustice of incarceration without due process, many Japanese Americans felt that it was their obligation to ensure that a similar injustice did not happen again. See Nakanishi, "Surviving Democracy's 'Mistake,'" 17–20.

39. See Tateishi, "The Japanese American Citizens League and the Struggle for Redress," 191–96, 219–24.

40. This official government apology letter accompanied redress payments, the first of which were sent out in October of 1990. See Daniels, "Redress Achieved," 220–23.

41. Clem Albers, "Waving goodbye as the train pulls away from the station. These girls are on their way to an assembly center with others from this area of Japanese ancestry. They will later be transferred to War Relocation Authority Centers to spend the duration." April 1, 1942, Los Angeles, Calif. Photo # 210–G–B18 (ARC # 536767), United States National Archives, College Park, Md. (hereafter cited as NACP). According to Gerald Robinson, Albers took only 381 of the photographs archived in

the WRA collection, which suggests that his tenure with the agency was relatively short. See Robinson, *Elusive Truth*, 31. A search on the National Archives' Archival Research Catalog (ARC) for photographs by Clem Albers turns up 383 images.

42. Ishizuka, *Lost and Found*, 125.

43. Zelizer, *Remembering to Forget*, 93.

44. Agamben, *Homo Sacer*, 181.

45. Ishizuka, *Lost and Found*, 124.

46. Danovitch, "The Past Recaptured," 103.

47. Kuramitsu, "Incarceration and Identity," 623.

48. Barthes, *Image, Music, Text*, 46.

49. The meanings of smiles themselves certainly are culturally contingent as well. See Hess, Beaupre, and Cheun, "Who to Whom and Why," 187–216.

50. Kozol, "Relocating Citizenship," 246.

51. "Frank Vail, Cameraman for Pathe photographs home life in one of the evacuee apartments," May 26, 1943, Tule Lake, Calif. Photo # 210–G-B537 (ARC # 537143), NACP. "Cameramen from the San Francisco newspapers photograph potato planting," May 26, 1943, Tule Lake, Calif. Photo # 210–G-B539 (ARC # 537145), NACP.

52. Dorothea Lange, April 4, 1942, San Francisco, Calif. Photo # 210–G-C438 (ARC # 537758), NACP.

53. Partridge, *Restless Spirit*, 80.

54. Dorothea Lange Papers, Bancroft Library, University of California, Berkeley.

55. Chin, "Come All Ye Asian American Writers," 52, 58.

56. Yamada, "Evacuation," 13.

57. Mike Masaoka, "Bulletin #149," Japanese American Citizens League, April 9, 1942. Dorothea Lange Papers, Bancroft Library, University of California, Berkeley.

58. Stange, *Symbols of Ideal Life*; and Rosler, "in, around, and afterthoughts."

Chapter 1: When the Innocents Suffer

Epigraph. Farewell letter photographed by Dorothea Lange. Photo # 210–G-A522 (ARC # 536414), NACP.

1. In addition to five motion pictures and two-dozen sound recordings, Record Group 210, "Records of the War Relocation Authority," contains approximately 15,000 still photographs. See "Reference Information Paper 70: A Finding Aid to Audiovisual Records in the National Archives of the United States Relating to World War II," http://www.archives.gov/publications/ref-info-papers/70/part-3.html#rg210.

2. Daniels, *Prisoners Without Trial*, 31.

3. "The Great January Panic," Manzanar Relocation Center, Community Analysis Section, December 16, 1943, "Stories Written by 'Evacuees,'" Folder 2, Box 7, Manzanar Records, Special Collections, UCLA.

4. The Western Defense Command's final report published in 1942 included a "Pictorial Summary" consisting of 149 images, which stressed the War Department's

organizational skills. See Higa and Wride, "Manzanar Inside and Out," 317–20; and also Davidov, "'The Color of My Skin,'" 226.

5. Daniels, *Concentration Camps*, 83.

6. "Introduction, Community Analysis Reports," Microfilm 1342, RG 210, United States National Archives, Washington, D.C., (hereafter USNA).

7. With the exception of those who were segregated to the Tule Lake concentration camp where mug shots were taken. Clem Albers, "Segregees are photographed," September 1943. Photo # 210-G-G18, NACP.

8. United States, *Relocation Communities*.

9. Daniels, *Concentration Camps*, 92–95, and Daniels, *Prisoners Without Trial*, 56–58.

10. Efforts to use photographs in social reform movements are traced by Stange in *Symbols of Ideal Life*.

11. Daniels, "Dorothea Lange," 47.

12. Smith, *Building New Deal Liberalism*, 222–31.

13. Memo to Dorothea Lange from the U.S. Dept. of Agriculture, Farm Security Administration, December 11, 1941, Dorothea Lange Archive, Oakland Museum of California.

14. Quoted in Stott, *Documentary Expression*, 61.

15. Curtis, *Mind's Eye, Mind's Truth*, 11.

16. After Stryker left the government, he became head of a photographic department for Standard Oil. See Stange, *Symbols of Ideal Life*, 108.

17. Denver Field Office, Box 5, and Information Division, Box 4, Entry 36, RG 210 USNA.

18. Information Division, Box 4, RG 210 USNA.

19. Ibid.

20. In 1942, Twentieth Century Fox released "Little Tokyo," a "B" movie about a spy ring of Japanese Americans. The Office of War Information found the film to be inflammatory because it characterized all people of Japanese descent as potential spies loyal to the Japanese emperor. The film's director used actual footage of the evacuation of Japanese Americans from Los Angeles, and in the opening sequence showed people of Japanese descent taking photographs while a narrator spoke of mass Japanese espionage. Koppes and Black, *Hollywood Goes to War*, 72–73.

21. Information Division, Box 4, RG 210 USNA.

22. The WRA hired seven photographers, including Lange and Albers. See Ohrn, *Dorothea Lange and the Documentary Tradition*, 254n25.

23. Information Division, Box 4, RG 210 USNA.

24. Denver Field Office, Box 5, RG 210 USNA.

25. Ibid.

26. Ibid.

27. Roger Daniels suspects that Lange might have been employed directly by Mil-

ton Eisenhower, who spent time in the Bay Area while head of the WRA. Daniels, "Dorothea Lange," 50.

28. Taylor, "California Social Scientist" interview, 228–29.

29. Ibid., 229.

30. Dorothea Lange, photo # 210–G–A60, NACP.

31. Dorothea Lange, photo # 210–G–A59, NACP.

32. Weglyn, *Years of Infamy,* 36–37.

33. Daniels, *Prisoners Without Trial,* 16.

34. Daniels, Taylor, and Kitano, "Chronology," xvi.

35. Daniels, *Concentration Camps,* 76; and Weglyn, *Years of Infamy,* 7.

36. Weglyn, *Years of Infamy,* 45; and Robinson, *By Order of the President,* 67.

37. In her article on Lange, Sally Stein discusses Lange's focus on bodily pose as "a recurrent pattern of gesture" which "constitutes a basic set of signs to express the effects of the Depression on the body." See Stein, "Peculiar Grace," 73.

38. The characters read "Wanto Sho Kai" or "East Bay Merchant Company." There are three types of characters used for Japanese. One type is comprised of Chinese characters, which are used in the Wanto Co. sign. The other two forms, hiragana and katakana, are based on Chinese characters. My thanks to both Jennifer Robertson and Natsu Oyobe for their translations.

39. In 1938, Lange made an image of another Southern Pacific billboard, showing displaced families camping out under a billboard that reads, "Travel while you sleep." See Lange and Taylor, *An American Exodus,* 87. There is a discrepancy in the dating of the "It takes 8 tons . . ." photograph. In Elizabeth Partridge's *Dorothea Lange: A Visual Life,* the photograph is dated to 1942, and Lange discusses it as if she made it while working for the WRA. But the Oakland Museum of California, who holds the image, maintains that according to Lange's papers the image was made in 1945, after Lange was no longer working for the WRA.

40. Hosokawa, *Nisei,* 317.

41. Elliott, *Dorothea Lange,* 104.

42. Quoted in Partridge, ed., *Dorothea Lange: A Visual Life,* 118.

43. Denver Field Office, Box 5, RG 210 USNA.

44. This position description also lists the duty of maintaining a "card file showing use of photographs, distribution and availability for publication."

45. Reports Division, Box 2, RG 210 USNA.

46. Clem Albers, photo # 210–G–C73, NACP.

47. Gordon, "Dorothea Lange Photographs the Japanese American Internment," 5.

48. Gordon was unable to ascertain the procedure or mechanisms involved in the WRA censorship process. Ibid., 41n1.

49. As Stephen Sumida has pointed out to me, the meaning of the message "Remember Pearl Harbor" on the boy's cap is unfixed. It could be signifying U.S. patriotism, and it is likely that Lange and the WRA would have read it as such, but the words

can also imply resistance. Looking back, the photograph is a profound reminder of how differently Nikkei remember Pearl Harbor from most other Americans.

50. Dorothea Lange, "The family unit is kept intact in various phases of evacuation of persons of Japanese ancestry. Above is a view at Wartime Civil Control Administration station, 2020 Van Ness Ave on April 6, 1942 when first group of 664 was evacuated from SF. The family unit likewise is preserved at War Relocation Authority centers where evacuees will spend the duration," April 6, 1942, San Francisco, Calif. Photo # 210–G–A96 (ARC # 536069), NACP.

51. See Takezawa, *Breaking the Silence,* 94. Also see Okubo, *Citizen 13660,* 89.

52. Dorothea Lange, photo # 210–G–A95 (ARC # 536068), NACP. Paul Taylor remembered that a WCCA official, Major Beasley, disapproved of Lange obtaining permission for this photograph to be reproduced by Caleb Foote in a pamphlet that portrayed incarceration as unjust until the same image was reproduced by the government in the Tolan Committee Congressional hearings. Taylor, "California Social Scientist," 229–30. Gordon discusses Lange's adversarial relationship with Beasley as well; see Gordon, "Dorothea Lange," 20–21.

53. This photograph and text were placed very prominently in the annual, immediately following the table of contents and preceding four photographs of the Pearl Harbor bombing. See Maloney, ed., *The U.S.A. at War,* 9.

54. See Stange, "Documentary Photography in American Social Reform Movements," 195.

55. Lange had to turn over all of her work to the government. The WRA, not Lange, owned the images. Gordon, "Dorothea Lange Photographs the Japanese American Internment," 20.

56. Lange, "Documentary Photography." n. pag.

57. The WRA dismissed Lange "without prejudice" on July 30, 1942, with the remark "completion of work." Dorothea Lange Papers, Bancroft Library, University of California, Berkeley.

58. Dorothea Lange, letter to Ansel Adams, November 12, 1943, Box 2, Collection 696 (Ansel Adams Papers), Department of Special Collections, University Research Library, University of California, Los Angeles (hereafter cited as Adams Papers UCLA).

59. Lange interview, "The Making of a Documentary Photographer," 190–91, 200–201.

Chapter 2: The Landscape of Loyalty

1. M. S. Alinder, *Ansel Adams,* 11, 22, 26, 97; and Spaulding, *Ansel Adams and the American Landscape,* 50, 108.

2. In addition to publishing the photographs in the book, Adams exhibited the images three times during the war: twice for those imprisoned at Manzanar, and a third time in the Museum of Modern Art, New York City, under the title Manza-

nar: Photographs by Ansel Adams of Loyal Japanese-American Relocation Center. See chapter 4. Although Adams conceived of the book and exhibition concurrently (both share certain images and texts), the book *Born Free and Equal* was produced independently of the exhibition.

3. Spaulding, *Ansel Adams and the American Landscape,* 198–99.

4. M. S. Alinder, *Ansel Adams,* 173. Newhall's wife, Nancy, would later be responsible for exhibiting Adams's Manzanar work in MoMA.

5. Ibid., 230.

6. Adams, "Conversations with Ansel Adams," 23. In a letter to Harold Ickes dated May 17, 1944, Adams wrote: "At the suggestion of my friend, Ralph Merritt, director of the project, I went to Manzanar and made these photographs" Ansel Adams, letter to Harold Ickes, May 17, 1944, Ickes File, Box 2, Adams Papers, UCLA.

7. Adams also knew that his esteemed colleague, Dorothea Lange, had worked on assignment for the War Relocation Authority and photographed the forced removal of Japanese Americans from the Bay Area. Furthermore, Adams's sensitivity to the plight of Japanese Americans had been heightened when he learned of the incarceration of Harry Oye, an Issei who had worked for many years as his family's "companion, gardener and cook." (Adams, "Conversations with Ansel Adams," 25.) In the interview, Adams went on to say that Harry Oye had been much better treated in hospitals during the war than U.S. citizens of Japanese ancestry "who were picked up by General DeWitt and moved into the relocation camps."

8. Ansel Adams, letter to David McAlpin, November 4, 1938, in M. S. Alinder and Stillman, eds., *Ansel Adams,* 108–111.

9. Ansel Adams, letter to Edward Weston, November 29, 1934, Ibid., 72–74.

10. Edward Weston, letter to Ansel Adams. December 3, 1934, Ibid., 75–76.

11. M. S. Alinder, *Ansel Adams,* 230n21.

12. Ansel Adams, letter to David McAlpin, November 4, 1938, in M. S. Alinder and Stillman, eds., *Ansel Adams: Letters and Images,* 108–11.

13. Ibid.

14. West Coast Military Zones, enforced from 1942 to 1945, included parts of Washington, Oregon, California, and Arizona. Daniels, *Prisoners Without Trial,* 52.

15. In a letter to Dillon Myer, Ralph Merritt wrote that military guards would be withdrawn from towers and gates between 8 a.m. and 6 p.m., and that the boundaries of the center would be handled by internal security officers. December 24, 1943. Folder 10, Box 18, Manzanar Records, Special Collections, UCLA.

16. The book *Camp and Community: Manzanar and the Owens Valley* provides profiles of Inyo County residents. Consisting of oral histories of local residents conducted during the 1970s, the book reveals how many people held onto anti-Japanese attitudes after the war. The introduction reproduces an interesting article from the *Inyo Independent* of February 1942 that argues for the removal of all Japanese Americans "several hundred miles from the coast" because "you cannot trust a Jap." Many residents of the Owens Valley were very surprised when they learned that the removal would affect them so directly. Garrett and Larson, eds., *Camp and Community,* 5.

17. A Kibei is a Japanese American citizen who was educated in Japan. According to a recent interview with Ueno, he was blamed for the beating because he had accused WRA officials of stealing food meant for the Japanese Americans. See *Rabbit in the Moon,* directed by Emiko Omori (PBS, 1999).

18. This account of the Manzanar riot is summarized from Weglyn, *Years of Infamy,* 122–25; and Hansen and Hacker, "The Manzanar 'Riot,'" 41–79. The camp newspaper, the *Manzanar Free Press,* stopped production after December 5, 1942, and did not resume until December 25, 1942. Once production resumed, the paper noted one death had occurred on December 6th and two on December 11th. Although Manzanar had endured the riot and subsequently martial law, the newspaper did not refer overtly to either the tragedy or its aftermath. See "Death," *Manzanar Free Press,* December 25, 1942: 6.

19. In the days before the riot, the *Manzanar Free Press* reported two violent acts: "unknown culprits tried to set fire to the Department Store," and "three boys sentenced to six months in Manzanar jail for breaking a window of a police woman internee." See the *Manzanar Free Press,* December 3, 1942: 1 and 5, and December 5, 1942: 1.

20. Hansen and Hacker, "The Manzanar 'Riot,'" 50.

21. National newspapers, including the *Washington Post* and the *New York Times,* carried the story of the riot on the first anniversary of the bombing of Pearl Harbor. The *New York Times* headline read: "Army Halts Rioting by Coast Japanese: Pro-Americans are Attacked at Camp Containing 10,000." Special to the *New York Times, New York Times,* December 7, 1942: 16.

22. Ralph Merritt, memo to Lt. Col. Kenneth Craycroft, January 9, 1945. Appendix 21, Box 4, Manzanar Records, Special Collections, UCLA.

23. An article that appeared on the front page of the *Manzanar Free Press* articulated Merritt's hope for peace: "To establish peace and harmony within the center as the goal for the coming year was the essence of the talk given by Project Director Ralph P. Merritt at a meeting of a representative group of 108 people at town hall." See "Peace and Harmony Main Topic of Talk," *Manzanar Free Press,* January 16, 1943: 1.

24. Text written by Adams to accompany his exhibition, Manzanar: Photographs by Ansel Adams of Loyal Japanese-American Relocation Center. Manzanar File, Exhibition Records, Erna and Victor Hasselblad Study Center, Museum of Modern Art, New York City (hereafter Manzanar File, MoMA).

25. Ansel Adams, letter to Dillon Myer, October 5, 1944, Box 2, Adams Papers, UCLA.

26. Ansel Adams, letter to Nancy Newhall, January 19, 1944, Ansel Adams Archive, Center for Creative Photography, University of Arizona, Tucson, Arizona (hereafter cited as Adams Archive, CCP). Nancy Newhall, Beaumont Newhall's wife, took over the Department of Photography at the Museum of Modern Art after her husband left for military service. Adams was good friends with both Nancy and Beaumont. Nancy Newhall championed Adams's *Born Free and Equal* project, traveled out to Manzanar to see the concentration camp for herself, and organized the exhibition of the work for MoMA.

27. Weglyn, *Years of Infamy,* 28.

28. Daniels, *Prisoners Without Trial,* 88.

29. Final Report, Manzanar Relocation Center, Volume 1, pp. A43–45, A110–112, Folder 1, Box 4, Manzanar Records, Special Collections, UCLA.

30. Letter to Ralph Merritt included in the Final Report, Manzanar Relocation Center, Volume 1, p. A156, Folder 1, Box 4, Manzanar Records, Special Collections, UCLA.

31. Ralph Merritt memo to Lt. Col. Kenneth Craycroft, January 9, 1945, included in Final Report, Manzanar Relocation Center, Volume 1, p. A161, Folder 1, Box 4, Manzanar Records, Special Collections, UCLA.

32. *Executive Order 9066* CD-ROM. According to the Manzanar report, "309 segregated in October 1943, 1,876 in February 1944." The period of delay was noted as difficult due to clearance of status and lack of housing in Tule Lake. "Final Report," pp. 478–80, Box 4, Manzanar Records, UCLA.

33. For a particularly poignant fictional account of the psychic trauma following the release of a "no-no" boy (the slang term for someone who answered "no" to both questions 27 and 28) from prison and his return home, see Okada, *No-No Boy.*

34. Adams, *Born Free and Equal,* 39–40.

35. Adams's take on segregation closely mirrored that of Dillon Myer in his WRA publication "The Segregation Program," Box 58, Manzanar Records, UCLA.

36. Adams, *Born Free and Equal,* 40.

37. The office of reports, run by WRA officials, kept camp records and published the *Manzanar Free Press.* For a historical discussion of the camp newspaper, see Kessler, "Fettered Freedoms," 70–79. Also see Luther, "Reflections of Cultural Identities in Conflict," 69–81.

38. A small box labeled "Cleared Proofs" in the Ansel Adams papers at UCLA contains all of the proofs checked by the Office of Reports. The verso of these proofs contains titles, the names of the people in the photographs, and whether they were "cleared." See Box 2, Adams Papers, UCLA.

39. In addition to the examination of the photographs, Dillon Myer personally read through a draft of the book. In a letter, Adams thanks Myer for his attention: "fine having you at our home yesterday—your checking over my text here was most fortunate because it will save sending dummy to DC. And I am flattered that you did not find more points for clarification." Ansel Adams, letter to Dillon Myer, October 5, 1944, Box 2, Adams Papers, UCLA.

40. Robert L. Brown, letter to Ansel Adams, March 8, 1944, Box 2, Adams Papers, UCLA.

41. Box 2, Adams Papers, UCLA.

42. "Final Report," p. 480, Box 4, Manzanar Records, UCLA.

43. Ansel Adams, letter to Dillon Myer, July 31, 1944. Box 2, Adams Papers, UCLA.

44. Ansel Adams, letter to Ralph Merritt, November 16, 1943. Adams sent Merritt

a rough draft for comments, he did not yet have a publisher for the project. Box 1, Adams Papers, UCLA.

45. See Dower, *War without Mercy,* 81.

46. *Life,* January 13, 1941: 25.

47. Quoted in Dower, *War without Mercy,* 10.

48. Quoted in Foote, *Outcasts!,* n. pag.

49. Ibid.

50. Ansel Adams, Draft of Introduction to *Born Free and Equal,* Folder 11, Box 19, Manzanar Records, Special Collections, UCLA.

51. Adams, *Born Free and Equal,* 103.

52. Harold Ickes, letter to Ansel Adams May 30, 1944, Manzanar File, MoMA.

53. Ansel Adams, Draft of Introduction to *Born Free and Equal,* Folder 11, Box 19, Manzanar Records, Special Collections, UCLA.

54. Irony has been used in this manner particularly well by art historians in their discussions of nineteenth-century French painting, including Blake and Frascina in "Modernization," 111–26.

55. Hutcheon, *Irony's Edge,* 11.

56. For more about the experiences of imprisoned children see Tong, "Race, Culture, and Citizenship," 3–40.

57. Manzanar's Final Report noted the gendered terms on which guilt was based: "A woman was loyal because she was a woman or because it was too much trouble or impossible to find out the facts, or because some man would do her thinking for her." Unbound copy of Final Report, Manzanar Relocation Center, Vol 1, Project Director's Report. Report supervised by Robert L. Brown, Folder 1, Box 4, Manzanar Records, Special Collections, UCLA.

58. An interesting children's book on the role of baseball in incarceration camps, which bases some of its illustrations on Adams's photographs, is Mochizuki, *Baseball Saved Us.*

59. Adams also made a photograph of the Yonemitsus in their living room, which was not reproduced in the book. In this image, a Beethoven record case was pulled from the shelf and displayed—a gesture Adams would have likely encouraged as he had trained to be a classical pianist before devoting himself to photography. In the background of the image, the radio with the grouping of objects on top is visible, indicating that it was likely that Adams found the arrangement and did not group the objects himself. See Box 2, Adams Papers, UCLA.

60. After the executive order, Nisei draft status had been lowered to 4-C, enemy alien, despite the fact that they were American born and U.S. citizens. The draft was reinstated in January 1944 for male Japanese Americans who had answered yes to the loyalty questions. Some Nisei protested the government reinstatement of the draft and refused to serve in the military while their citizenship rights and the freedom of their families remained abridged. Many of these protesters were sent to higher security jails for the remainder of the war. Daniels, *Prisoners without Trial,* 35, 64.

61. Adams, *Born Free and Equal,* 56.

62. Francis Stewart made at least three photographs of Lucy Yonemitsu dated February 12, 1943, in Manzanar, Calif. Photos 210–G-B179 (ARC # 536922); 210–G-B180 (ARC # 536942); and 210–G-B181 (ARC # 536924), NACP. Burt Minura also appears in the work of both Stewart and Adams.

63. For more on Children's Village, see Nobe, "The Children's Village at Manzanar," 65–71.

64. Adams acknowledges these difficulties in "The People": "Traditionally a clean people, the evacuees are phenomenal in their management of person and home under difficult circumstances; the barracks are without running water or other facilities except electric lights and oil heaters." Later in the text, he writes, "The evacuation made family life difficult in many ways; it created for children of impressionable age environmental problems that will be hard to eradicate." See Adams, *Born Free and Equal,* 52, 58.

65. Takemoto, *Nisei Memories,* 176.

66. Ralph Merritt, "Your World," Manzanar High School Commencement Speech, July 3, 1943, Folder 6, Box 18, Manzanar Records, Special Collections, UCLA.

67. Dr. Edwin E. Lee, Dean of the School of Education, UCLA, "Pioneers of 1945," Draft of Speech delivered to Manzanar High School Commencement, June 2, 1945, Folder 7, Box 18, Manzanar Records, Special Collections, UCLA.

68. Ralph Merritt, Draft of Editorial for *Manzanar Free Press,* August 17, 1945, Folder 3, Box 18, Manzanar Records, Special Collections, UCLA.

69. For a fascinating study of the visual construction of San Francisco's Chinatown, see A. W. Lee, *Picturing Chinatown.*

70. Teruko Hayashi, "Graduation Speech," Folder 7, Box 18, Manzanar Records, Special Collections, UCLA.

71. In Manzanar's Final Report, moments of conflict are described in detail, including the distribution of bulletins by "underground" groups who critiqued government policy and who offered a rebuke of the pioneer myth in their appraisal of furlough work: "The white man told us to get out of California; now they want to use us as economic serfs. Do not go on furlough!" Final Report, Manzanar Relocation Center, Volume 1, p. A31, Folder 1, Box 4, Manzanar Records, Special Collections, UCLA.

72. Several photographs made during the Manzanar project have since become detached from *Born Free and Equal* and are consumed on merely a formal level. Adams never insisted that every photograph made for the project had to be published within its wartime context.

73. As Anne Hammond points out, "Adams avoided photographing activities which would identify internees as culturally more Japanese than American," including the making of geta sandals. Hammond, "Ansel Adams at Manzanar Relocation Center," 253.

74. Adams, *Born Free and Equal,* 56.

75. War Relocation Authority, *The Evacuation,* 92.

76. Quoted in Chin, "Come All," 58.

77. Adams, *Born Free and Equal*, 36.

78. One important difference between Masaoka and Adams, however, is that Masaoka was an active agent in government policy regarding Japanese Americans and Adams was promoting a system already in place.

79. Agamben, *Homo Sacer*, 166–71

80. Daniels, *Prisoners Without Trial*, 20.

81. See Grover, "The Winner Names the Age," 14–18.

82. Adams, *Born Free and Equal*, 110. Adams quoted a letter he received from Myer. See Dillon Myer letter to Ansel Adams, July 21, 1944. Box 2, Adams Papers, UCLA.

83. Ansel Adams, letter to Tom Maloney, September 16, 1944, Box 2, Adams Papers, UCLA.

84. It is this aspect of *Born Free and Equal* Stephen Sumida discussed in a 1995 paper on John Okada's *No-No Boy*. Sumida, "John Okada's *No-No Boy*."

85. Ansel Adams, letter to Harold Ickes, June 6, 1944. Box 2, Adams Papers, UCLA.

86. M. S. Alinder, *Ansel Adams*, 235–36. See "Best Sellers of the Week," *San Francisco Chronicle*, March 11, 18, 25, and April 1, 1945.

87. Embrey, "Born Free and Equal," 24.

88. Beaumont Newhall, letter to Ansel Adams, February 1, 1945, Adams Archive, CCP.

89. There were pamphlet publications like *OUTCASTS!* by Caleb Foote that argued against the incarceration and asserted the falseness of the charge that Japanese Americans were unassimilated. Robert Shaffer has written about those outside of the camps who opposed the incarceration. See his "Cracks in the Consensus," 84–120, and "Opposition to Internment," 597–619.

90. In addition to the 2002 version of *Born Free and Equal* edited by Wynne Benti, John Armor and Peter Wright published many of Adams's Manzanar photographs in their book *Manzanar*. Also, Emily Medvec published some of *Born Free and Equal* in a catalog to accompany an exhibition; see Medvec, *Born Free and Equal*.

91. Adams, *Born Free and Equal*, 58.

Chapter 3: The Right to Represent

1. Nobuho Nagasawa, *Toyo Miyatake's Camera*, 1993. The sculpture is 18" × 18" × 21¾" on top of a 4' high tripod. 369 East First Street, Los Angeles, California.

2. For a moving account of the making of the Japanese American National Museum's important exhibition, America's Concentration Camps, see Ishizuka, *Lost and Found*, 57–117.

3. Elena Tajima Creef notes that Toyo Miyatake was fictionalized as Mr. Zenihiro in the very popular 1976 television movie based on Jeanne Wakatsuki Houston's novel *Farewell to Manzanar*. Creef characterized Zenihiro as a "heroic, underground

chronicler of internment camp history and experience." Mr. Zenihiro was played by Pat Morita. Creef, *Imaging Japanese America*, 57.

4. The Miyatake family photography studio exists today, though it has moved from its Little Tokyo address: Toyo Miyatake Studio, San Gabriel Village, 235 West Fairview Avenue, San Gabriel, California 91776, www.toyomiyatake.com.

5. The exhibition, Three Generations: Toyo Miyatake Studio, was held in the Japanese American Cultural and Community Center in Los Angeles from February 21 through April 5, 1998.

6. Toyo Miyatake's wife became the business manager and his son Archie worked as his assistant.

7. Edward Weston, letter to Tina Modotti, August 1925. Quoted in Miyatake, Fujishima, and Hosoe, eds., *Toyo Miyatake*, 11.

8. *Toyo Miyatake: Infinite Shades of Gray*, directed by Robert Nakamura. See also Higa and Wride, "Manzanar Inside and Out," 327.

9. Bulletin no. 135 from March 30, 1942, gives instructions for the move to assembly centers, including "No contraband items as described . . . may be carried." See Box 1:11 MSS 97/145C, Dorothea Lange Papers, Bancroft Library. It was not until February of 1945 that Manzanar's project director issued bulletins that revoked the contraband regulations. The return of the right to use a camera, however, applied only to citizens. Bulletins 74 and 75, February 19, 1945, Folder 13, Box 7, Manzanar Records, Special Collections, UCLA.

10. Miyatake, Fujishima, and Hosoe, eds., *Toyo Miyatake*, 5.

11. See Howe, Markham, Nagatani, and Rankin, eds., *Two Views of Manzanar*.

12. Archie Miyatake, personal interview, August 3, 1998.

13. The story surrounding his smuggled camera often leads to the assumption that such a risk would only be taken in order to provide evidence of abuse. Miyatake's photographs, however, do not depict such trauma. I maintain in this chapter that as a dedicated artist, Miyatake could not live without a camera. For him, being able to continue his creative production was worth the risk. It is important to interrogate why a smuggled camera assumes evidentiary images. As Kobena Mercer has argued in a chapter titled "Black Art and the Burden of Representation": "When artists are positioned on the margins of the institutional spaces of cultural production, they are burdened with the impossible task of speaking as 'representatives,' in that they are widely expected to 'speak for' the marginalized communities from which they come." Miyatake's photographs did speak to the community of Manzanar, but to ask them to speak for the full experience of incarceration is placing too large of a burden on the legs of his tripod. Mercer, *Welcome to the Jungle*, 235.

14. According to Miyatake in a 1974 interview, he stayed in his barrack and sat quietly during the riot. Transcription of taped interview conducted by Joe Grant Masaoka, transcribed by Nancy Ross, December 5, 1974, Tape 54, Box 519, Collection 2010, Japanese American Research Project, University Research Library, Department

of Special Collections, University Research Library, University of California, Los Angeles (hereafter cited as JARP, Special Collections, UCLA).

15. Daniels, Taylor, and Kitano, "Chronology," xx.

16. "Cooperative Enterprises Serve Residents' Needs," *Manzanar Free Press,* September 10, 1943: 5.

17. The WRA's stated goal was to make "each relocation center . . . as nearly self-sufficient as possible." See United States Department of the Interior, *Relocation Communities,* 3.

18. Ibid.

19. Hiroshi Neeno, "Co-op Information Bureau," *Manzanar Free Press,* February 10, 1943: 3.

20. Archie Miyatake, personal interview, August 3, 1998.

21. Japanese Americans, including professional artists and amateurs, created a large body of other visual material, including paintings and sketches during their time in camp. Many of these works communicate disapproval of and resistance to incarceration. Work by such artists was exhibited in a 1972 exhibition titled Months of Waiting, organized by the California Historical Society and the Japanese American Citizens League. For a study of such representations, see Higa, *The View from Within.*

22. Section on Cooperative Enterprises, Final Report Manzanar Relocation Center, Folder 1, Box 5, Manzanar Records, Special Collections, UCLA.

23. "A Nisei Mother Looks at Evacuation," Community Analysis Section, Manzanar Relocation Center, October, 26, 1943, Folder 2, Box 7, Manzanar Records, Special Collections, UCLA.

24. "Photo Studio to Hold Grand Opening Monday," *Manzanar Free Press,* April 10, 1943: 1.

25. According to an oral history interview conducted in 1974, Miyatake claims to have received all of his photographic equipment in camp from his storage facility because the storage company went bankrupt. Transcription of taped interview conducted by Joe Grant Masaoka, transcribed by Nancy Ross, December 5, 1974. Tape 54, Box 519, Collection 2010, JARP, Special Collections, UCLA.

26. "Local Studio Presents Status and Personnel," *Manzanar Free Press,* April 21, 1943: 1. The proposed plans for the studio also highlighted the talents of Jack Iwata, who had worked in Toyo Studios before the war, and Robert Arikawa, who was to serve as an apprentice. "Projects Planning and Research Bureau Proposed Plans for Portrait Studio," Box 15, Folder 9, Manzanar Records, Special Collections, UCLA.

27. *Manzanar Free Press,* Saturday, April 10, 1943: 1.

28. "Photo Studio Temporarily Closed Due to Lack of Photographer," *Manzanar Free Press,* May 29, 1943: 1.

29. *Manzanar Free Press,* Saturday, May 29, 1943: 1.

30. "Grads Reminded About Pictures," *Manzanar Free Press,* June 28, 1943: 3.

31. The ban on cameras was not lifted until early 1945, but this only applied to citizens. Non-citizens were still forbidden from owning or operating a camera. Ralph Merritt, Project Director's Bulletin No. 74, February 19, 1945, Folder 13, Box 7, Manzanar Records, Special Collections, UCLA.

32. Miyatake, Fujishima, and Hosoe, eds., *Toyo Miyatake*, 12.

33. Ibid.

34. This interview also implies that Miyatake was not captured with his camera, either because the administrator failed to learn of its existence or chose not to act on this knowledge if he did.

35. In December 1934, Weston wrote Adams, asserting that there was social significance in a rock as well as a line of unemployed people. See Edward Weston, letter to Ansel Adams, December 3, 1934, in M. S. Alinder and Stillman, eds., *Ansel Adams*, 75–76.

36. Photographers who photographed Manzanar but were sponsored externally, including Ansel Adams and Dorothea Lange, were also unmentioned. Robert L. Brown, "Final Report: Manzanar Relocation Center, Division Functional Reports," Vol. II, Box 4, Manzanar Records, Special Collections, UCLA.

37. "$5000 Fine or Prison Term for Law Violation," *Manzanar Free Press*, June 2, 1943: 1.

38. According to a letter to Dillon Myer from Ralph Merritt, as of December 24, 1943, all military guards were to be withdrawn from the towers and the gates between 8 a.m. and 6 p.m., during which time internal security officers would be in charge. Letter from Ralph Merritt to Dillon Myer. December 24, 1943, Folder 10, Box 18, Manzanar Records, Special Collections, UCLA. A figure appears to be climbing either up or down the tower's ladder. Thanks to Stephanie Morimoto for pointing out this detail to me.

39. National Japanese American Historical Society, *Teacher's Guide*, ii.

40. The two uses of the Miyatake photograph also utilize different croppings of the image.

41. Fleeman, "Manzanar—Bittersweet Tourist Park," *San Francisco Chronicle*, A18. The photograph reproduced in the newspaper is a variant of "Boys Behind Barbed Wire" in which the boys are positioned closer together and the boy in the middle no longer hangs onto the fence.

42. The *San Francisco Chronicle* claimed that the National Park Service owns the photograph. Personal communication between Michele Levandowski and *San Francisco Chronicle*, March 29, 2005. According to Archie Miyatake, the Miyatake family owns the photograph. According to Alisa Lynch, chief of interpretation and cultural resources management at the Manzanar National Historic Site, the National Park Service has copies and occasionally purchases temporary use rights for displays but they do not own the copyright. Many incorrectly assume that the image is government produced. Personal communication between Michele Levandowski and Alisa Lynch, March 30, 2005.

43. Archie Miyatake, personal interview, March 20, 1998.

44. See Rosler, "in, around, and afterthoughts," 306.

45. Although there has been major rethinking in the discipline of anthropology on the validity of ethnography performed by outsiders on insiders, that relationship still is not sufficiently questioned as it is reproduced in other representational practices such as documentary photography. Kirin Narayan argues that the categories of "insider/native" and "outsider/non-native" are limiting in that they privilege an "authentic" view of the "insider" and fail to conceptualize the cultural identities of all anthropologists as shifting and transformative. See Narayan, "How Native," 671–86. Also see the classic volume by Clifford, *The Predicament of Culture.*

46. Rosler, "in, around, and afterthoughts," 308.

47. Rosler describes the subject of documentary photography as the "group of powerless presented to the socially powerful." See Rosler, "in, around, and afterthoughts," 306. Abigail Solomon-Godeau describes FSA photography as representing the poor for "a different class of audience" and as a reproduction of dominant social relations. See Solomon-Godeau, *Photography at the Dock,* 178, 180.

48. Narayan, "How Native," 676.

49. Archie Miyatake, personal interview, March 20, 1998.

50. According to Archie Miyatake, it was also possible that a friend of his father's who was a police officer might have taken Toyo Miyatake to the outskirts of Manzanar to photograph. Archie Miyatake, personal interview, August 3, 1998.

51. Solomon-Godeau, *Photography at the Dock,* 176.

52. Toward the end of the incarceration, Miyatake was allowed to travel to the Poston and Gila River concentration camps in Arizona to make photographs of art works produced by Japanese Americans for a book on camp art. Eaton's *Beauty Behind Barbed Wire* sought to cultivate "appreciation and love for . . . our people of Japanese ancestry," as well as celebrate the "distinguished record of the War Relocation Authority." See Eaton, *Beauty Behind Barbed Wire,* xiii. Miyatake's photographs were not included as examples of prisoner artistic production. A much later publication on artistic production inside camp did cite Miyatake as an artist in his own right. See Okutsu, *Expressions from Exile,* 9.

53. Honda, ed., *Our World,* n. pag. This citation is from the reprinted 1944 yearbook of Manzanar High School, which includes updates on the lives of the yearbook's editors.

54. In her discussion of FSA photographs, Maren Stange has discussed the sometimes disruptive relationship between text and image. See Stange, "Documentary Photography in American Social Reform Movements," 205.

55. See James, *Exile Within.*

56. There were both white and Japanese American teachers working as educators in concentration camp schools. Japanese American teachers were subordinated to the white staff by decreased pay and status. Ibid., 57–60.

57. Rollin C. Fox, "Manzanar Secondary School," Education Section Summary, War

Relocation Authority, May 31, 1945. Box 59, Manzanar Records, Special Collections, UCLA.

58. Honda, *Our World,* n. pag.

59. In retrospect, these images read as haunting memorials to forfeited youth. Like the photographic installations of contemporary artist Christian Boltanski, the repeating rows of faces with similar smiles, matching outfits and neatly combed hair suggest trauma through their very banality. Boltanski's *Altar to the Chases High School* (1987) serves as a memorial to the youth whose lives were extinguished during the Holocaust. In this work he blurs the students' faces in a way that obscures individual identities but still allows their expressions to be legible. Thus rendered, the faces stand for an individual and thousands at the same time.

60. Archie Miyatake, personal interview, August 3, 1998.

61. When asked how the photograph of the pliers was allowed by Janet Goldberg, the yearbook advisor, Archie Miyatake explained that she interpreted it as showing a positive move towards relocation out of the camp. Archie Miyatake, personal interview, August 3, 1998.

62. Honda, *Our World,* n. pag.

63. The chapter of Monica Sone's autobiography, *Nisei Daughter,* devoted to the wedding of her brother Henry expresses the significance of these types of life events during incarceration. The families of the bride and groom acquired town passes so that the actual ceremony could take place in Twin Falls (the reception took place in the camp), and the photographs could be made in a professional studio. Despite their incarceration and the tension during the photo shoot ("The hysteria of the wedding preparations was plainly reflected in all our faces in the finished picture. The photographer valiantly tried to make the eleven of us relax and look natural. . . ."), the wedding photographs remained an essential part of the marriage ritual. Sone, *Nisei Daughter,* 208. I am grateful to Stephen Sumida for calling my attention to Sone's work.

64. P. Chikahisa, quoted in Mass, "Psychological Effects," 160.

65. Bruce Kaji, quoted in Honda, *Our World,* n.pag.

66. A line at the bottom of the September 6, 1944, issue of the *Manzanar Free Press* asks residents if they have remembered to register to vote. According to Roger Daniels, incarcerated Japanese American citizens did not have their right to vote suspended, and could in theory have applied to vote as absentees from their home districts. In point of fact, however, few Nisei were of voting age (21 at that time) during the incarceration. E-mail to Jasmine Alinder from Roger Daniels, July 17, 2007.

Chapter 4: Art/History

1. For analyses that focus on the Japanese American National Museum's exhibition America's Concentration Camps, see Ishizuka, *Lost and Found,* 57–117, and Creef, *Imaging Japanese America,* 119–43.

2. Dorothea Lange encouraged Adams to get his Manzanar work out as quickly as

possible via newspaper articles. Dorothea Lange, letter to Ansel Adams, November 12, 1943, Box 2, Adams Papers, UCLA.

3. One example of the many rejection letters Adams received was from Marshall Field of the *Chicago Sun*. In it Field tersely stated that he was "unable to be of any help." Marshall Field, letter to Ansel Adams, December 2, 1943, Box 2, Adams Papers, UCLA.

4. Ansel Adams, telegram to Nancy Newhall, January 19, 1944, Manzanar Records, MoMA.

5. M. S. Alinder, *Ansel Adams*, 175.

6. Newhall, *The History of Photography*.

7. M. S. Alinder, *Ansel Adams*, 165. Lynes, *Good Old Modern*, 160.

8. Newhall et al., "The New Department," 4–5.

9. Newhall wrote that "through the very facility of the medium, its quality may become submerged." Newhall et al., "The New Department," 4.

10. Newhall et al., "The New Department," 5.

11. Phillips, "The Judgment Seat," 21.

12. Barr's 1942 exhibition Painting and Sculpture in the Museum of Modern Art, for example, created a history and context for the works on view by naming the major art movements of the early twentieth century and then explaining those categories and listing each artist whom the curators felt fit them. Barr, *Painting and Sculpture*.

13. Lynes, *Good Old Modern*, 233–38.

14. Edward Steichen's position on photographic aesthetics had changed quite drastically from his early days as a photographer at the turn of the century. At that time, Steichen had been a committed pictorialist and founding member of the Photo-Secession, a group that sought to raise the status of photography to that of fine art through images that adopted soft-focus and other techniques to obscure photographic precision. Newhall, *The History of Photography*, 158–60, 183–84, 263–66.

15. Road to Victory press release, Road Records, MoMA.

16. Staniszewski, *The Power of Display*, 145.

17. Bayer's exhibition designs for Steichen employed El Lissitzky's principles but, as Benjamin Buchloh has pointed out, Bayer and Steichen appropriated the exhibition techniques to other ideological ends: "What in Lissitzky's hands had been a tool of instruction, political education, and the raising of consciousness was rapidly transformed into an instrument for prescribing the silence of conformity and obedience." Buchloh, "From Faktura to Factography," 69.

18. Chanzit, *Herbert Bayer*, 20.

19. Phillips, "Steichen's Road to Victory," 41.

20. Phillips, "Judgement Seat," 44n46.

21. Newhall et al., "New Department," 4.

22. Quoted in Phillips, "Judgement Seat," 39. Steichen's definition of the "inherent characteristics" of the photograph had changed dramatically from his pictorialist days of the 1900s-20s.

23. Road Records, MoMA.

24. Cohen, *Herbert Bayer*, 302.

25. "Road to Victory," *Art Digest*, 5

26. Staniszewski, *Power of Display*, 209.

27. Beaumont Newhall, letter to Ansel Adams, June 3, 1942, Adams Archive, CCP.

28. Ansel Adams, letter to Alfred Stieglitz, August 22, 1943, Adams Archive, CCP.

29. Newhall et al., "New Department," 5.

30. Harold Ickes, letters to Ansel Adams, May 30 and June 16, 1944, Box 2, Adams Papers, UCLA. This tour was never realized.

31. Ralph Merritt, letter to Ansel Adams, July 11, 1944, Box 2, Adams Papers, UCLA. I have not been able to locate an exhibition checklist for either of the two Manzanar showings so it is impossible to determine whether one differed from the other.

32. Memo to Nancy Newhall, June 30, 1944, Manzanar Records, MoMA.

33. Ralph Merritt, letter to Elodie Courter, August 21, 1944, Box 2, Adams Papers, UCLA.

34. Ansel Adams, letter to Ralph Merritt, August 23, 1944, Adams Papers, UCLA.

35. Elodie Courter, letter to Ralph Merritt, September 6, 1944, Adams Papers, UCLA.

36. David McAlpin, letter to Ansel Adams, September 1944, Adams Archive CCP.

37. Nancy Newhall, letter to Ansel Adams, July 20, 1944, Adams Archive CCP. Although I have not come across a letter that explains why the committee would have preferred a general exhibition on racial intolerance, it seems clear that committee members were uncomfortable with an exhibition that dealt exclusively with Japanese Americans.

38. Ansel Adams, letter to Nancy Newhall, July 23, 1944, Adams Archive CCP.

39. Lynes, *Good Old Modern*, 237.

40. Quoted in Lynes, *Good Old Modern*, 233. The Central Press story appeared on June 20, 1941.

41. Ansel Adams, letter to Nancy Newhall, August 23, 1944, Manzanar Records, MoMA

42. Nancy Newhall, letter to Sara (NewMyer?), June 15, 1944, Adams Papers, UCLA.

43. Nancy Newhall, letter to Ansel Adams, October 5, 1944, and Monroe Wheeler to James Soby, Director Armed Services Program, October 26, 1944, Manzanar Records, MoMA.

44. Ansel Adams, *Born Free and Equal*, 110.

45. Ansel Adams letter to Nancy Newhall, October 23, 1944, Adams Archive CCP.

46. Nancy Newhall, press release, Manzanar Records, MoMA.

47. In the book, images were paired as book display dictates.

48. In one of the Manzanar exhibitions, this portrait was also positioned at one end of the display, but it is not possible to determine from the installation photograph whether it is at the exhibition's beginning or end.

49. David McAlpin, letter to Ansel Adams, December 1944, Adams Archive CCP.

50. Ansel Adams, letter to Beaumont Newhall, December 24, 1944, Adams Archive CCP.

51. Ansel Adams, letter to David McAlpin, December 30, 1944, Adams Archive CCP.

52. Ansel Adams, letter to Beaumont Newhall, March 1, 1945, Adams Archive CCP.

53. M. S. Alinder, *Ansel Adams,* 220.

54. John Szarkowski, Steichen's successor, rejected Steichen's technique and asserted an aesthetic approach to photography that Peter Galassi, the current chief curator of the Department of Photography, carries on. Szarkowski and Galassi's approach to photography, radically different than Steichen's, was also different from Newhall and Adams's in that Szarkowski de-emphasized photography's technical history and the significance of print quality, and developed an aesthetic trajectory that came out of street photography and culminated in the work of photographers such as Garry Winogrand.

55. Edward Weston, "Pepper No. 30.," 1930. Galassi, *American Photography,* 110.

56. Duncan, *Civilizing Rituals,* 17.

57. Remarkably, at the same moment I was critiquing American Photography, anthropologist Lindsey French was in the exhibit next door formulating a devastating assessment of the MoMA exhibit of Cambodian prisoner photographs. See French, "Exhibiting Terror," 131–56.

58. In Dorothea Lange's 1966 one-person exhibition in MoMA, two photographs from the period of WWII were included: the photograph of the billboard and the young girls pledging allegiance (figures 7 and 8). In the exhibition's catalog, both images are dated 1942. In the back of the catalog, more precise information is given in a reprinted excerpt from Lange's notes, which provides the wartime context of Japanese American evacuation. Elliot, *Dorothea Lange,* 54–55, 104.

59. http://americanhistory.si.edu/perfectunion/experience/

60. Jennifer Locke, personal interview, February 9, 1998.

61. Ibid.

62. Crew and Sims, "Locating Authenticity," 159–75.

63. Examples of this type of history museum include the U.S. Holocaust Memorial Museum in Washington, D.C., with exhibits designed by Ralph Applebaum Associates, and the Museum of African American History in Detroit.

64. Tom Crouch, personal interview, February 10, 1998.

65. Ibid.

66. Tagg, *The Burden of Representation*, 12.

67. In his film about Japanese American incarceration, *Come See the Paradise* (1990), director Alan Parker based much of the movie's look on WRA photographs. One quick shot, for example, draws on Lange's photograph of the Oakland store-front with the "I am an American" sign. In the movie, the still image is activated by a vandal who breaks the store's window.

68. The caption for the Albers photograph reads, "Scene at Fuji Hotel prior to evacuation of residents of Japanese ancestry from this area." Photo # 210–G–B61 (ARC # 536810), USNA.

69. For an account of how whiteness in the context of citizenship was redefined during the nineteenth and twentieth centuries to include some immigrant groups and exclude others see Jacobson, *Whiteness of a Different Color*. See also Haney Lopez, *White by Law*, and Ngai, *Impossible Subjects*.

Chapter 5: Virtual Pilgrimage

1. Creef, *Imaging Japanese America*, 18.

2. Other contemporary photographers of Japanese American concentration camp sites include Joan Myers and Christopher Landis. Myers's photographs of the ten sites and of objects she has found in them are published in her book *Whispered Silences*, which includes an essay by Gary Okihiro. Landis has photographed only Manzanar and produced the photographs, along with poetry, essays, map, and bibliography in a limited edition portfolio titled *Pilgrimage: Images from Manzanar*.

3. According to the Manzanar National Historic Site Web page, the site became a California Registered Historical Landmark in 1972 and a National Historic Site twenty years later. See http://www.nps.gov/manz/index.htm. For an analysis of the process by which certain sites become officially marked and others not, see Jordan, *Structures of Memory*.

4. See Tateishi, "The Japanese American Citizens League," 191–95, and Daniels, "Redress Achieved," 219–23.

5. According to Frank and Joanne Iritani, annual pilgrimages to Manzanar began in December 1969. See Iritani and Iritani, *Ten Visits*, 20. Before the Iritanis' insightful guide appeared, the Asian Student Union of Los Angeles City College published directions in 1977 for a self-guided tour of Manzanar. Manzanar has been a National Historic Site in name since 1992, but only in the summer of 1997 did the National Park Service take full control of the land. In 1998, the Manzanar Committee published a very helpful guide titled *Reflections in Three Self-Guided Tours of Manzanar*, which includes maps and photographs. Now in addition to the exhibition in the visitors center, the National Park Service also hands out brochures leading people on a self-guided driving tour of the site.

6. Nora, "Between Memory and History," 7–24.

7. Purdum, "U.S. Starts to Dust Off," *New York Times*, A6.

8. Ibid.

9. Michi Weglyn attributes this desire to the impact of the civil rights movement and the Vietnam War. Weglyn, *Years of Infamy,* 279. During the 1990s in particular, many Sansei have given voice to their own psychological stress over their parents' incarceration. This articulation of incarceration's legacy is seen not only in photographs by Nagatani and by Masumi Hayashi, but in other creative media, including videos by Rea Tajiri and Janice Tanaka, the poetry of Lawson Inada, the scholarship of Karin Higa, the writing of David Mura, and community based discussion groups such as the Sansei Legacy Project in Alameda, California. Also see Nakao, "Sansei Dig up Buried Roots," C-1+.

10. Janis, *Nuclear Enchantment,* 10.

11. My meeting with the Nagatanis took place on August 2, 1998.

12. Nagata, *Legacy of Injustice,* 99. Other reasons Nagata provides for the silence of Nisei on the issue of incarceration include: repression associated with post-traumatic stress disorder, attempts to protect their children from the burden of incarceration, belief that their experiences are incomprehensible to others, and a perception that Sansei might not have been interested. Nagata, *Legacy of Injustice,* 100–101. Also see Nagata, "Japanese American Internment," 47–69.

13. Ishizuka, *Lost and Found,* 125–26.

14. Quoted in Gensensway and Roseman, *Beyond Words,* 15–16.

15. For a recent example of the despicable practice of the justification of incarceration, see Malkin, *In Defense of Internment.*

16. See Okada, *No-No Boy,* and Sone, *Nisei Daughter.*

17. See Sumida, "Protest and Accommodation," 207–47.

18. An interesting collection of papers that addresses "the relationship between the experience of cultural displacement and the construction of cultural identity" is Bammer, ed., *Displacements,* xiv.

19. Young applies the term "countermonument" not to artifacts that remain in their sites of use, but to self-consciously constructed memorials that refuse to adopt the traditional vocabulary of memorial architecture and instead focus on the problem of remembrance itself. Young, *The Texture of Memory,* 27–48.

20. In Jerome, the same family has owned the land on which the incarceration site was built for 180 years. The grandchildren of the man who rented the property to the government for the concentration camp gave Nagatani permission to photograph and showed him where the few obscured, surviving ruins of the camp lay. Nagatani in turn signed a book owned by the man, which logs visitors to the property. This interaction gave Nagatani access to the site beyond the opaque public facade of the memorial marker, enabling him to reflect on the intersection of histories present in these environments.

21. The marker's text reads: "Jerome, Relocation Center, 1942–1944, On February 19, 1942, Pres. Franklin Roosevelt signed into law Executive Order No. 9066, interning over 120,000 persons of Japanese ancestry, and this act irrevocably changed

their lives. The majority of these people were American citizens. As a result of all this war time hysteria these people were forcibly removed from their homes on the West coast of the United States and also in Hawaii to be interned by the War Department in one of the ten relocation centers located in the interior of the U.S.A. At Jerome there were over 6,700 interned from September 1, 1942 and through July 1944. These temporary shelters with shared living quarter [*sic*] community dining halls and gathering facilities were the norm. Constant on-going surveillance by the army served as a constant reminder of each resident's captivity and loss of freedom. This memorial is dedicated by the Jerome Preservation Committee an [*sic*] also the Japanese American Citizen League to those persons of Japanese ancestry who suffered the indignity of being incarcerated because of their ethnic background. May this monument serve to remind us of all these incidents and inspire us to be more vigilant and more alert in the safe guarding of the rights of all Americans, regardless of their race, color or creed."

22. Daniels, *Prisoners Without Trial*, 58. Weglyn, *Years of Infamy*, 44.

23. Young, "Memory and Counter-Memory," 82.

24. In translation the marker reads, "August 1943; Monument to the dead Japanese of Manzanar." Translation by David Rosenfeld.

25. By "phenomenological" I mean that the images call into question how the photographer—and by proxy, the viewer—come to know objects, and how those objects are reconciled within their sites. For an explanation of phenomenology, see Ihde, *Experimental Phenomenology*.

26. Alpers, *The Art of Describing*, 133–35.

27. Howe et al., eds., *Two Views of Manzanar*.

28. The caption for this figure reads, "This must have been a cruel sight for the internees who had owned cars. The cars they drove to the camp were confiscated and then left here to rust," see Miyatake et al., eds., *Toyo Miyatake*, 51.

29. Taylor, *Jewel of the Desert*, 92–93.

30. See Bright, "Mother Nature and Marlboro Men."

31. This trajectory, which projects twentieth-century aesthetic discourse onto nineteenth-century photographers, has been brought into question by Krauss in her essay "Photography's Discursive Spaces," 293.

32. Szarkowski, *American Landscapes*, 5.

33. See Szarkowski, *New Topographics;* and Baltz, *The New Industrial Parks,* Plate 14, "Foundation Construction, Many Warehouses, 2892 Kelvin, Irvine, California."

34. Patrick Nagatani, personal interview, December 5, 1995.

35. See Szasz and Nagatani, "Constricted Landscapes," 157–88; and Alinder, *Virtual Pilgrimage*.

36. I purposely use the word "art" to modify "photography," although I am aware that scholars such as Abigail Solomon-Godeau have defined postmodern photography in opposition to art photography. Looking back on the 1980s, it seems more accurate to say that postmodern photography became art photography, as work by

artists such as Cindy Sherman, Barbara Kruger, and Richard Prince monopolized galleries, reviews, articles, books, museums, and commercial sales. Issues of aesthetics may be a point of contention, but the lack of technical finish in much postmodern photography became itself a stylistic tool to signify art world photography. See Solomon-Godeau, *Photography at the Dock,* 103–23.

37. Patrick Nagatani, personal interview, November 27, 1995.

38. Kugelmass, "The Rites of the Tribe," 382–427.

39. Ibid., 412–13.

40. Hayashi died tragically in 2006. Her work lives on through exhibitions and on the Web. See www.masumimuseum.com and www.masumihayashi.com.

41. Masumi Hayashi, personal interview, July 19, 1999.

42. Hayashi's first panoramic photo collages were made in 1985 from 3-D photographs taken with a Nimslo 3-D camera, but she found that back-to-back 3-D photographs made visual coherency a problem. She then began and continued to use a 35mm Nikon manual camera. Masumi Hayashi, personal interview, July 19, 1999.

43. On Bentham's invention of the panopticon as a mode of penal surveillance, see Foucault, *Discipline and Punish,* 195–228.

44. Masumi Hayashi, personal interview, July 19, 1999.

45. Ibid.

46. *Who's Going to Pay for These Donuts Anyway?* directed by Janice Tanaka (1995); and *History and Memory,* directed by Rea Tajiri (1991). See Sturken, "Absent Images of Memory," 687–707.

47. Masumi Hayashi, personal interview, July 19, 1999.

48. The process of sending out apologies and payments took several years. They were sent out to the oldest surviving, former prisoners first. As she was one of the youngest, Hayashi did not receive her payment until 1993, hence her apology is signed by President Clinton.

49. Masumi Hayashi, artist's statement accompanying the exhibition Transition/ Dislocation: Images of Upheaval, curated by Marjorie Talalay for the Cleveland Center for Contemporary Art, Cleveland, Ohio, November 15, 1996–January 26, 1997.

50. See www.masumihayashi.com.

51. Spickard, *Japanese Americans,* 130.

Epilogue

Epigraph. From Soga, "Death at the Camp," 64.

1. Davidov, "'The Color of My Skin,'" 240.

2. Sturken, "Absent Images of Memory," 694.

3. Zelizer, "From the Image of Record," 104–7.

4. Ibid., 107.

5. Sturken, "Absent Images of Memory," 695.

6. Fumiko Hayashida, personal interview, July 1999.

7. Conrat and Conrat, *Executive Order 9066,* 43.

8. Hayashida collection.

9. Tokuda and Adada, "Fumi Hayashida," Hayashida collection.

10. Hayashida collection.

11. Rosler, "in, around, and afterthoughts," 315–16. Thompson died in 1983.

12. Partridge, "Migrant Mother—Icon or Person?" www.elizabethpartridge.com, May 8, 2006.

13. Sturken, "Absent Images of Memory," 690.

Bibliography

Archives

Ansel Adams Archive. Center for Creative Photography. University of Arizona. Tucson, Ariz.

Ansel Adams Papers. Collection 696. Special Collections. University of California, Los Angeles Research Library.

Dorothea Lange Archive. The Oakland Museum of California. Oakland, Calif.

Dorothea Lange Papers. Bancroft Library. University of California, Berkeley.

Exhibition Records. Erna and Victor Hasselblad Study Center. Museum of Modern Art. New York City.

Hayashida collection. Seattle, Wash.

Japanese American Research Project. Collection 2010. Special Collections. University of California, Los Angeles Research Library.

Manzanar War Relocation Center Records. Collection 122. Special Collections. University of California, Los Angeles Research Library.

Miyatake family collection. Montebello, Calif.

National Archives. Washington, D.C. Record Group 210.

National Archives II. College Park, Md. Record Group 210—Still Pictures Branch.

Interviews

Adams, Ansel. "Conversations with Ansel Adams." An oral history conducted by Ruth Teiser and Catherine Harroun. Regional Oral History Office. Bancroft Library. University of California, Berkeley: 1972–75.

Crouch, Tom. Personal interview. February 10, 1998.

Hayashi, Masumi. Personal interview. July, 19 1999.

Hayashida, Fumiko. Personal interview. July 23–24, 1999.

Lange, Dorothea. "The Making of a Documentary Photographer." Interview by Su-
 zanne B. Reiss. Regional Oral History Project. Bancroft Library. University of
 California, Berkeley: 1968.
Locke, Jennifer. Personal interview. February 9, 1998.
Miyatake, Archie. Personal interviews. March 20, 1998, and August 3, 1998.
Nagatani, Diane and John. Personal interview. August 2, 1998.
Nagatani, Patrick. Personal interviews. November 18, 1995, November 27, 1995, and
 December 5, 1995.
Taylor, Paul Schuster. "California Social Scientist." Interview by Suzanne B. Reiss. Earl
 Warren Oral History Project. Bancroft Library. University of California, Berkeley,
 1973.

Newspapers

Los Angeles Times
Manzanar Free Press
New York Times
Rafu Shimpo (Los Angeles)
San Francisco Chronicle
Seattle Post-Intelligencer
Washington Post

Books and Articles

Adams, Ansel, ed. *A Pageant of Photography.* San Francisco: Crocker-Union, 1940.
———. *Born Free and Equal: The Story of Loyal Japanese Americans.* New York: U.S.
 Camera, 1944.
———. *The Portfolios of Ansel Adams.* Boston: New York Graphic Society, 1981.
Agamben, Giorgio. *Homo Sacer: Sovereign Power and Bare Life.* Trans. Daniel Heller-
 Roazen. Stanford, Calif.: Stanford University Press, 1998.
Alinder, Jasmine. "Displaced Smiles: Photography and the Incarceration of Japanese
 Americans During World War II." *Prospects: An Annual of American Cultural
 Studies* 30 (2005): 519–37.
———. *Virtual Pilgrimage: Patrick Nagatani's "Japanese American Concentration
 Camp" Portfolio.* Albuquerque: The Albuquerque Museum, 1998.
Alinder, Mary Street. *Ansel Adams: A Biography.* New York: Henry Holt, 1996.
Alinder, Mary Street and Andrea Gray Stillman, eds. *Ansel Adams: Letters and Im-
 ages, 1916–1984.* Boston: Little, Brown and Co., 1988.
Alpers, Svetlana. *The Art of Describing: Dutch Art in the Seventeenth Century.* Chi-
 cago: The University of Chicago Press, 1983.
Anderson, Margo, and Stephen E. Fienberg, "History, Myth Making, and Statistics:
 A Short Story about the Reapportionment of Congress and the 1990 Census." *PS:
 Political Science and Politics* XXXIII (December 2000): 783–92.

Antze, Paul, and Michael Lambek, eds. *Tense Past: Cultural Essays in Trauma and Memory.* New York: Routledge, 1996.

Armor, John, and Peter Wright. *Manzanar: Photographs by Ansel Adams, Commentary by John Hersey.* New York: Vintage Books, 1989.

Baltz, Lewis. *The New Industrial Parks Near Irvine, California.* New York: Leo Castelli/Castelli Graphics, 1974.

Bammer, Angelika, ed. *Displacements: Cultural Identities in Question.* Bloomington: Indiana University Press, 1994.

Barr, Alfred H., Jr. *Painting and Sculpture in the Museum of Modern Art.* Brattleboro, Vt.: The Museum of Modern Art, 1942.

Barthes, Roland. *Image, Music, Text.* New York: Hill and Wang, 1977.

Bartlett, Frederic C. *Remembering: A Study in Experimental Social Psychology.* Cambridge: Cambridge University Press, 1954.

Benjamin, Walter. *Reflections.* Ed. Peter Demetz. New York: Harvest/HBJ, 1979.

Benti, Wynne, ed. *Born Free and Equal.* Bishop, Calif.: Spotted Dog Press, 2002.

Berger, Martin A. *Sight Unseen: Whiteness and American Visual Culture.* Berkeley: University of California Press, 2005.

Blake, Nigel, and Francis Frascina. "Modernization: Spectacle and Irony." In *Modernity and Modernism: French Painting in the Nineteenth Century.* Ed. Francis Frascina et al. 111–24. New Haven, Conn.: Yale University Press, 1993.

Bright, Deborah. "Of Mother Nature and Marlboro Men: An Inquiry into the Cultural Meanings of Landscape Photography." In *The Contest of Meaning.* Ed. Richard Bolton. 125–42. Cambridge, Mass.: MIT Press, 1989.

Buchloh, Benjamin. "From Faktura to Factography." In *The Contest of Meaning.* Ed. Richard Bolton. 48–80. Cambridge, Mass.: MIT Press, 1989.

Chalfen, Richard. *Turning Leaves: The Photograph Collections of Two Japanese American Families.* Albuquerque: University of New Mexico Press, 1991.

Chanzit, Gwen F. *Herbert Bayer: Collection and Archive at the Denver Art Museum.* Denver: Denver Art Museum, 1988.

Chin, Frank. "Come All Ye Asian American Writers." In *The Big Aiiieeeee!* Eds. Jeffrey Paul Chan, Frank Chin, Lawson Fusao Inada, and Shawn Wong. 1–92. New York: Meridian, 1991.

Clifford, James. *The Predicament of Culture: Twentieth Century Ethnography, Literature and Art* . Cambridge, Mass.: Harvard University Press, 1988.

Cohen, Arthur A. *Herbert Bayer: The Complete Work.* Cambridge, Mass.: MIT Press, 1984.

Coleman, A. D. *Light Readings.* Oxford: Oxford University Press, 1979.

Commission on Wartime Relocation and Internment of Civilians. *Personal Justice Denied: Report of the Commission of Wartime Relocation and Internment of Civilians.* Washington, D.C.: Government Printing Office, 1982.

Conrat, Maisie, and Richard Conrat. *Executive Order 9066.* Los Angeles: California Historical Society, 1972.

Creef, Elena Tajima. *Imaging Japanese America: The Visual Construction of Citizenship, Nation and the Body.* New York: New York University Press, 2004.

Crew, Spencer R., and James E. Sims. "Locating Authenticity: Fragments of a Dialogue." In *Exhibiting Cultures: The Poetics and Politics of Museum Display.* Eds. Ivan Karp and Steven Lavine. 159–75. Washington, D.C.: Smithsonian Institution Press, 1991.

Curtis, James. *Mind's Eye, Mind's Truth: FSA Photography Reconsidered.* Philadelphia: Temple University Press, 1989.

Daniels, Roger. "Words Do Matter: A Note on Inappropriate Terminology and the Incarceration of the Japanese Americans." In *Nikkei in the Pacific Northwest: Japanese Americans and Japanese Canadians in the Twentieth Century.* Eds. Louis Fiset and Gail Nomura. 183–207. Seattle: University of Washington Press, 2005.

———. *Prisoners Without Trial: Japanese Americans in World War II.* 1993, New York: Hill and Wang, 2004.

———. "Dorothea Lange and the War Relocation Authority." In *Dorothea Lange: A Visual Life.* Ed. Elizabeth Partridge. 45–55. Washington, D.C.: Smithsonian Institution Press, 1994.

———. "Redress Achieved." In *Japanese Americans: From Relocation to Redress.* Eds. Roger Daniels, Sandra C. Taylor and Harry H. L. Kitano. 219–23. Seattle: University of Washington Press, 1991.

———. *Concentration Camps: North America: Japanese in the United States and Canada during World War II.* 1971, Malabar, Fla.: Robert E. Krieger Publishing, 1981.

———. *The Politics of Prejudice: The Anti-Japanese Movement in California and the Struggle for Japanese Exclusion.* Berkeley and Los Angeles: University of California Press, 1962.

Daniels, Roger, Sandra C. Taylor, and Harry H. L. Kitano. "Chronology." In *Japanese Americans: From Relocation to Redress.* Eds., Roger Daniels, Sandra C. Taylor and Harry H. L. Kitano. xv-xxi. Seattle: University of Washington Press, 1991.

Danovitch, Sylvia. "The Past Recaptured: The Photographic Record of the Internment of the Japanese-Americans." *Prologue* 12.2 (Summer 1980): 91–103.

Davidov, Judith Fryer. "'The Color of My Skin, the Shape of My Eyes': Photographs of Japanese-American Internment by Dorothea Lange, Ansel Adams and Toyo Miyatake." *The Yale Journal of Criticism* 9.2 (1996): 223–44.

Dower, John W. *War Without Mercy: Race and Power in the Pacific War.* New York: Pantheon Books, 1986.

Drinnon, Richard. *Keeper of Concentration Camps: Dillon S. Myer and American Racism.* Berkeley: University of California Press, 1987.

Duncan, Carol. *Civilizing Rituals: Inside Public Art Museums.* New York: Routledge, 1995.

Eaton, Allen H. *Beauty Behind Barbed Wire: The Arts of Japanese in Our War Relocation Camps.* New York: Harper and Brothers, 1952.

Edwards, Elizabeth, ed. *Anthropology and Photography.* New Haven, Conn.: Yale University Press, 1992.

Elliott, George P. *Dorothea Lange.* New York: The Museum of Modern Art, 1966.

Embry, Sue Kunitomi. "Born Free and Equal." In *Born Free and Equal.* Ed. Wynne Benti. 24–26. Bishop, Calif.: Spotted Dog Press, 2002.

———. *The Lost Years, 1942–1946.* Los Angeles: Moonlight Publications, 1972.

French, Lindsey. "Exhibiting Terror," In *Truth Claims: Representation and Human Rights.* Eds. Mark P. Bradley and Patrice Petro. 131–56. New Brunswick, N.J.: Rutgers University Press, 2002.

Foote, Caleb. *Outcasts! The Story of America's Treatment of Her Japanese-American Minority.* New York: The Committee on Resettlement of Japanese Americans, 1942.

Forresta, Merry A., Stephen Jay Gould, and Karal Ann Marling. *Between Home and Heaven: Contemporary American Landscape Photography.* Washington, D.C.: Smithsonian Institution, 1992.

Foucault, Michel. *Discipline and Punish: The Birth of the Prison.* Trans. Alan Sheridan. New York: Vintage Books, 1979.

Galassi, Peter. *American Photography 1890–1965.* New York: Museum of Modern Art, 1995.

Garrett, Jessie A., and Ronald C. Larson, eds. *Camp and Community: Manzanar and the Owens Valley.* Fullerton, Calif.: California State University, 1977.

Gender Beyond Memory: The Works of Contemporary Women Artists. Trans. Megumi Kitahara, Gavin Frew and Fumiko Yokoyama. Tokyo: Tokyo Metropolitan Museum of Photography, 1996.

Gesensway, Deborah, and Mindy Roseman. *Beyond Words: Images from America's Concentration Camps.* Ithaca, N.Y.: Cornell University Press, 1987.

Gordon, Linda. "Dorothea Lange Photographs the Japanese American Internment." In *Impounded: Dorothea Lange and the Censored Images of Japanese American Internment.* Eds., Linda Gordon and Gary Okihiro. 5–45. New York: W. W. Norton, 2006.

Grover, Jan Zita. "The Winner Names the Age: Historicism and Ansel Adams's Manzanar Photographs." *Afterimage* (April 1989): 14–18.

Hammond, Anne. "Ansel Adams at Manzanar Relocation Center, 1943–1944." *History of Photography* 30.3 (Autumn 2006): 245–57.

Haney Lopez, Ian F. *White by Law: The Legal Construction of Race.* New York: New York University Press, 1996.

Hansen, Arthur A., ed. *Japanese American World War II Evacuation Oral History Project: Part IV Registers.* Munich: K. G. Saur, 1995.

Hansen, Arthur A., and David A. Hacker. "The Manzanar 'Riot': An Ethnic Perspective." In *Voices Long Silent: An Oral Inquiry into the Japanese American Evacuation.* Eds. Arthur A. Hansen and Betty E. Mitson. 41–79. Fullerton, Calif.: California State University, Oral History Program, 1974.

Hayashi, Masumi. "American Concentration Camps." *See* 1:1 (Winter 1995): 32–35.

Hess, Ursula, Martin G. Beaupre, and Nicole Cheung. "Who to Whom and Why." In *An Empirical Reflection on the Smile*. Ed. Millicent H. Abel. 187–216. Lewiston, N.Y.: The Edwin Mellen Press, 2002.

Higa, Karin. *The View from Within: Japanese American Art from the Internment Camps, 1942–1945*. Los Angeles: Japanese American National Museum, the UCLA Wight Gallery and the UCLA Asian American Studies Center, 1992.

Higa, Karin, and Tim B. Wride. "Manzanar Inside and Out: Photo Documentation of the Japanese Wartime Incarceration." In *Reading California: Art, Image, and Identity, 1900–2000*. Eds. Stephanie Barron, Sheri Bernstein, and Ilene Susan Fort. 314–37. Berkeley: University of California Press, 2000.

Honda, Diane Yotsuya, ed. *Our World: Manzanar, California*. 1944. Logan, Utah: Herff Jones Yearbook Company, 1998.

Hosokawa, Bill. *Nisei: The Quiet Americans*. New York: William Morrow, 1969.

Houston, Jeanne Wakatsuki, and James D. Houston. *Farewell to Manzanar*. Boston: Houghton Mifflin, 1973.

Howe, Graham, Jacqueline Markham, Patrick Nagatani, and Scott Rankin, eds. *Two Views of Manzanar*. Los Angeles: UCLA Wight Gallery, 1978.

Hutcheon, Linda. *Irony's Edge: The Theory and Politics of Irony*. London: Routledge, 1994.

Ichioka, Yuji, ed. *Views from Within: The Japanese American Evacuation and Resettlement Study*. Los Angeles: University of California at Los Angeles Press, 1989.

Ihde, Don. *Experimental Phenomenology*. New York: State University of New York Press, 1986.

Iritani, Frank, and Joanne Iritani. *Ten Visits: Accounts of Visits to All the Japanese American Relocation Centers*. San Mateo, Calif.: Japanese American Curriculum Project, Inc., 1995.

Ishiwata, Maya, ed. *Patrick Nagatani and Andrée Tracey: Polaroid 20x24 Photographs 1983–1986*. Tokyo: Gallery Min, 1987.

Ishizuka, Karen L. *Lost and Found: Reclaiming the Japanese American Incarceration*. Urbana: University of Illinois Press, 2006.

Jacobson, Matthew Frye. *Whiteness of a Different Color: European Immigrants and the Alchemy of Race*. Cambridge, Mass.: Harvard University Press, 1998.

James, Thomas. *Exile Within: The Schooling of Japanese Americans 1942–1945*. Cambridge, Mass.: Harvard University Press, 1987.

Janis, Eugenia Parry. *Nuclear Enchantment: Photographs by Patrick Nagatani*. Albuquerque: University of New Mexico Press, 1991.

Jordan, Jennifer. *Structures of Memory: Understanding Urban Change in Berlin and Beyond*. Stanford, Calif.: Stanford University Press, 2006.

Kessler, Lauren. "Fettered Freedoms: The Journalism of World War II Japanese Internment Camps." *Journalism History* (Summer/Autumn 1988): 70–79.

Kitano, Harry H. L. *Japanese Americans: The Evolution of a Subculture.* Englewood Cliffs, N.J.: Prentice-Hall, 1969.

Koppes, Clayton R., and Gregory D. Black. *Hollywood Goes to War: How Politics, Profits and Propaganda Shaped World War II Movies.* Berkeley: University of California Press, 1987.

Kozol, Wendy. "Relocating Citizenship in Photographs of Japanese Americans during World War II." In *Haunting Violations: Feminist Criticism and the Crisis of the "Real".* Eds. Wendy S. Hesford and Wendy Kozol. 217–50. Urbana: University of Illinois Press, 2001.

Krauss, Rosalind. "Photography's Discursive Spaces." In *The Contest of Meaning.* Ed. Richard Bolton. 287–302. Cambridge, Mass.: MIT Press, 1989.

Kugelmass, Jack. "The Rites of the Tribe: American Jewish Tourism in Poland." In *Museums and Communities: The Politics of Public Culture.* Ed. Ivan Karp. 382–427. Washington, D.C.: Smithsonian Institution Press, 1992.

Kuramitsu, Kristine. "Internment and Identity in Japanese American Art." *American Quarterly* 47 (1995): 619–58.

Lange, Dorothea, and Paul Schuster Taylor. *An American Exodus: A Record of Human Erosion in the Thirties.* 1939. New Haven, Conn.: Yale University Press, 1969.

———. "Documentary Photography." In *A Pageant of Photography.* Ed. Ansel Adams. San Francisco: Crocker Union, 1940.

Lee, Anthony W. *Picturing Chinatown: Art and Orientalism in San Francisco.* Berkeley, University of California Press, 2001.

Lee, Erika. *At America's Gates: Chinese Immigration during the Exclusion Era, 1882–1943.* Chapel Hill: University of North Carolina Press, 2003.

———. "The Chinese Exclusion Example: Race, Immigration, and Ameican Gatekeeping, 1882–1924." *Journal of American Ethnic History* (Spring 2002): 36–62.

Leighton, Alexander. *The Governing of Men: General Principles and Recommendations Based on Experience at a Japanese Relocation Camp.* 1945. New York: Octagon Books, Inc., 1964.

Life. Untitled. January 13, 1941: 25.

Linenthal, Edward T., and Tom Engelhardt eds. *History Wars: The Enola Gay and Other Battles for the American Past.* New York: Henry Holt, 1996.

Luther, Catherine A. "Reflections of Cultural Identities in Conflict: Japanese American Internment Camp Newspapers during World War II." *Journalism History* (Summer 2003): 69–81.

Lynes, Russell. *Good Old Modern: An Intimate Portrait of the Museum of Modern Art.* New York: Antheneum, 1973.

Malkin, Michelle. *In Defense of Interment: The World War II Round-Up and What It Means for America's War on Terror.* Washington, D.C.: Regnery, 2004.

Maloney, Tom, ed. *The U.S.A. at War: U.S. Camera 1944.* New York: U.S. Camera/Duell, Sloan & Pearce, 1944.

Marr, Carolyn J. "Marking Oneself: Use of Photographs by Native Americans of the Southern Northwest Coast." *American Indian Culture and Research Journal* 20.3 (1996): 51–64.

Mass, Amy Iwasaki. "Psychological Effects of the Camps on Japanese Americans." In *Japanese Americans From Relocation to Redress*. Eds., Rogers Daniels, Sandra C. Taylor and Harry H. L. Kitano. 159–62. Seattle: University of Washington Press, 1991.

Maxwell, Anne. *Colonial Photography and Exhibitions: Representations of the Native and the Making of European Idenitites*. London: Leicester University Press. 1999.

Medvec, Emily. *Born Free and Equal: An Exhibition of Ansel Adams Photographs*. Washington, D.C.: Echolight Corporation, 1984.

Melion, Walter, and Susanne Küchler. "Introduction: Memory, Cognition and Image Production." In *Images of Memory: On Remembering and Representation*. Eds. Melion and Küchler. 1–46. Washington, D.C.: Smithsonian Institution Press, 1991.

Mercer, Kobena. *Welcome to the Jungle: New Positions in Black Cultural Studies*. New York: Routledge, 1994.

Miyatake, Atsufumi [Archie], Taisuke Fujishima, and Eikoh Hosoe, eds. *Toyo Miyatake Behind the Camera 1923–1979*. Trans. Paul Petite. Tokyo: Bungeishunju Co. Ltd., 1984.

Mochizuki, Ken. *Baseball Saved Us*. New York: Lee and Low Books, 1993.

Mura, David. *Where the Body Meets Memory: An Odyssey of Race, Sexuality and Identity*. New York: Anchor Books, 1996.

Myers, Joan, and Gary Y. Okihiro. *Whispered Silences: Japanese Americans and World War II*. Seattle: University of Washington Press, 1996.

Nagata, Donna. *Legacy of Injustice: Exploring the Cross-generational Impact of Japanese American Internment*. New York: Plenum Press, 1993.

———. "Japanese American Internment: Exploring the Transgenerational Consequences of Traumatic Stress." *Journal of Traumatic Stress* 3 (1990): 47–69.

Nakanishi, Don T. "Surviving Democracy's 'Mistake': Japanese Americans and the Enduring Legacy of Executive Order 9066!" *Amerasia Journal* 19.1 (1993): 7–35.

Nakao, Annie. "Sansei Dig up Buried Roots." *San Francisco Examiner.* Sunday, May 26, 1996: C-1.

Narayan, Kirin. "How Native Is a 'Native' Anthropologist?" *American Anthropologist* 95 (1993): 671–86.

National Japanese American Historical Society. *Teacher's Guide: The Bill of Rights and the Japanese American World War II Experience*. San Francisco: National Japanese American Historical Society, 1992.

Newhall, Beaumont. *The History of Photography*. 1937. New York: Museum of Modern Art, 1982.

Newhall, Beaumont, et al. "The New Department of Photography." *Bulletin of the Museum of Modern Art* 8:2 (December/January 1940): 4–5.

Ngai, Mae M. *Impossible Subjects: Illegal Aliens and the Making of Modern America.* Princeton, N.J.: Princeton University Press, 2005.

Nobe, Lisa N. "The Children's Village at Manzanar: The World War II Eviction and Detention of Japanese American Orphans." *Journal of the West* (April 1999): 65–71.

Nora, Pierre. "Between Memory and History: Les Lieux de Mémoire." *Representations* 26 (1989): 7–24.

Ohrn, Karin Becker. *Dorothea Lange and the Documentary Tradition.* Baton Rouge, La.: Louisiana State University Press, 1980.

Okada, John. *No-No Boy.* 1957. Seattle: University of Washington Press, 1976.

Okamura, Raymond K. "The American Concentration Camps: A Cover-up Through Euphemistic Terminology." *Journal of Ethnic Studies* 10.3 (Fall 1982): 95–109.

Okihiro, Gary. "Japanese Resistance in America's Concentration Camps." *Amerasia* 2:1 (Fall 1973): 20–34.

Okubo, Miné. *Citizen 13660.* 1946. Seattle: University of Washington Press, 1983.

Okutsu, James K. *Expressions from Exile: 1942–1945. Japanese American Art from the Concentration Camps.* San Francisco: San Francisco University Press, 1979.

Partridge, Elizabeth. *Restless Spirit: The Life and Work of Dorothea Lange.* New York: Viking, 1998.

———. Ed. *Dorothea Lange: A Visual Life.* Washington, D.C.: Smithsonian Institution Press, 1994.

Pegler-Gordon, Anna. "Chinese Exclusion, Photography, and the Development of U.S. Immigration Policy." *American Quarterly* 58.1 (March 2006): 51–77.

Phillips, Christopher. "The Judgment Seat of Photography." In *The Contest of Meaning.* Ed. Richard Bolton. 15–48. Cambridge, Mass.: MIT Press, 1989.

———. "Steichen's Road to Victory." *Exposure* 18.2 (Fall 1980): 38–48.

Pinney, Christopher. "The Parallel Histories of Anthropology and Photography." In *Anthropology and Photography.* Ed. Elizabeth Edwards. 74–96. New Haven, Conn.: Yale University Press, 1992.

Purdham, Todd S. "U.S. Starts to Dust Off a Dark Spot in History for All to See." *New York Times.* June 20, 1998: A6.

Reflections in Three Self-Guided Tours of Manzanar. Los Angeles: The Manzanar Committee, 1998.

"Road to Victory." *Art Digest* 16.17 (June 1, 1942): 5

Robinson, Gerald H. *Elusive Truth: Four Photographers at Manzanar.* Nevada City, Calif.: Carl Mautz Publishers, 2002.

Robinson, Greg. *By Order of the President:FDR and the Internment of Japanese Americans.* Cambridge, Mass.: Harvard University Press, 2001.

Rosler, Martha. "in, around, and afterthoughts (on documentary photography)." In *The Contest of Meaning.* Ed. Richard Bolton. 303–42. Cambridge, Mass.: MIT Press, 1989.

Sekula, Allan. "The Body and the Archive." In *The Contest of Meaning*. Ed. Richard Bolton. 343–89. Cambridge, Mass.: MIT Press, 1989.

———. "The Traffic in Photographs." In *Modernism and Modernity: The Vancouver Conference Papers*. Eds. Benjamin H. D. Buchloh, Serge Guilbaut and David Solkin. 121–154. Nova Scotia: Press of the Nova Scotia College of Art and Design, 1983.

Semin, Didier, Tamar Garb, and Donald Kuspit. *Christian Boltanski*. London: Phaidon, 1997.

Shaffer, Robert. "Opposition to Internment: Defending Japanese American Rights During World War II." *The Historian* (1999): 597–619.

———. "Cracks in the Consensus: Defending the Rights of Japanese Americans During World War II." *Radical History Review* 72 (1998): 84–120

Smith, Jason Scott. *Building New Deal Liberalism: The Political Economy of Public Works, 1933–1956*. New York: Cambridge University Press, 2005.

Smith, Joshua P. *The Photography of Invention: American Pictures of the 1980s*. Cambridge, Mass.: MIT Press, 1989.

Soga, Keiho. "Death at the Camp." In *Poets Behind Barbed Wire*. Eds. and trans. Jiro Nakano and Kay Nakano. 61–66. Honolulu, Hawaii: Bambo Ridge Press, 1983.

Solomon-Godeau, Abigail. *Photography at the Dock: Essays on Photographic History, Institutions and Practices*. Minneapolis: University of Minnesota Press, 1991.

Sone, Monica. *Nisei Daughter*. 1953. Seattle: University of Washington Press, 1979.

Spaulding, Jonathan. *Ansel Adams and the American Landscape*. Berkeley: University of California Press, 1995.

Spickard, Paul R. *Japanese Americans: The Formation and Transformations of an Ethnic Group*. New York: Twayne Publishers, 1996.

Stange, Maren. "Documentary Photography in American Social Reform Movements: The FSA Project and its Predecessors." In *Multiple Views: Logan Grant Essays on Photography*. Ed. Daniel P. Younger. 195–224. Albuquerque: University of New Mexico Press, 1991.

———. *Symbols of Ideal Life: Social Documentary Photography in America 1890–1950*. Cambridge: Cambridge University Press, 1989.

Staniszewski, Mary Anne. *The Power of Display: A History of Exhibition Installations at the Museum of Modern Art*. Cambridge, Mass.: MIT Press, 1998.

Starn, Orin. "Engineering Internment: Anthropologists and the War Relocation Authority." *American Ethnologist* 13.4 (November 1986): 700–20.

Stein, Sally. "Peculiar Grace: Dorothea Lange and the Testimony of the Body." In *Dorothea Lange: A Visual Life*. Ed. Elizabeth Partridge. 58–89. Washington, D.C.: Smithsonian Institution Press, 1994.

Sturken, Marita. *Tangled Memories: The Vietnam War, The Aids Epidemic, and the Politics of Remembering*. Berkeley: University of California Press, 1997.

———. "Absent Images of Memory: Remembering and Reenacting the Japanese Internment." *Positions* 5.3 (1997): 687–707.

Sumida, Stephen H. "John Okada's *No-No Boy* as a Novel of Japanese American Re-

sistance." Annual Conference of the Japanese Association for American Studies, Sendai International Center, Japan: June 1995.

———. "Protest and Accommodation, Self-Satire and Self-Effacement, and Monica Sone's *Nisei Daughter.*" In *Multicultural Autobiography: American Lives.* Ed. James Robert Payne. 207–47. Knoxville: University of Tennessee Press, 1992.

Szarkowski, John. *American Landscapes: Photographs from the Collection of the Museum of Modern Art.* New York: The Museum of Modern Art, 1981.

———. *New Topographics: Photographs of a Man-altered Landscape.* Rochester, N.Y.: George Eastman House, 1975.

Szasz, Ferenc M., and Patrick Nagatani. "Constricted Landscapes: The Japanese American Concentration Camps, A Photographic Essay." *New Mexico Historical Review* 71 (1996): 157–88.

Tagg, John. *The Burden of Representation: Essays on Photographies and Histories.* Minneapolis: University of Minnesota Press, 1988.

Takemoto, Paul Howard. *Nisei Memories: My Parents Talk about the War Years.* Seattle: University of Washington Press, 2006.

Takezawa, Yasuko I. *Breaking the Silence: Redress and Japanese American Ethnicity.* Ithaca, N.Y.: Cornell University Press, 1995.

Tanaka, Chester. *Go For Broke: A Pictorial History of the Japanese American 100th Infantry Battalion and the 442d Regimental Combat Team.* Novato, Calif.: Presidio Press, 1982.

Tateishi, John. "The Japanese American Citizens League and the Struggle for Redress." In *Japanese Americans: From Relocation to Redress.* Eds. Roger Daniels, Sandra C. Taylor and Harry H. L. Kitano. 191–95. Seattle: University of Washington Press, 1991.

Taylor, Sandra C. *Jewel of the Desert: Japanese American Internment at Topaz.* Berkeley: University of California Press, 1993.

Thomas, Dorothy Swaine, and Richard S. Nishimoto. *The Spoilage! Japanese American Evacuation and Resettlement.* Berkeley: University of California Press, 1946.

Tokuda, Tama, and Teri Adada. "Fumi Hayashida." *Tomo No Kai.* Seattle, 1993.

Tong, Benson. "Race, Culture, and Citizenship among Japanese American Children and Adolescents during the Internment Era." *Journal of American Ethnic History* (Spring 2004): 3–40.

United States Department of the Interior, War Relocation Authority. *Legal and Constitutional Phases of the WRA Program.* Washington, D.C.: U.S. Government Printing Office, 1946.

———. *WRA: A Story of Human Conservation.* Washington, D.C.: U.S. Government Printing Office, 1946.

———. *Relocation Communities for Wartime Evacuees.* Washington, D.C.: War Relocation Authority, 1942.

Weglyn, Michi. *Years of Infamy: The Untold Story of America's Concentration Camps.* Seattle: University of Washington Press, 1996.

Williams, Val. *Warworks: Women, Photography and the Iconography of War.* London: Virago Press, 1994.

Yamada, Mitsuye. *Camp Notes and Other Writings.* New Brunswick, N.J.: Rutgers University Press, 1992.

Young, James. "Memory and Counter-Memory: Towards a Social Aesthetic of Holocaust Memorials." In *After Auschwitz: Responses to the Holocaust in Contemporary Art.* Ed. Monica Bohm-Duchen. 78–102. Sunderland: N. Center for Contemporary Art, 1995.

———. *The Texture of Memory: Holocaust Memorials and Memory.* New Haven, Conn.: Yale University Press, 1993.

Zelizer, Barbie. "From the Image of Record to the Image of Memory: Holocaust Photography, Then and Now." In *Picturing the Past: Media, History, and Photography.* Eds. Bonnie Brennen and Hanno Hardt. 98–121. Chicago and Urbana: University of Illinois Press, 1999.

———. *Remembering to Forget: Holocaust Memory through the Camera's Eyes.* Chicago: University of Chicago Press, 1998.

Films, Videos, and Other Media

Andre's Lives. Directed by Brad Lichtenstein. First Run/Icarus Films, 1999.

Come See the Paradise. Directed by Alan Parker. Twentieth Century Fox, 1990.

Executive Order 9066: The Incarceration of Japanese Americans during World War II. CD-ROM. Los Angeles: Regents of the University of California, 1998.

History and Memory. Directed by Rea Tajiri. Akiko Productions, 1991.

Rabbit in the Moon. Directed by Emiko Omori. Public Broadcasting System, 1999.

Something Strong Within. Directed by Robert A. Nakamura. Produced by Karen L. Ishizuka, 1995.

Toyo Miyatake: Infinite Shades of Gray. Directed by Robert A. Nakamura. Produced by Karen L. Ishizuka. Japanese American National Museum Media Arts Center, 2001.

Who's Going to Pay for These Donuts Anyway? Directed by Janice Tanaka. National Asian American Telecommunications Association, 1995.

Index

JASMINE ALINDER is an assistant professor of history at the University of Wisconsin–Milwaukee. She grew up in northern California surrounded by photographs and photographers. Alinder's project on photography and Japanese American incarceration began through her encounter with the contemporary photographs of Patrick Nagatani.

The University of Illinois Press
is a founding member of the
Association of American University Presses.

Composed in 10.5/13 Adobe Minion Pro
with FF Meta display
at the University of Illinois Press
Manufactured by Thomson-Shore, Inc.

University of Illinois Press
1325 South Oak Street
Champaign, IL 61820-6903
www.press.uillinois.edu